THE RULERS OF RUSSIA

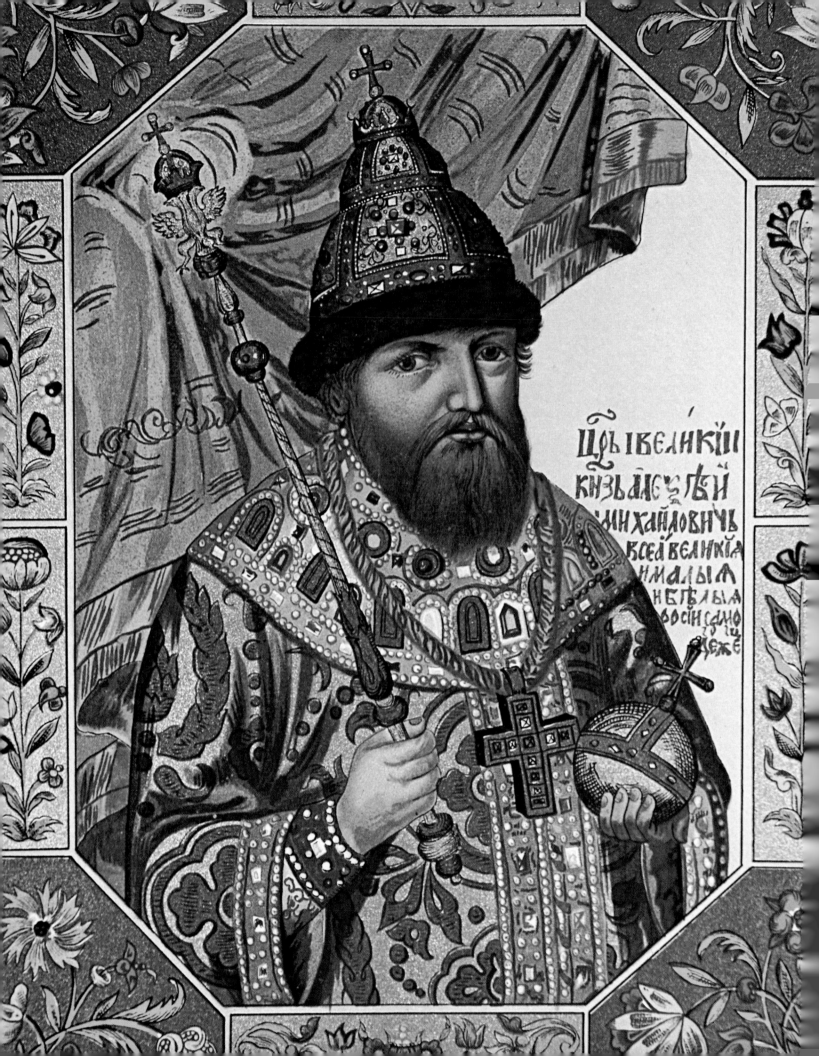

Црь і великїи
кнзь але ѯѣй
михайловичь
всеа велики́
и малы́
и белы́
россїи само
держе

THE RULERS OF RUSSIA

by

Peter Andrews

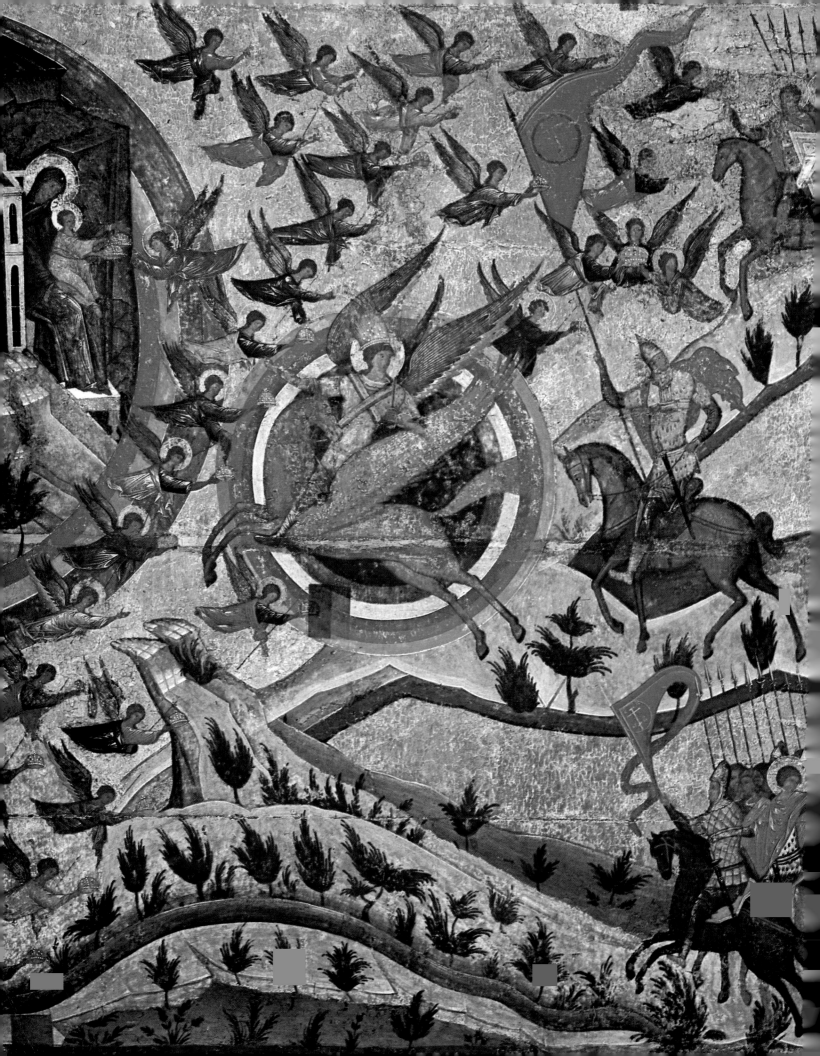

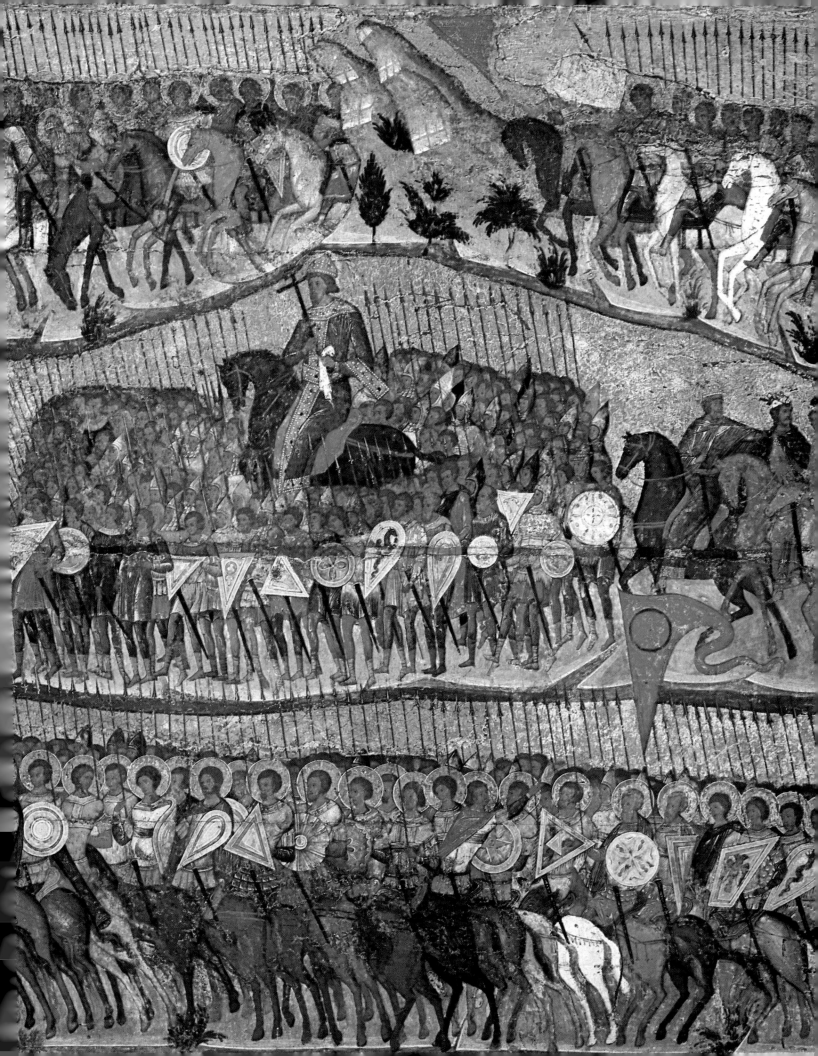

Treasures of the World was created by
Tree Communications, Inc.
and published by Stonehenge Press Inc.

TREE COMMUNICATIONS, INC.

PRESIDENT
Rodney Friedman

PUBLISHER
Bruce Michel

VICE PRESIDENTS
Ronald Gross
Paul Levin

EDITOR
Charles L. Mee, Jr.

EXECUTIVE EDITOR
Shirley Tomkievicz

ART DIRECTOR
Sara Burris

PICTURE EDITOR
Mary Zuazua Jenkins

TEXT EDITORS
Henry Wiencek Thomas Dickey

ASSOCIATE EDITORS
Vance Muse Artelia Court

ASSISTANT ART DIRECTOR
Carole Muller

ASSISTANT PICTURE EDITORS
Deborah Bull Carol Gaskin
Charlie Holland Linda Silvestri Sykes

COPY EDITOR
Fredrica A. Harvey

ASSISTANT COPY EDITOR
Cynthia Villani

PRODUCTION MANAGER
Peter Sparber

EDITORIAL ASSISTANTS
Carol Epstein Martha Tippin
Holly McLennan Wheelwright

FOREIGN RESEARCHERS
Rosemary Burgis (London) Bianca Spantigati Gabbrielli (Rome)
Patricia Hanna (Madrid) Alice Jugie (Paris)
Traudl Lessing (Vienna) Dee Pattee (Munich)
Brigitte Rückriegel (Bonn) Simonetta Toraldo (Rome)

CONSULTING EDITOR
Joseph J. Thorndike, Jr.

STONEHENGE PRESS INC.

PUBLISHER
John Canova

EDITOR
Ezra Bowen

RESEARCHER
Eric Schurenberg

ADMINISTRATIVE ASSISTANT
Elizabeth Noll

THE AUTHOR: Peter Andrews, a contributing editor of *American Heritage* magazine, has written several books on American history, including *A Tragedy of History*, *In Honored Glory*, and *The Reluctant Hero*.

CONSULTANT FOR THIS BOOK: Marina Kovalyov was curator at the Hermitage and curator of decorative arts at the Ethnographical Museum of the People of the USSR, both in Leningrad. She emigrated to the United States in 1979 and has worked as a research assistant at the Brooklyn Museum in New York.

Published simultaneously in Canada.
Library of Congress catalogue card number 82-50159
ISBN 0-86706-051-4
ISBN 0-86706-076-X (lib. bdg.)
ISBN 0-86706-077-8 (retail ed.)
STONEHENGE with its design is a registered trademark of Stonehenge Press Inc.
Printed in U.S.A. by R.R. Donnelley & Sons.
For reader information about any Stonehenge book, please write: Reader Information/
Stonehenge Press Inc./303 East Ohio Street/Chicago, Illinois 60611.

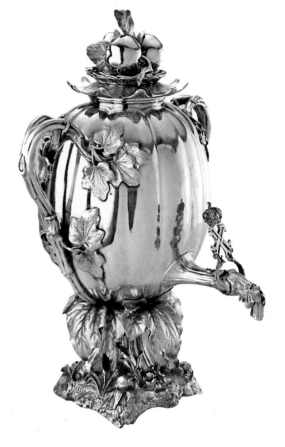

COVER: *A gold and enamel egg, created in the workshops of famed goldsmith Carl Fabergé, bears scenes of Czar Nicholas II and his family—the last of Russia's Romanov dynasty. The scene at center is of Nicholas's coronation in 1896.*

TITLE PAGE: *Alexei I, the second Romanov to take the throne, is rendered in brilliant detail in this seventeenth-century portrait. He wears a round crown and holds a gem-studded orb and scepter— all regalia of czarist authority.*

OVERLEAF: *The archangel Michael leads Ivan the Terrible and his armies on a victory march in this sixteenth-century icon. The scene celebrates Ivan's conquest of a Mongol city in 1552.*

ABOVE: *Crafted in the shape of a melon, this gold and silver samovar—an urn used to hold water for tea—was made in 1866 for Alexander III, before he became czar. His initials are on the spout, which is surmounted by a crown.*

CONTENTS

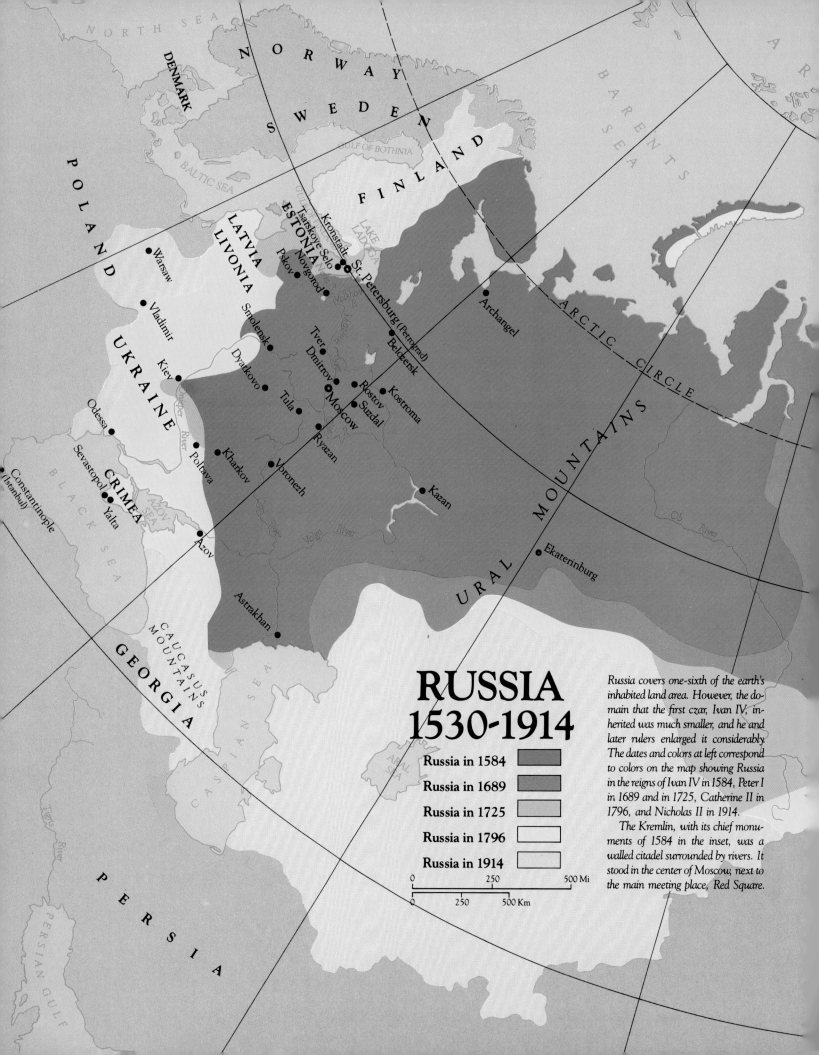

RUSSIA
1530-1914

Russia in 1584
Russia in 1689
Russia in 1725
Russia in 1796
Russia in 1914

0 250 500 Mi

0 250 500 Km

Russia covers one-sixth of the earth's inhabited land area. However, the domain that the first czar, Ivan IV, inherited was much smaller, and he and later rulers enlarged it considerably. The dates and colors at left correspond to colors on the map showing Russia in the reigns of Ivan IV in 1584, Peter I in 1689 and in 1725, Catherine II in 1796, and Nicholas II in 1914.

The Kremlin, with its chief monuments of 1584 in the inset, was a walled citadel surrounded by rivers. It stood in the center of Moscow, next to the main meeting place, Red Square.

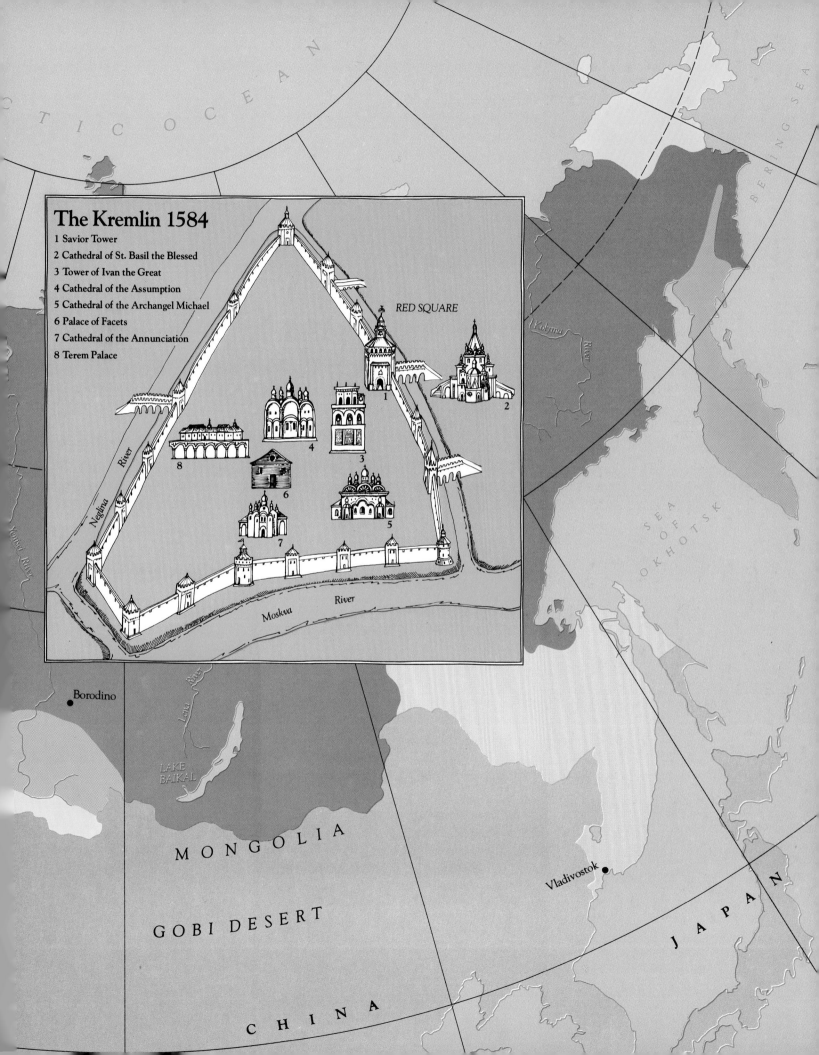

The Kremlin 1584

1 Savior Tower
2 Cathedral of St. Basil the Blessed
3 Tower of Ivan the Great
4 Cathedral of the Assumption
5 Cathedral of the Archangel Michael
6 Palace of Facets
7 Cathedral of the Annunciation
8 Terem Palace

RED SQUARE

Neglina River

Yenisei River

Moskva River

Borodino

LAKE BAIKAL

Lena River

MONGOLIA

GOBI DESERT

Vladivostok

JAPAN

CHINA

ARCTIC OCEAN

BERING SEA

Kolyma River

SEA OF OKHOTSK

I

IVAN THE TERRIBLE

CRUELTY, VIOLENCE—AND THE SACRED ICON

I n 1554 English explorers searching for a northern sea route to China sailed into the daunting waters of the Arctic Ocean and landed on the shore of a strange land. The governor of the region gave shelter to the Englishmen and sent messengers to the far-off capital of his ruler, the czar, with the news that foreigners had landed on their shores. After many weeks the messengers returned with orders to take the Englishmen to the czar. They traveled on sleighs through a frigid, forbidding land, guarded by tough soldiers who slept on the snow without even a tent over their heads. In the towns they passed, the people were so poor they ate rotten fish; yet they gladly handed over their precious horses to the travelers when told that the foreigners were guests of the czar. At last they arrived at an immense city of wood, "rude and without order," as the English captain, Richard Chancellor, described it. The Englishmen had reached Moscow—the capital of Russia, ruled by the mighty czar Ivan IV, or Ivan the Terrible.

Nothing had prepared the Englishmen for the dazzling splendor of

A sixteenth-century portrait of the first czar, Ivan IV, or Ivan the Terrible, captures the determination of a ruler who turned his country into a world power.

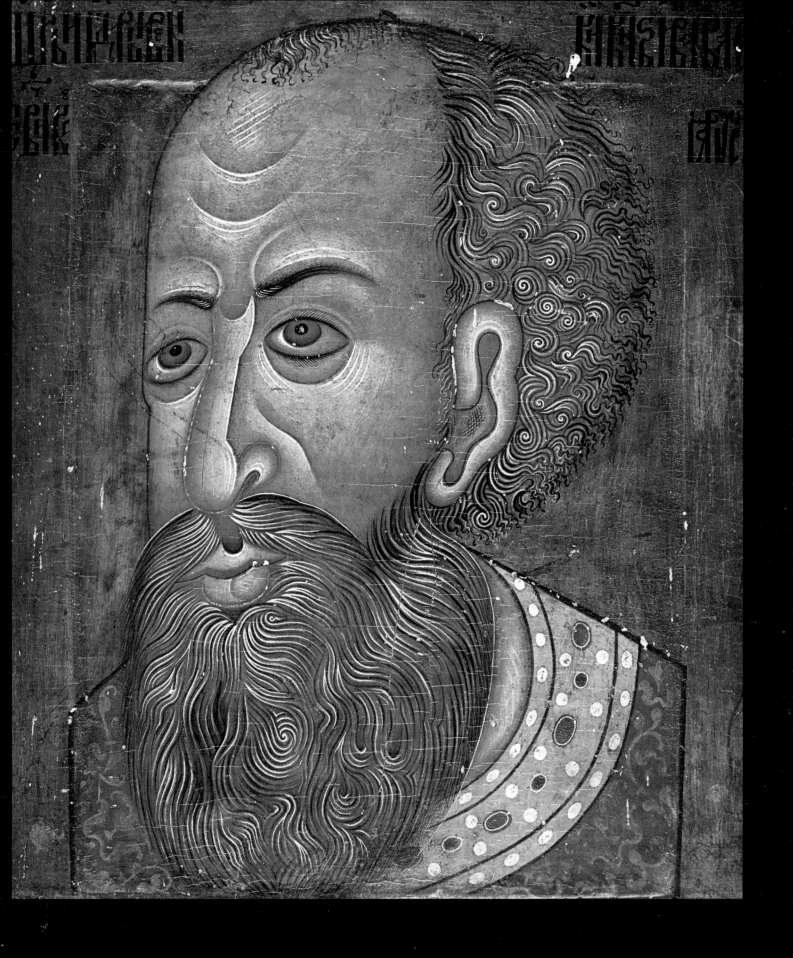

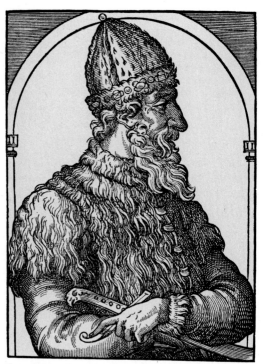

Ivan III, or Ivan the Great, above, left his grandson Ivan IV an invaluable legacy of independence. During his forty-three-year reign Ivan the Great used the twin tools of warfare and diplomacy to stabilize Russian boundaries and drive out the Mongols.

the czar. Ivan received them, in Chancellor's account, wearing "a long garment of beaten gold, with an imperial crown upon his head, and a staff of crystal and gold in his right hand." The czar was a handsome, imposing man with a flowing auburn beard and flashing blue eyes. Around him stood more than a hundred courtiers, all clad in golden robes. The czar greeted the foreigners graciously and feted them at a banquet where the food was served on huge plates of gold, and the czar gulped his wine from a gem-encrusted goblet.

The opulence of Ivan's court had little of the refined elegance of western Europe's capitals, for the Russia of Ivan the Terrible was still a relatively primitive, unruly, and young nation. The Russian state began to emerge in the late fifteenth and early sixteenth centuries, when Ivan the Terrible's grandfather, Grand Prince Ivan III—also called Ivan the Great—united the Russian lands under the throne of Moscow. His realm stretched from the town of Smolensk in the west to the Ural Mountains and from the shores of the Arctic Ocean almost to those of the Caspian Sea.

Of this region's early history little is known. A succession of nomadic peoples roamed these lands between the fourth and ninth centuries. The first permanent settlers were the Slavs, a farming people who migrated from eastern Europe to the Ukraine in the ninth century. The ninth century also saw the arrival of the Vikings, who established trading settlements on the Dnieper and Volga Rivers. Their Volga settlement was called Rus—the origin of the name Russia. A Viking prince called Rurik fathered a dynasty of princes and boyars, or noblemen, who organized the region's trade in furs, timber, honey, and wax. Ivan the Terrible was himself a member of this dynasty. The descendants of Rurik founded the great commercial cities of Kiev, on the Dnieper River, and Novgorod to the north, as well as a shabby town on the Moskva River that ultimately grew into the queen of Russia's cities—Moscow.

Moscow owed its eminence to a series of shrewd and acquisitive princes who bought, stole, or conquered the regions around the city. Moscow's princes lived at the center of the city in a fortress called the Kremlin. Many Russian cities were built around a kremlin, where

the lords and their people took shelter during attacks by rival towns; but Moscow's fortress grew to be the most magnificent. The Kremlin walls eventually enclosed sixty-five acres of ground and a complex of palaces, churches, and administrative buildings. One of the walls of the Kremlin looked out over a large plaza named the Beautiful Square. At that time the Russian word for beautiful also meant red; eventually this second meaning took precedence, and Moscow's grandest public place became known as Red Square.

In the middle of the thirteenth century, Moscow and much of Russia were devastated by invaders from Asia called the Mongols, who seemed to come from hell itself. "A savage people of Tartars, hellish of aspect, as voracious as wolves in their hunger for spoils, and as brave as lions, have invaded my country," wrote the queen of Georgia, the realm between the Caspian and Black Seas. The "hellish Tartars" was a pun—but not a humorous one—on the words "Tatar" and "Tartar." The Mongol army that invaded Georgia included members of the Tatar tribe, whose name grimly suggested the Latin word for hell—*tartarus.*

The Mongols, under Genghis Khan, had exploded from their remote homeland in Mongolia early in the thirteenth century, conquered China, and swept into central Asia. Before his death in 1227, Genghis Khan unleashed his invincible armies on Russia. His grandsons completed the task, storming through Russia in a terrible onslaught. In one ruined city a Russian chronicler recorded that "no eye remained open to weep for the dead" after the bloody rampage of the Tatars, as the Russians usually called the Mongols. The victorious Tatars set up a tent city north of the Caspian Sea to serve as their capital. For more than two centuries the Tatars extracted burdensome taxes from the Russian people, but they allowed Russia's princes and boyars to retain some political autonomy.

Though the Tatars burned Moscow, their invasion ironically provided a boost to Moscow's fortunes. The Tatars so thoroughly destroyed the city of Kiev that the Russian Orthodox Church, which had been centered in Kiev, shifted its hierarchy to Moscow, adding immensely to the city's prestige. Russia had been converted to

This sixteenth-century woodcut by a German traveler reveals the Russians' adeptness at using skis and sleds. While foreign visitors were impressed with such skills, they were also repelled by some of the local customs, such as seldom allowing women to leave their homes, even to attend Church services.

Christianity in an abrupt and startling manner in A.D. 990. Grand Prince Vladimir of Novgorod, dissatisfied with his pagan faith in lightning gods and spirits of the forest, sent agents to investigate the four principal faiths of the time: Islam, Judaism, Roman Catholicism, and Eastern Orthodox Christianity. Perhaps because Vladimir's envoys to Constantinople, capital of the Byzantine Empire, reported that the Orthodox service they attended there was so wondrous—"We knew not whether we were in heaven or on earth" —the grand prince opted for Orthodox Christianity. He ordered his people to be christened immediately, using force to persuade diehard pagans.

Christianity may have been imposed on the Russian people, but it quickly took hold of the Russian soul. The Church led Russia away from barbarism, provided the Russians with a sense of unity, and inspired Russian artists to create beautiful treasures. These churchly treasures, relics, and other religious objects were brought to Moscow's Kremlin after the sack of Kiev. Moscow became the residence of the patriarch, the head of the Russian Orthodox Church. The Russian faithful looked to Moscow as their holy city, revered it as Europe's Catholics revered Rome, and esteemed the prince of Moscow as the man who ruled by the grace of God. In the sixteenth century that ruler was a man more devilish than saintly— Ivan the Terrible.

From his earliest years Ivan had shown a taste for cruelty, made all the worse because he grew up in an atmosphere of terror within the gloomy walls of the Kremlin. One night a squad of armed men burst into Ivan's bedroom. He bolted out of bed in fright, certain that he would be murdered on the spot—but the assassins were seeking another victim, a priest who had ended up on the losing side of a palace plot. Ivan's father, Grand Prince Vasili of Moscow, died when Ivan was only three years old. Moscow's boyars took charge of the city and of Ivan's upbringing.

To distract the heir to Moscow's throne from politics, the boyars encouraged Ivan's natural tendency toward violence and sadism. When, on the streets of Moscow, the boy assaulted men and women

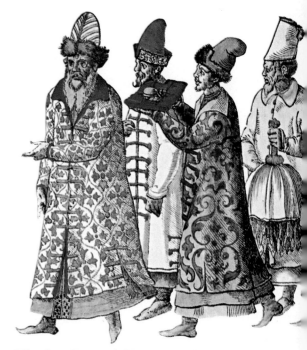

When Ivan IV sent diplomats west, they dressed in fine embroidered robes and observed the strictest protocol. Above, a group of Moscow boyars, or noblemen, enters the court of a German prince in 1576, lined up by rank and carrying furs as gifts.

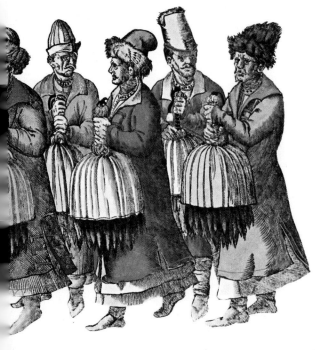

who dared not strike back, the boyars applauded him. By the time he was ten, Ivan was amusing himself by tossing dogs from the Kremlin walls and watching them writhe in pain below.

Ivan suffered most at the hands of the boyar Andrei Shuisky, who ruled Moscow as prince regent. Shuisky kept Ivan on a meager diet and threatened to execute Ivan's only friend. Ivan, by the age of thirteen, had learned all too well Shuisky's lessons in the effectiveness of brutality. In December 1543 Shuisky appeared in the Kremlin without his normal retinue of bodyguards. Ivan called to his own guards to seize Shuisky and handed him over to the keepers of the kennel, who clubbed the regent to death. In an equally bold stroke, Ivan announced that he would take not only the title his father had held, "grand prince," but also the grander title of "czar," a contraction of "caesar" that echoed the glories of imperial Rome.

In 1547 Ivan was crowned. Three times during the ritual of coronation boyars showered him with gold and silver coins, symbolizing the wealth all hoped Ivan would enjoy. Just a few weeks after the coronation, the young czar married Anastasia Romanovna, the lovely, bright daughter of the obscure noble Romanov family. The match was a fortunate one, for Anastasia's gentle ways proved to be the balm that soothed Ivan's tempestuous violent spirit.

Early in his reign Ivan was a benevolent reformer. He enacted a new code of laws, allowed towns some independence in making local decisions, and convened a national assembly to advise him on matters of state. He regularly sought the advice of high churchmen, and even included a priest in his intimate council of advisers.

Ivan also planned a daring campaign against Russia's ancestral enemies, the Tatars, who retained their grasp on the regions of Kazan and Astrakhan, through which the Volga River flowed to the Caspian Sea. In its upper reaches the Volga passed close to Moscow, making it a potentially lucrative avenue of trade, if only Ivan could seize its Caspian outlet. In 1552 he marched south with an army of 150,000 men. Aided by engineers who undermined the turrets of the Tatar fortress, Ivan captured Kazan. In 1556 Astrakhan also fell to the czar, making the Volga a Russian river for the first time. The

TEXT CONTINUED ON PAGE 22

THE CZAR'S TASTE

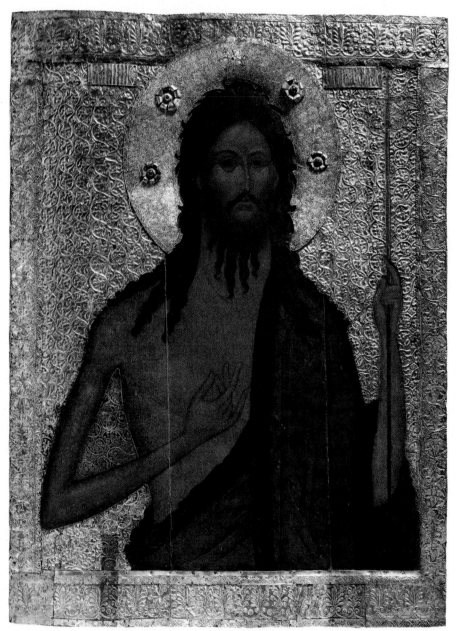

For the true believer in the Russian Orthodox Church, holy paintings were literally windows on eternity. Every home, down to the poorest peasant hut, would have an honored place for at least one of these icons, which in daily prayer became the faithful's point of contact with the spiritual world. In a particularly grand cathedral, such as the Archangel Michael in Moscow, a hundred icons might hang in glorious array upon a special partition, the iconostasis, built in front of the main altar. Tradition and a watchful Church hierarchy limited the subjects of the paintings to a few standard themes, such as incidents from the life of Christ. Ivan IV, who regarded himself as head of both Church and state, took a characteristically conservative interest in the art of iconography. "The holy and venerable icons," he told a Church council in 1551, must "be faithful to the consecrated type." Religious leaders dutifully agreed with the czar that "in nothing will the painters follow their own fancy." The clever tyrant had already established control over the production of icons by founding the first government workshops for the craft, after a devastating fire in 1547 destroyed much of Moscow's architecture and art. Some of the most talented painters worked for Ivan IV and his family, but the work was often donated to cathedrals or monasteries as an act of piety. The term "czar's taste" indicated that an icon was a superior product of Moscow art. Some beautifully transcend the strict rules, perhaps by dramatic expression or color choice, but originality was always secondary to the primary intention—the creation of a sacred object.

John the Baptist, who announced the coming of Christ into this world, is at once a divinely inspired emissary and a believably thoughtful human being in this icon, which perfectly illustrates the artistic sophistication of the sixteenth-century Moscow school. Flesh tones complement the silver-gilt stamped mount and filigreed halo.

The twelfth-century icon (opposite) named Virgin of Vladimir—after the provincial city where it first gained fame—was Russia's most beloved icon, perhaps because of the tender air it projects. After 1395 it hung in a Moscow church, and Ivan IV later worshiped in its presence.

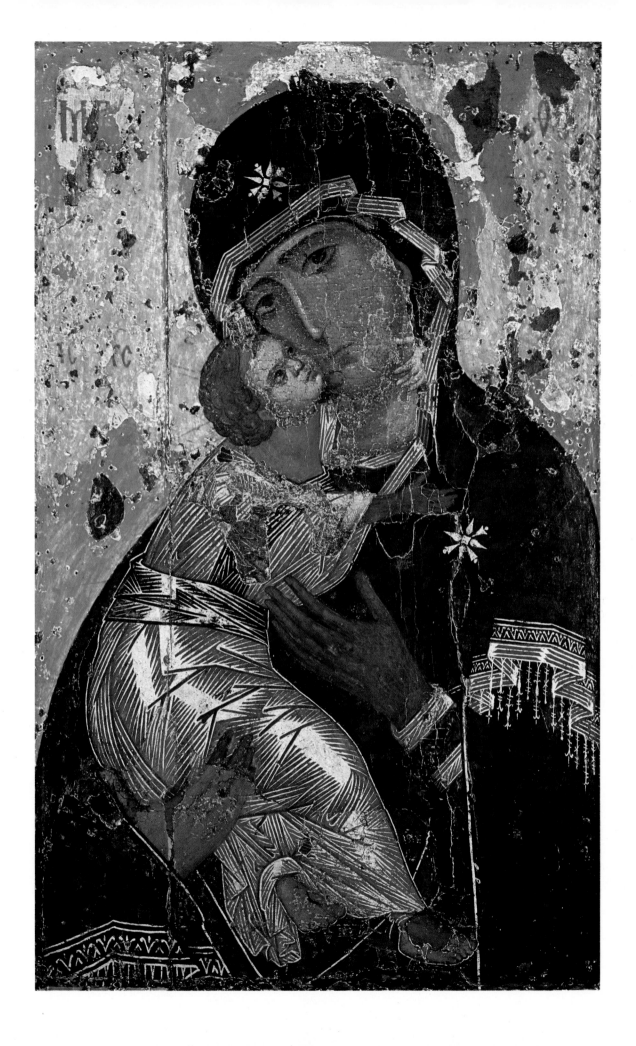

17

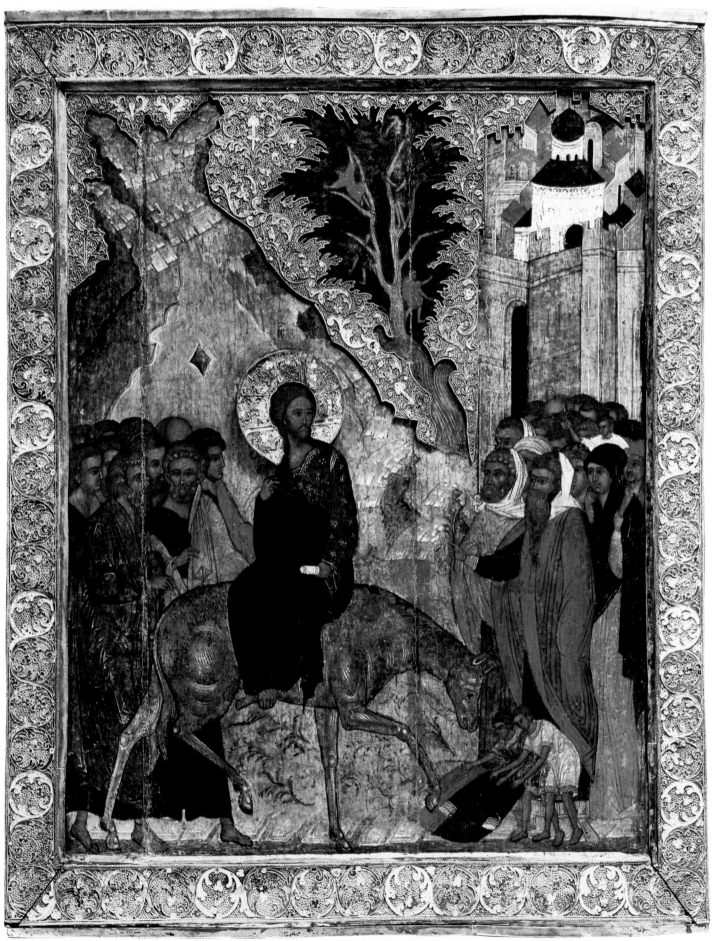

Christ's entry into Jerusalem upon the back of a donkey has the grandeur of a court reception in this icon from Ivan IV's workshop.

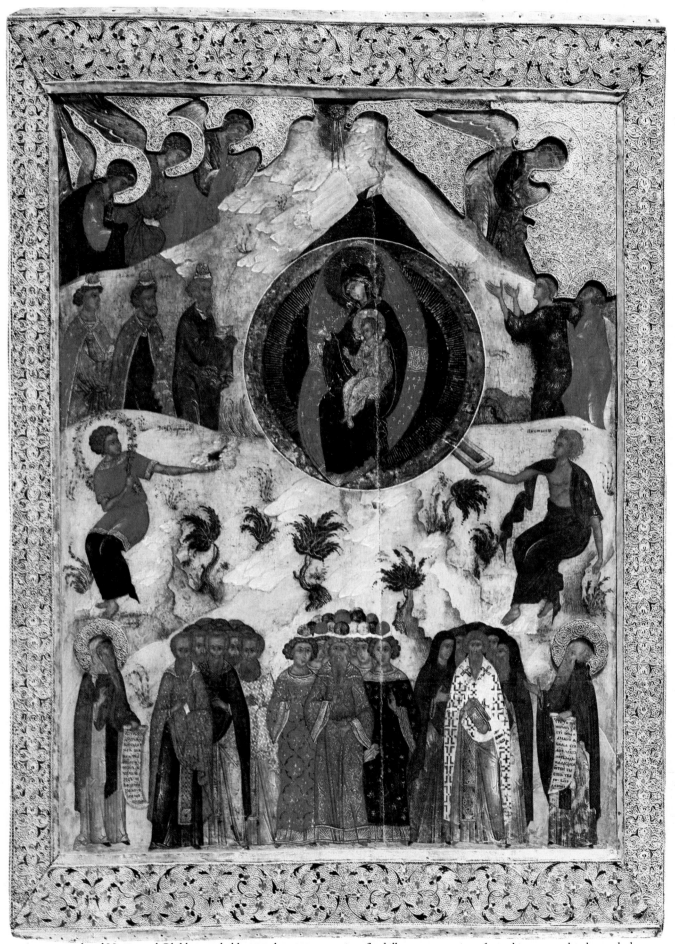

An encapsulated Virgin and Child, guarded by angels, appears against flat hills as a procession of worshipers marches beneath them.

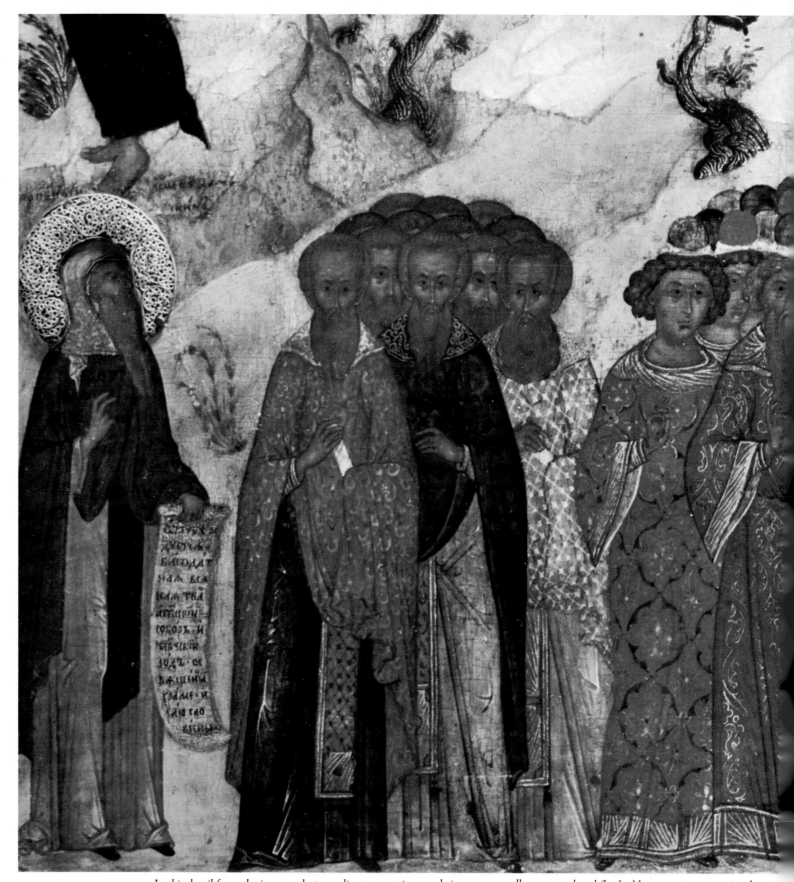

In this detail from the icon on the preceding page, priests and singers—grandly costumed and flanked by two saints—praise the

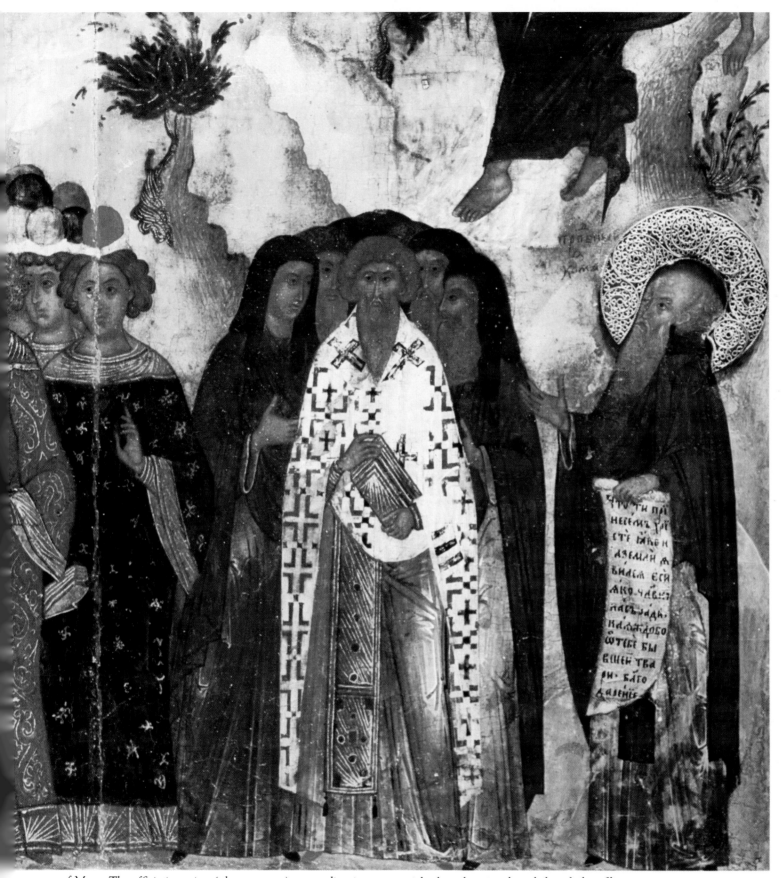

name of Mary. The officiating priest (above, center) wears glittering ceremonial robes; the saints have halos of silver filigree.

TEXT CONTINUED FROM PAGE 15

victory did not completely eliminate the Tatars, however, and they remained a source of trouble to the Russians for centuries.

In gratitude for his victory over the Tatars, which Ivan attributed to divine aid, the czar built an extravagant cathedral, St. Basil's, on Red Square. Around a central church, topped by a lofty, onion-shaped golden dome, Ivan built nine subsidiary churches, each with its own exuberant dome. To adorn the interior of St. Basil's, artists created a profusion of religious paintings called icons. The icon was a peculiarly Russian art form: painters depicted Christ, the Virgin Mary, saints, and religious scenes in a flat, two-dimensional fashion. The very simplicity of the icons made them appear more spiritual and otherworldly. The Russian love for splendor asserted itself in the icons' frames—lavish cases of silver and gold studded with gems.

Ivan dearly loved the bright show made by expensive jewelry, and his regalia may have been more brilliant than any in Europe. Seeing Ivan's orb, scepter, and crown for the first time in 1576, the ambassador from the Holy Roman Empire reported, "Never in my life have I seen things more precious or more beautiful." The czar possessed so many crowns that sometimes at dinner it pleased him to change headgear between courses.

At his state dinners the czar dressed in a long, brocaded robe laced with gold and set with pearls. A good host—when he was not sending a recalcitrant boyar down to the wine cellar to be strangled—Ivan entertained hundreds, sometimes thousands of guests at a time. The banquets were opulent spectacles, with the czar sometimes dining on a table of gold and distributing golden robes for the guests to wear. On great occasions he ordered the finest objects from his royal treasury brought into the banquet hall and heaped on a central table for all to admire. A procession of servants would enter the hall bearing vessels shaped like exotic and mythical animals—ostriches, unicorns, lions, and even a rhinoceros.

The brilliance of Ivan's early reign disintegrated into a national horror. The catalyst was the death of his wife, Anastasia Romanovna, in 1560. Ivan adored his wife, who always had a calming influence on the czar's volatile temper. At Anastasia's funeral Ivan

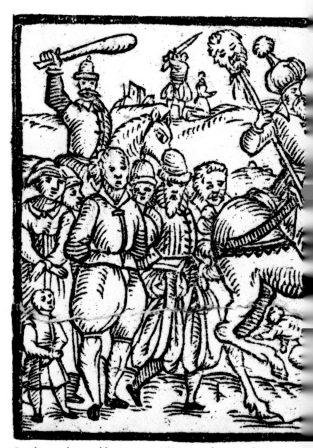

In this violent tableau on a 1582 woodcut, a deranged Ivan the Terrible—on horseback—brandishes a severed head before a crowd. The scene is a fictionalized example of the crazed assaults led by Ivan. In one such massacre, in Novgorod, Ivan murdered at least thirty thousand citizens because he suspected their Church leaders of treason.

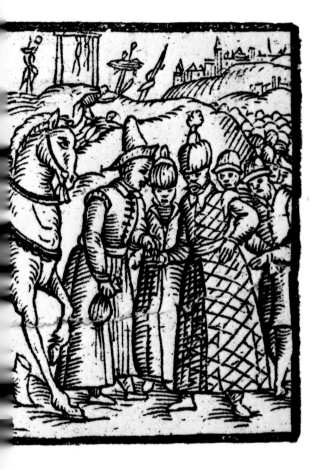

was so weakened from crying that he could not stand up, and as time passed his grief only became more intense, gradually turning into paranoia. He began to suspect that the boyars had poisoned Anastasia, and then that he was completely surrounded by traitors. His grief and suspicion came to a climax in 1564, when Ivan suddenly abdicated the throne and left Moscow. Unfortunately he was persuaded to return.

During his brief abdication Ivan had drawn up an astounding plan. Thenceforth there would be two Russias—one, known as the dominion, was to be ruled by the boyars; the second would be Ivan's personal realm, called *oprichnina*, the "private court." To create his new nation, Ivan simply declared that about half of Russia was his. He summarily evicted, sometimes by assassination, the boyars who owned property in the new realm. To administer his unquestionable will Ivan organized a private police force, the Blackness of Hell—an army of six thousand black-robed men, skilled in torture and murder. Ivan and his men galloped through Russia on black horses, with the severed heads of dogs tied to their saddles as symbols of ferocity, spreading unspeakable terror.

Ivan's bloodlust reached its apogee in January 1570 with the slaughter of the population of Novgorod, an epic in the history of barbarism. Believing that some of the Church leaders were disloyal to him, Ivan marched on Novgorod and ordered some five hundred monks and nuns clubbed to death. The next day he passed sentence on the entire city. Each day some thousand or so citizens were brought before Ivan to be tortured and then murdered. It was the czar's pleasure to vary the techniques of execution: the victims were flogged to death, dismembered, roasted over fires, thrown off high walls, or stuffed through the ice of the river. Four weeks of murder, and thirty thousand lives, were needed to quench the czar's fury.

Ivan's crowning deed of madness and violence was the murder of his son and heir, the czarevitch Ivan. In his country palace one night, Ivan came upon his pregnant daughter-in-law when she was wearing only her nightgown. Enraged that the woman would allow herself to be seen dressed immodestly, the czar slapped her with such

violence that she later suffered a miscarriage. The czarevitch, grieving and angry, argued with his father, and the czar struck his son on the head with his iron staff. The czarevitch collapsed, bleeding from his temple. Ivan shrieked for the doctors, but they could not save the czarevitch's life.

Tormented by guilt, Ivan walked the entire seventy-five miles to Moscow beside the carriage carrying his son's body. Before the funeral Ivan ordered a heap of jewels poured into the coffin. He held the belief, common in his day, that gems possessed magical powers and may have thought that this magnificent, glittering gift might somehow bring his son back from the dead.

Ivan spent the remaining two and a half years of his rule lost to the roiling mists of insanity. He shambled through the Kremlin alternately laughing and weeping hysterically. A disease caused his body to swell and emit a loathsome odor. When a comet, in the shape of a burning cross, appeared over Russia in 1584, Ivan took it as an evil omen—"This sign foretells my death." The czar summoned sixty witches to restore his health by their spells, but after examining the stars, the witches pronounced that Ivan would die on March 18.

In the weeks before the dreaded date, Ivan ordered his courtiers to carry him every day into his treasury, where he believed he might find some comfort—and perhaps a cure—through the potent magic of his gems. In a bizarre ritual he fondled the different gems—rubies, sapphires, diamonds—calling out their healing properties in vain, until he fainted and had to be carried away. On March 17, while playing chess, Ivan collapsed and died.

Like most Russian stories the life of Ivan the Terrible abounds with ironies. With mad cruelty he had made the czar the most powerful man in Russia. Yet by murdering the czarevitch Ivan, he left the throne to his son Fëdor, a feebleminded man who took a childish delight in ringing church bells. Ivan himself said that Fëdor was better suited to be a bell ringer than a czar. But the most striking irony is Ivan's artistic legacy. The treasure most closely associated with his bloody, monstrous reign is the icon—one of the most sublimely spiritual creations of man.

FOR GOD'S PLEASURE

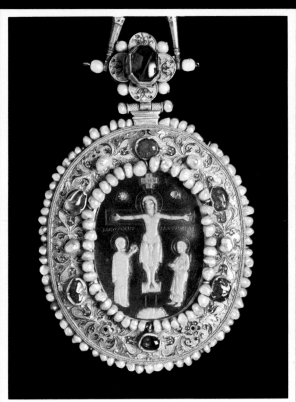

This jeweled panagia, or priest's chest plate, with a cameo at the center, exemplifies the elegance and richness of the gifts that Ivan IV and his family gave the Church.

In the eyes of most Russians, Moscow was the heart of Christendom, the third Rome, and the true home of Christianity since the fall of ancient Rome and then of Constantinople, the capital of the Byzantine Empire. As father figure of Russia, Ivan IV used his absolute power—which he believed came from God—to make the Orthodox Church in Moscow resplendent. Thanks largely to his grandfather, the Kremlin already possessed beautiful churches, among them the cathedrals of the Archangel Michael, of the Assumption, and of the Annunciation. Ivan himself built the most magnificent of all Russian churches, St. Basil the Blessed, and surrounded it with nine lesser churches. Then the czar and his family furnished these edifices as well as other churches with lavish ritual objects, such as the ones here and on pages 28–43, that rivaled any of the artworks they commissioned for their own personal use.

Craftsmen in the royal workshops perfected such metalworking techniques as filigreeing (producing lacework in gold and silver), embossing, and nielloing, which called for making fine incisions in a metal surface and then filling the cuts with a dark gray sulphide substance. Few European craftsmen knew this art, but the nielloed treasures of Moscow were famous for their enamellike, black velvety look.

The czar's goldsmiths were also expert at nesting a colorful variety of precious gems in the ornate reliquaries, chalices, and book covers they designed. These stones were a tribute not only to Ivan's Christian devotion but to the wealth of his realm and to his trade routes, which ran to the Orient as well as to Europe. A jewel that the czar and his family loved was the native freshwater pearl, which occurred plentifully in Russia's riverbeds. Ivan's pearl-encrusted robes caused his foreign guests to gape, and he no doubt wished to inspire similar feelings of awe when he gave pearls to the Church. They symbolized his generosity, as did other expensive pieces, such as the cross on page 29 and in detail on pages 30–31, that are poignantly inscribed with prayers for his family's welfare. Unprincipled though he was, in his heart Ivan the Terrible may have been as pious as any serf.

This silver-gilt cover for the Gospels, produced by imperial craftsmen for the Cathedral of the Assumption in Moscow, is an extraordinary example of filigree work. The intricate background of flattened and twisted wires sets off the cast figure of the crucified Christ. At each corner Matthew, Mark, Luke, and John serenely compose the Gospels.

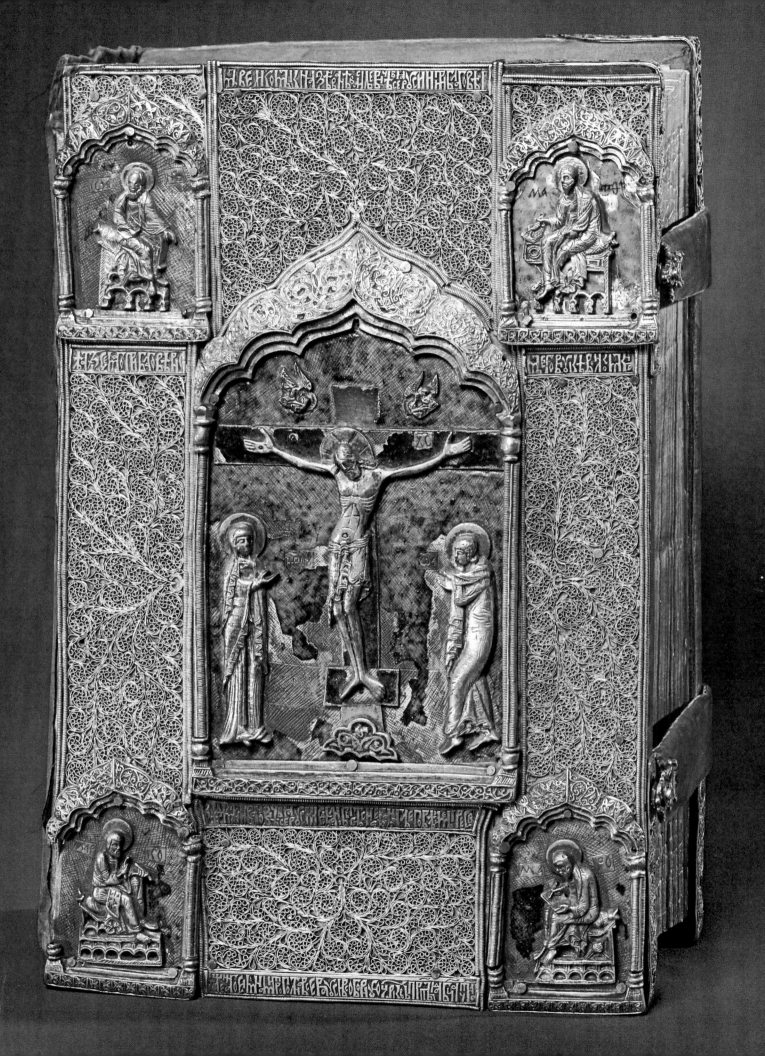

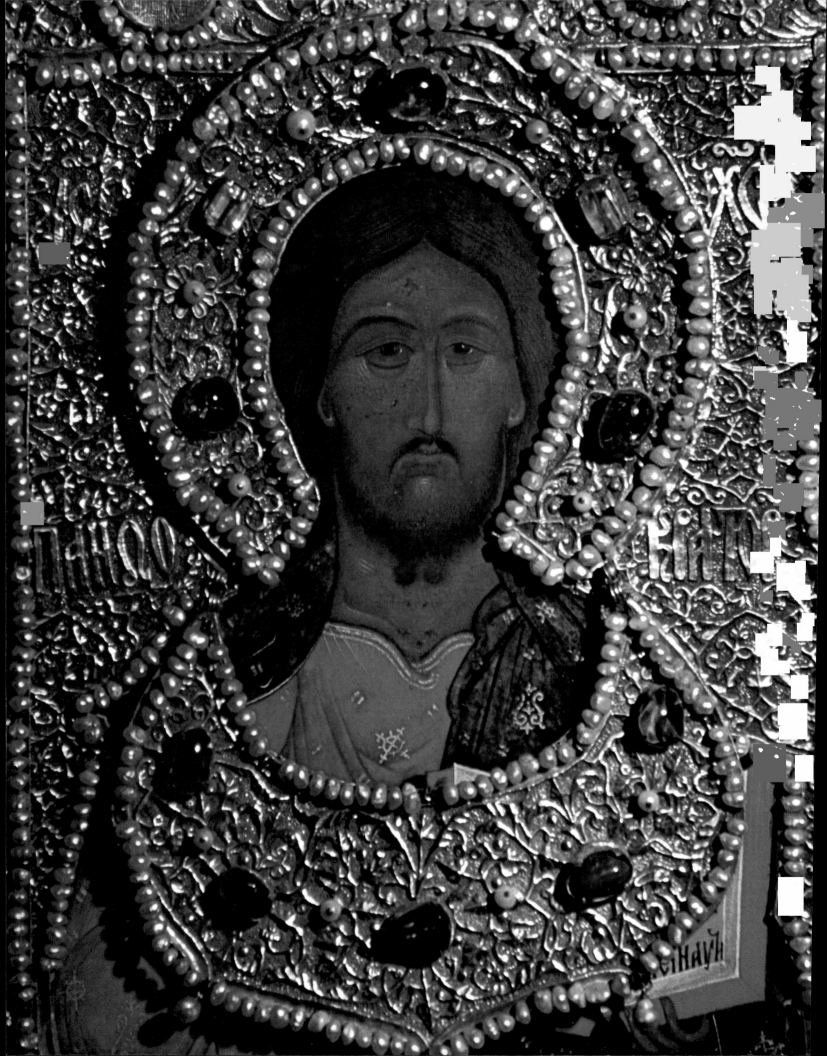

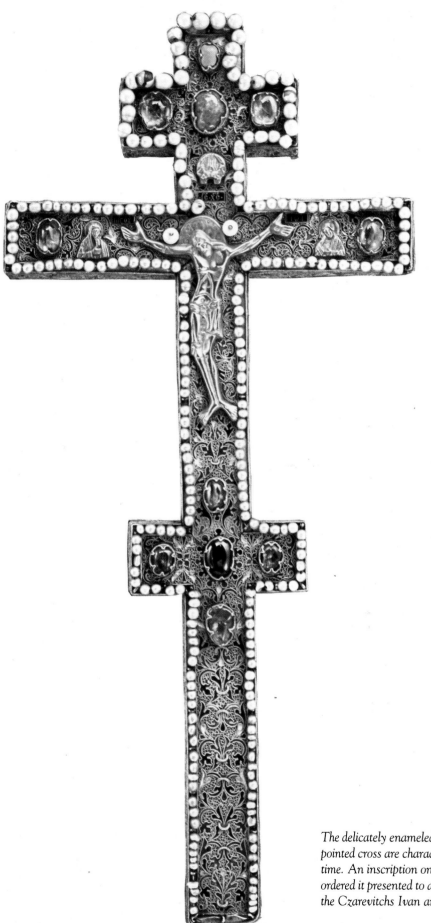

The delicately enameled floral patterns on this eight-pointed cross are characteristic of Moscow art of the time. An inscription on the reverse reveals that Ivan ordered it presented to a monastery "for the health of the Czarevitchs Ivan and Fëdor," his sons.

OVERLEAF: In this detail of Ivan's own crucifix, above, cast gold figures of Christ and attendants gleam inside the border of native Russian pearls.

Pearls, sapphires, and almandines encrust the silver-gilt mounting of the icon opposite, a gift from a member of Ivan's family to a nunnery.

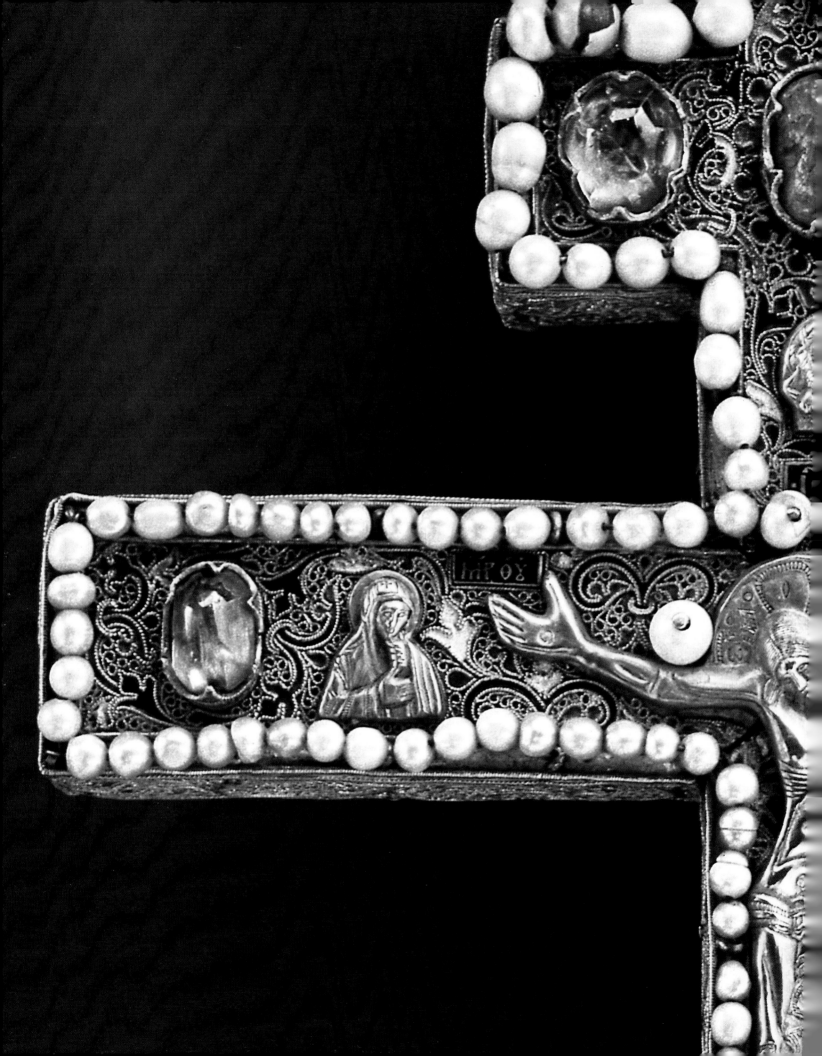

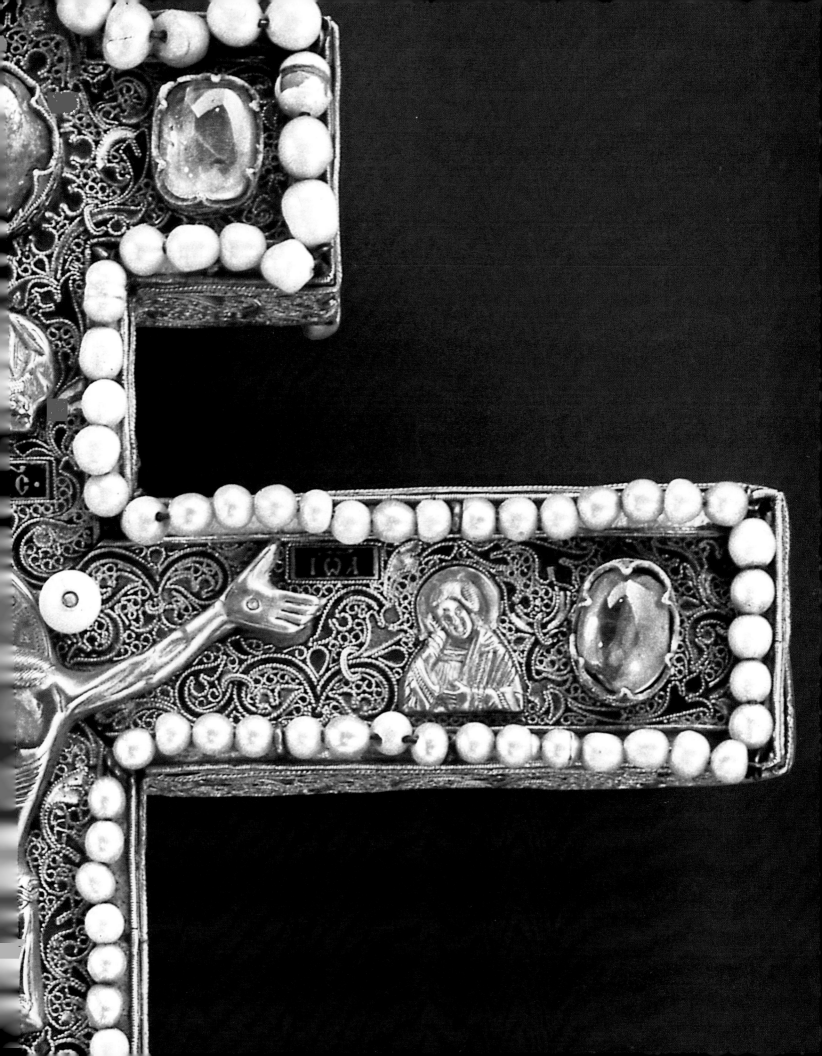

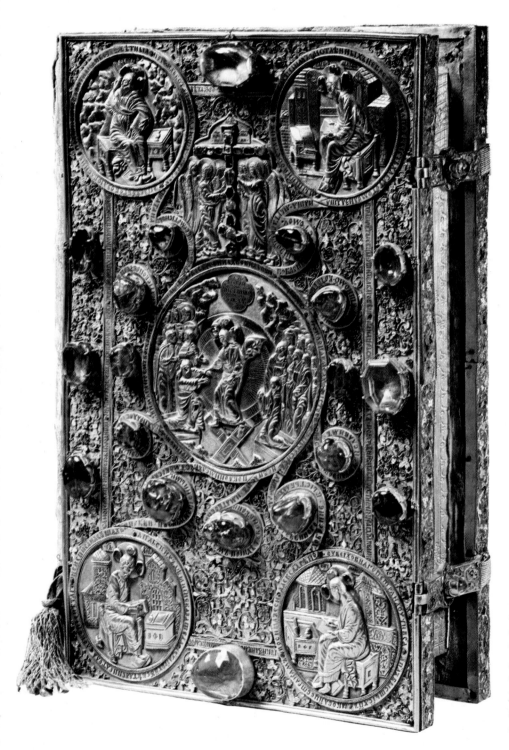

Oddly enough Ivan disliked diamonds, and when he commissioned this book cover—about two feet high—for the Cathedral of the Annunciation in the Kremlin in 1571, he ordered sapphires, a favorite stone, as well as rubies and topazes. Instead of being cut as brilliants, many of the gems retain their natural shape, as was the fashion of the time. Intended to hold a Gospel book, this masterpiece of the gold-worker's art is ornamented with gracefully curving, filigreed grape vines with clusters of miniature gold grapes. In the detail opposite, the evangelist Mark, seated at a desk, wears a halo of precious stones.

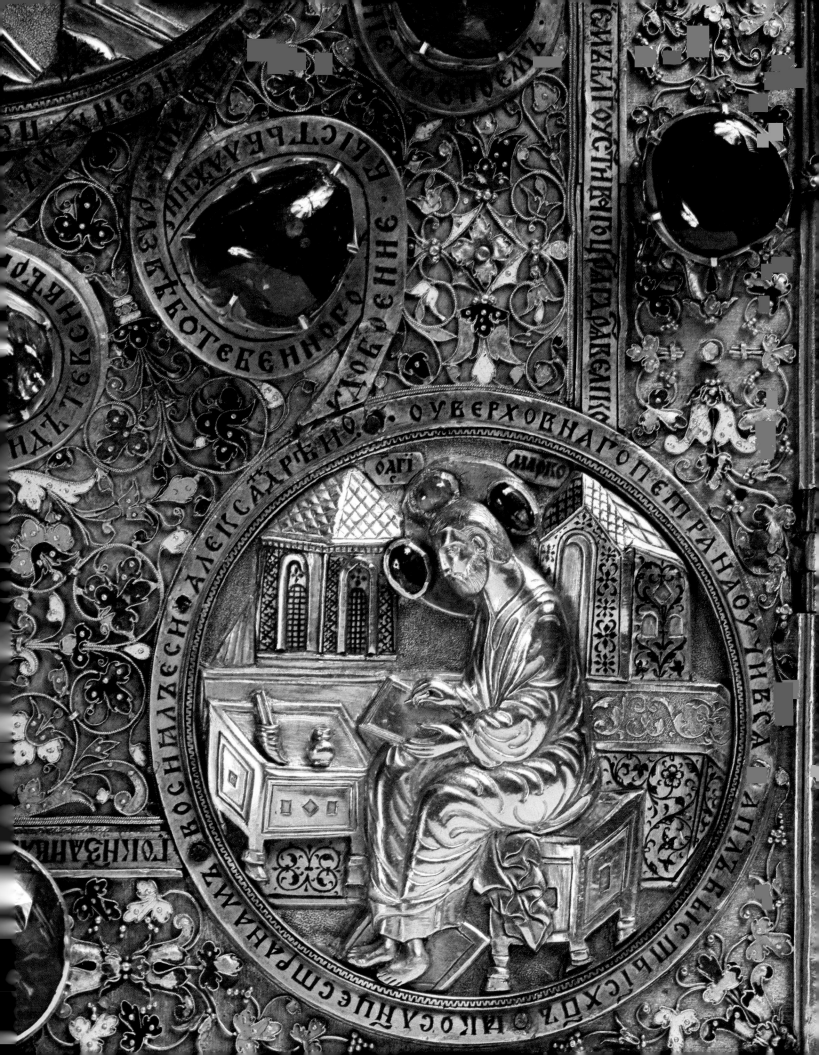

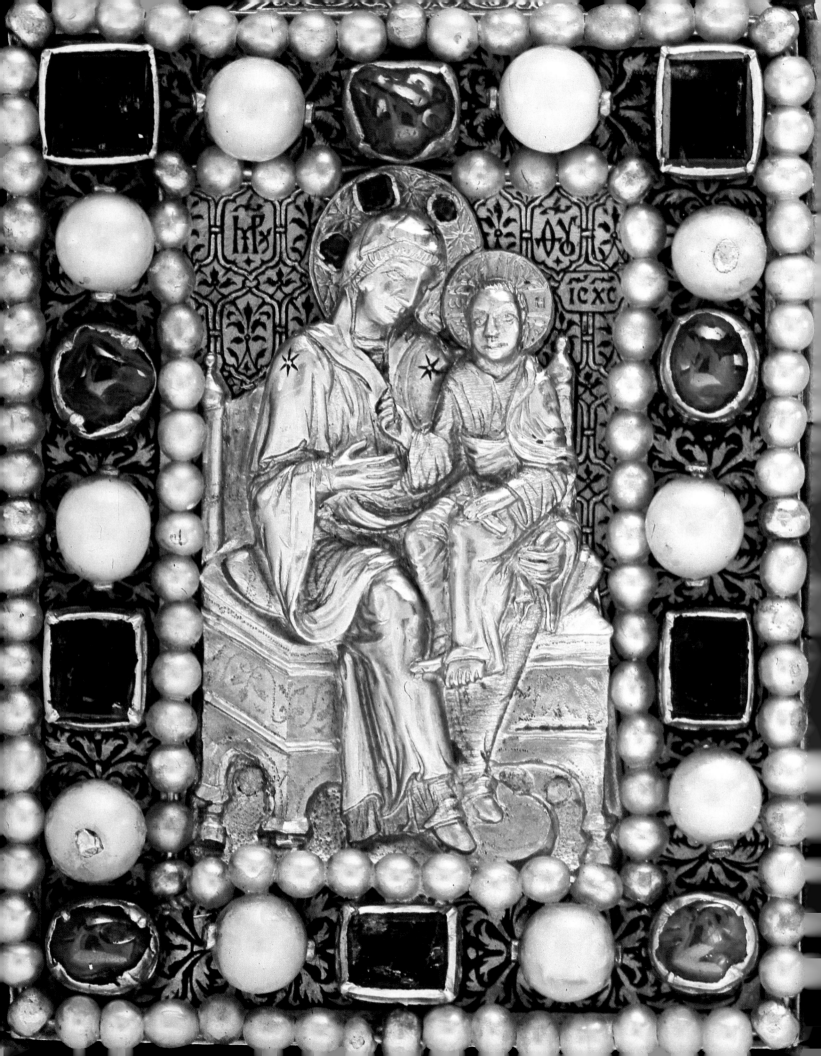

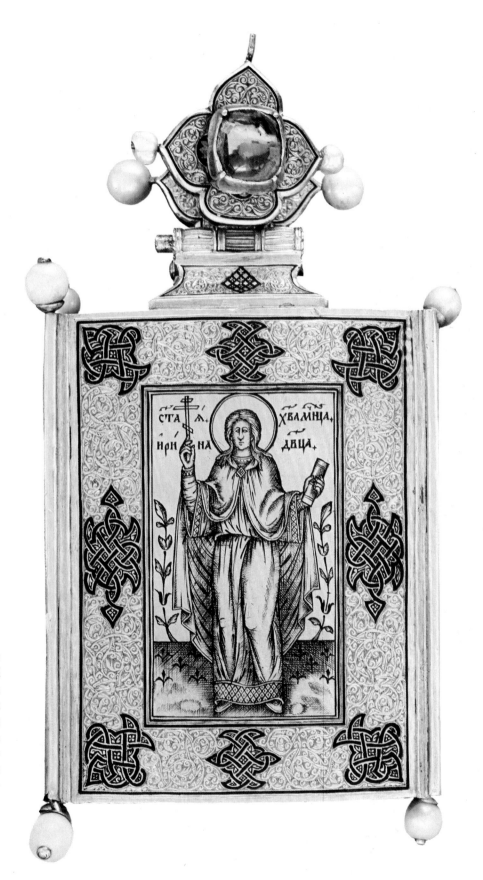

The reliquary at right, about two and a half inches by four and a half inches, bears a masterful nielloed engraving of Irina—a martyred saint who was burned to death for refusing to deny her Christian beliefs. A gift from Czar Fëdor I to his wife, the czarina Irina, the sacred object portrays the Virgin Mary with the Christ Child on the other side (in detail opposite). The czarina would have prayed daily holding this lovely work, which combines religious devotion with a husband's wish that his wife be blessed.

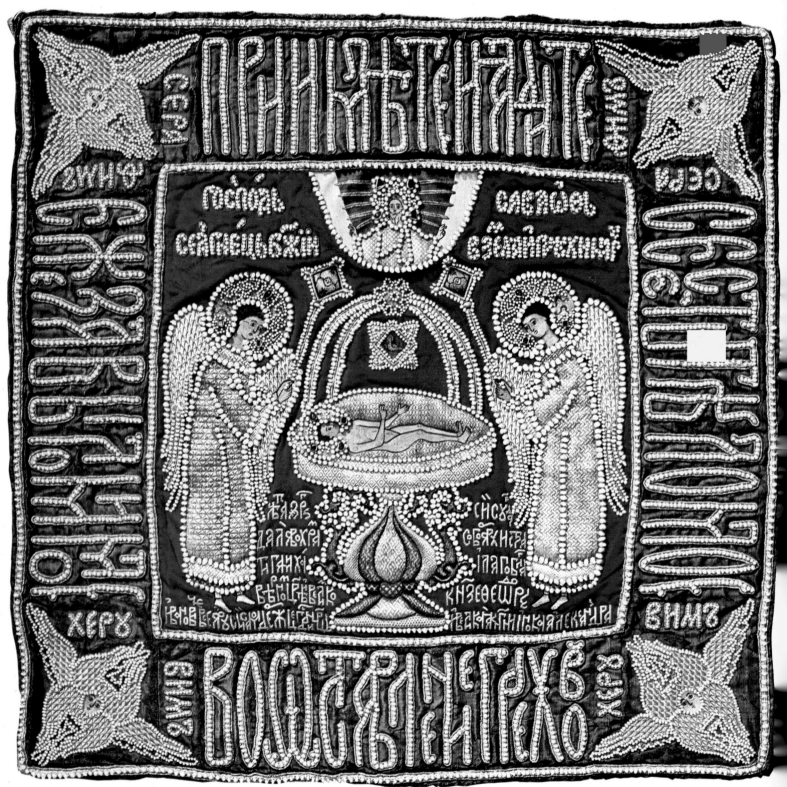

This shimmering embroidery, a product of Czarina Irina's workshop, covered the Eucharist—sacramental Bread and Wine consumed during Church services in remembrance of Christ. Angels worship the infant Christ, center, who gazes upward at the two other manifestations of Christianity's heavenly Trinity—God the Father and the Holy Ghost. Pearls, gems, and silk threads decorate the red and blue damask background.

After Fëdor I died, in 1598, Irina donated the gold chalice opposite, a masterpiece of engraving, to a Kremlin cathedral in his memory.

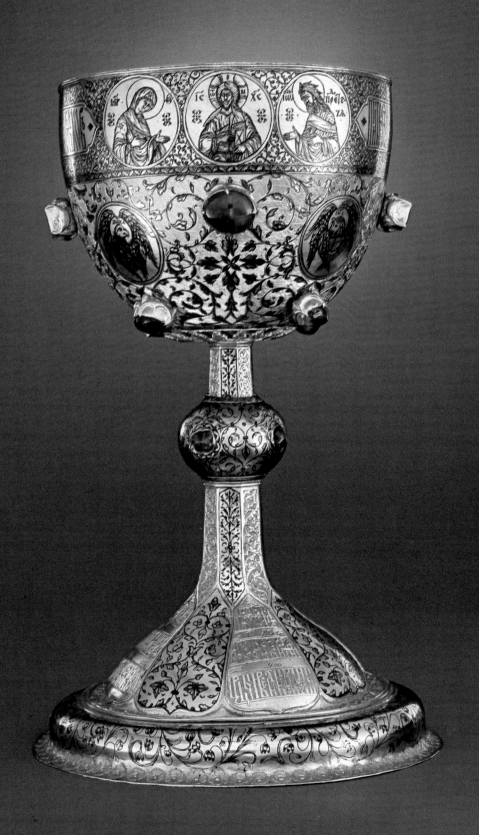

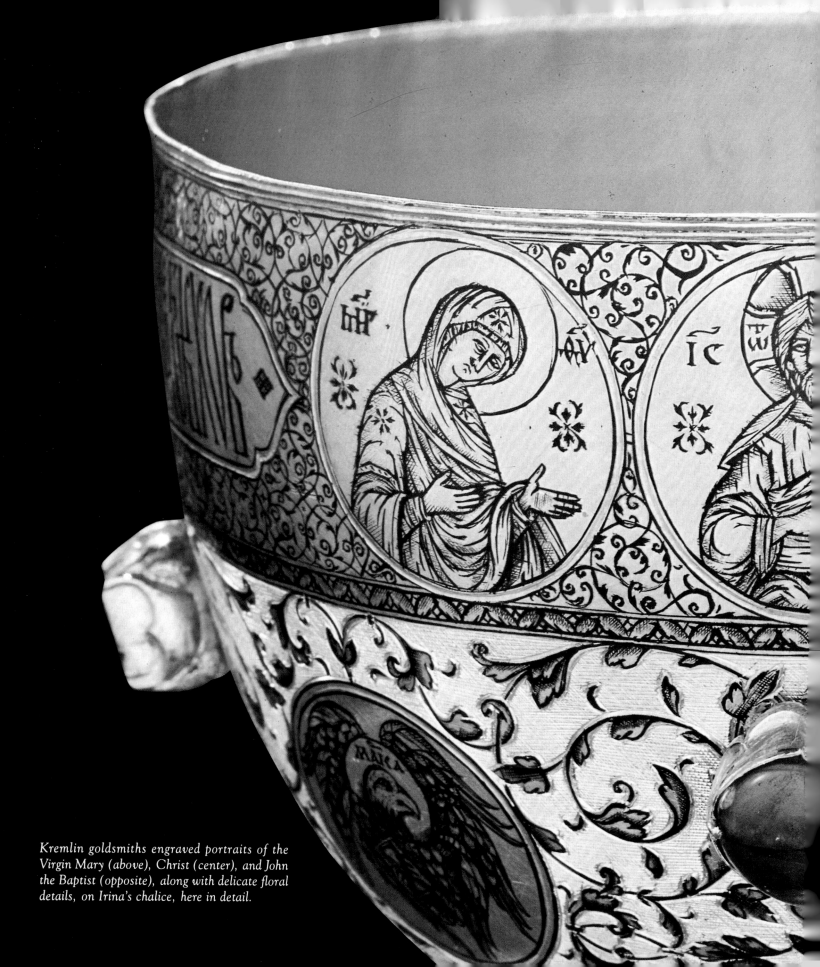

Kremlin goldsmiths engraved portraits of the Virgin Mary (above), Christ (center), and John the Baptist (opposite), along with delicate floral details, on Irina's chalice, here in detail.

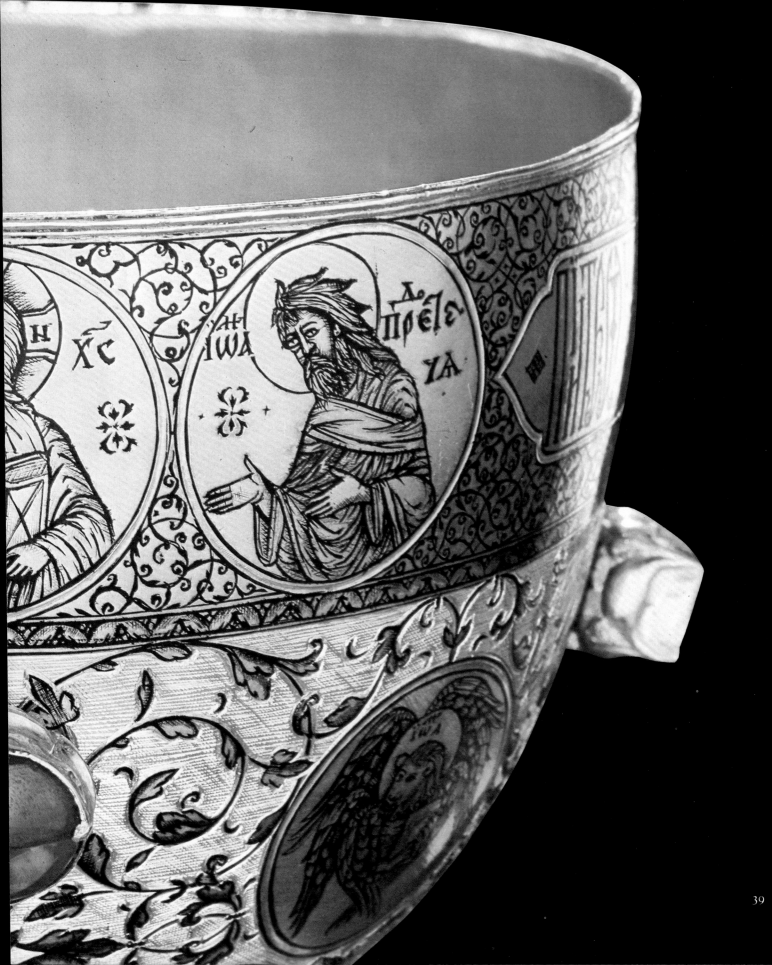

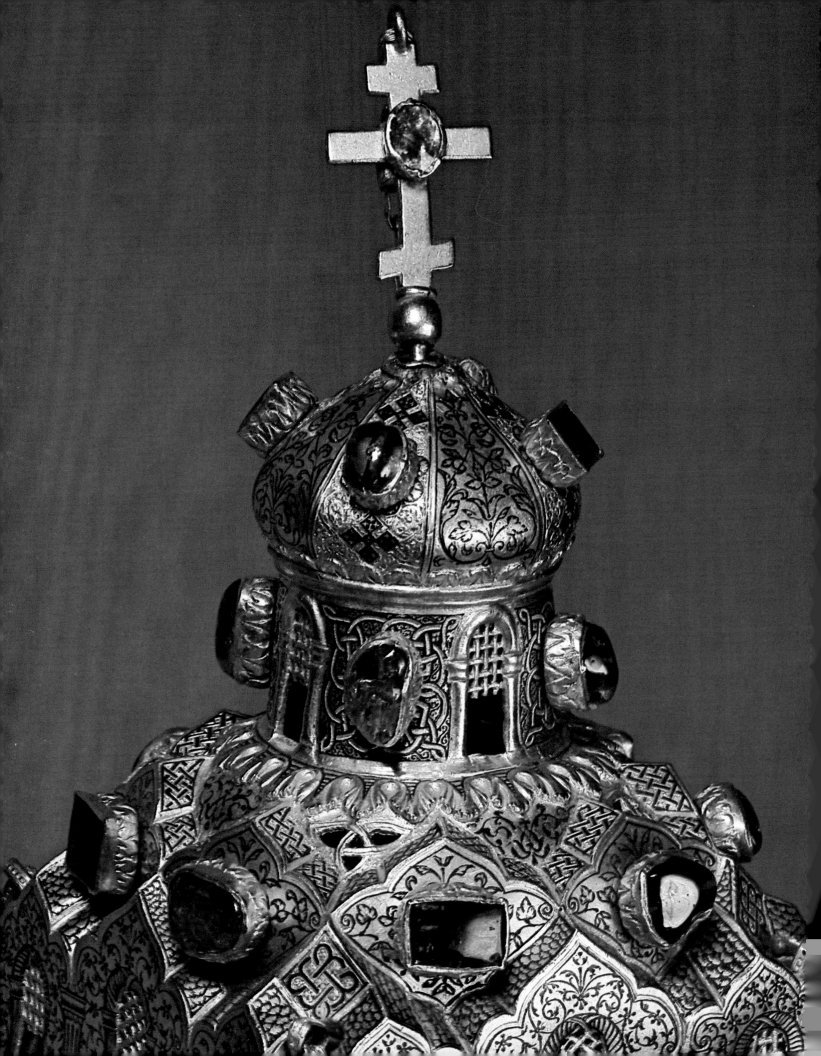

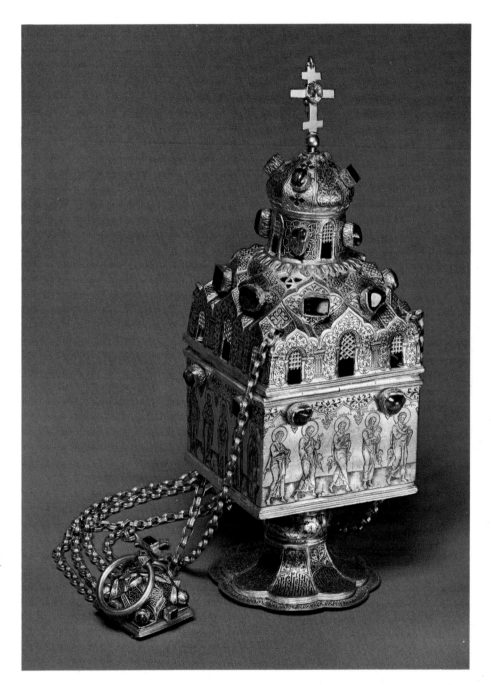

This remarkable golden censer, a vessel for burning incense, was Irina's gift in 1598 to the Cathedral of the Archangel Michael. Grateful clerics valued the unusual work so highly they used it only on particular holy occasions and never more than nine times in one year. In the detail opposite, the nielloed decoration around the windows and an onion-style dome are miniaturized motifs from Russian architecture.

OVERLEAF: One side of the censer's base portrays, left to right, five apostles: Paul, Mark, Luke, Andrew, and Bartholomew. They move gracefully and naturally across the gold background, as though the artist had modeled them from life.

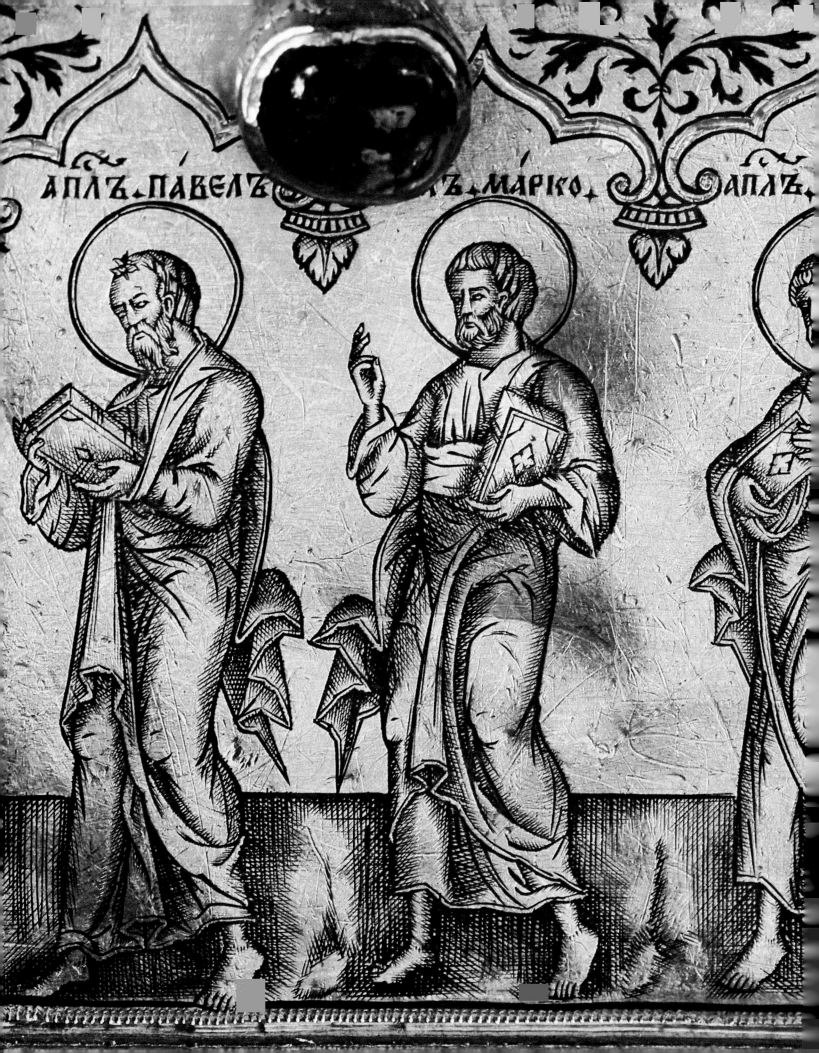

АПЛЪ ПАВЕЛЪ · · · · ПЪ МАРКО · АПЛЪ ·

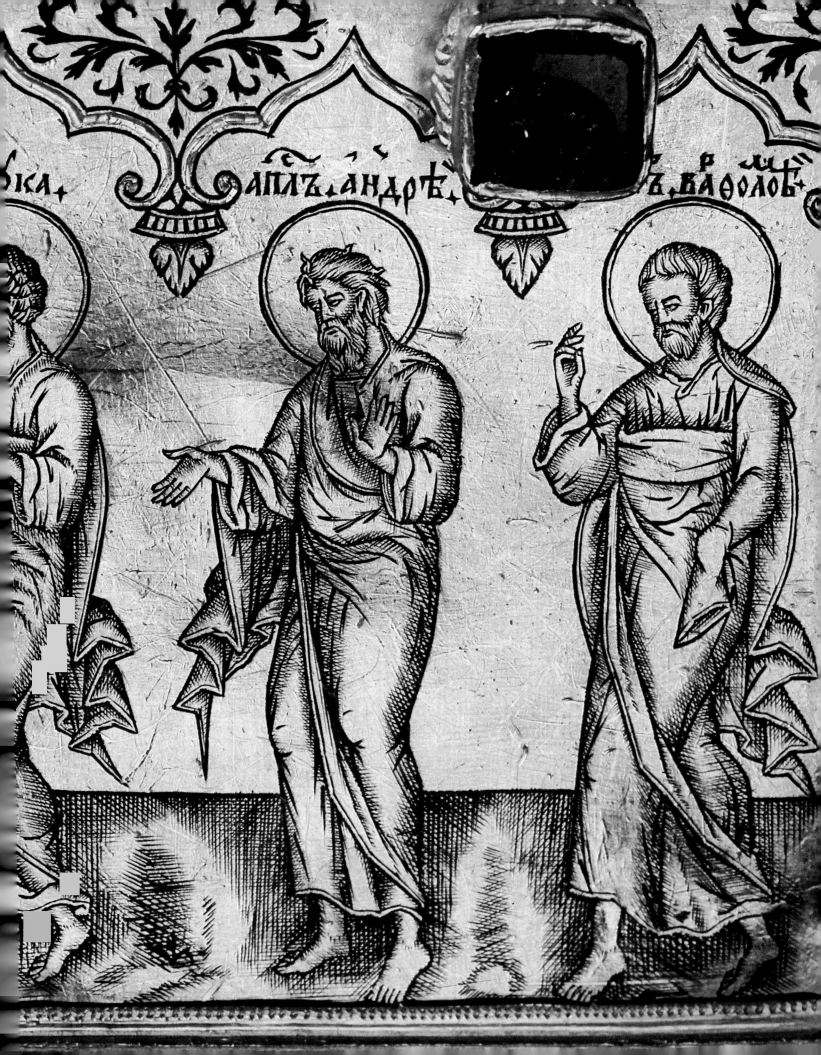

АПЛ҃Ъ АНДРѢ ҃ Ъ ВАѲОЛОѢ҃

ҕКА

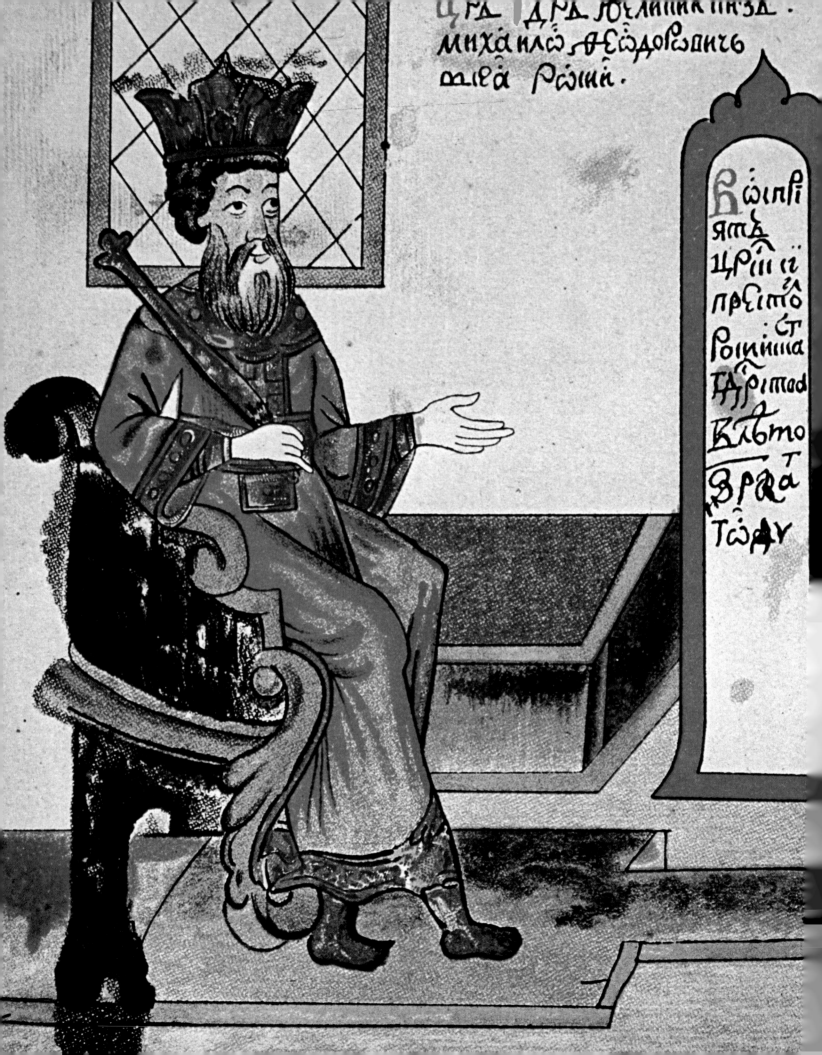

II

THE FIRST ROMANOVS

BEGINNINGS OF A DYNASTY

Czar Fëdor I, true to his father's prediction, spent his happiest hours as Russia's sovereign in a royal bell tower, pulling on the ropes and adding his imperial tones to Moscow's clangor of bells. During the fourteen years of Fëdor's reign, the real work of ruling the nation was carried out by Boris Godunov, a brilliant courtier of Mongol ancestry. Boris had served in the hazardous position of Ivan the Terrible's taster—sampling the czar's food to see if it was poisoned—and had become one of Ivan's intimate advisers.

When Fëdor died in 1598 without an heir, the dynasty of Rurik was extinguished. The lack of an obvious heir to the throne posed a vexing problem, which the Russians solved with a distinctly unautocratic method—they decided to hold an election. A convocation of boyars, priests, and representatives from Russia's towns met to choose a new czar and settled upon Boris Godunov. Boris and his supporters immediately staged a demonstration to show that he enjoyed popular backing. A crowd of hirelings gathered in front of Boris's house and prayed with a plaintive, moaning sound for Boris to

Chosen czar in 1613, Mikhail Romanov—displaying his crown and scepter opposite—was founder of a dynasty that ruled Russia for three hundred years.

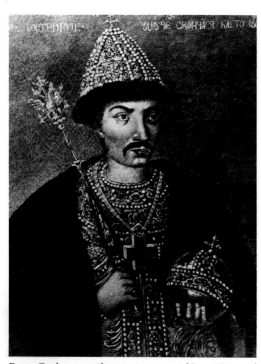

Boris Godunov, a favorite courtier of Ivan IV's and regent to Ivan's son Fëdor, schemed successfully to be chosen czar after Fëdor died, in 1598. Boris was by turn progressive and tyrannical, and his death in 1605 was followed by the Time of Trouble—a period of anarchy lasting for eight years, out of which the Romanovs rose to rule Russia.

accept the crown. Those who did not moan loudly enough were whipped by Boris's agents until they were able to moan with the desired note of urgency.

Some blood had been spilled along Boris's path to the throne, but whether Boris himself was responsible remains one of the enduring mysteries of Russian history. Czar Fëdor's successor should have been his half-brother, the czarevitch Dmitri; but one day in 1591, the nine-year-old boy had been found with his throat cut. An investigating committee concluded that the youngster suffered an epileptic fit while playing with a knife and accidentally slashed himself—a bizarre but possibly correct explanation. However, throughout Boris's reign the court whispered that he had ordered the murder of the boy to clear his path to the throne. Posterity was also a harsh judge in this case. The nineteenth-century Russian writer Alexander Pushkin believed that Boris had killed Dmitri and used the story of the murder as the plot for his play *Boris Godunov.* The Russian composer Modest Musorgski later set the play to music, forever casting Boris in the role of the crazed child killer.

At his coronation Czar Boris placed his hands upon the pearls sewn in his shirt and pledged to use the wealth of the throne to help his people. Indeed his compassion for the Russian common people earned him the nickname "bright-souled Boris." He showed no compassion to political rivals. Fearing a threat to his power from the Romanov family—the relatives of Ivan the Terrible's wife, Anastasia—Boris cruelly forced their leader into the priesthood and the leader's wife into a nunnery.

Although a commoner by birth, Boris had a monarch's taste for grandiose building projects. He ordered a great stone wall built around the Moscow district where the boyars and merchants lived and then had the wall whitewashed—giving the district its sobriquet, "the white city." Of the many fortresses, churches, and other projects Boris commissioned, the most striking was the belfry he built in the center of the Kremlin to honor Grand Prince Ivan III, the ruler who had made Moscow the most powerful of all Russian cities. For the site of the Tower of Ivan the Great, Boris chose the top

of a hill within the Kremlin. Capped by a splendid golden dome, the belfry contained 33 bells and towered 270 feet above Moscow.

Aware that Russia lagged behind Europe in science and education, Boris attempted to Westernize Russia; but the results were not successful. When he tried to establish a university in the European tradition, he had to give up the idea in the face of opposition from an Orthodox clergy fearful of any Western contamination. He sent thirty carefully selected young Russians to study abroad and master Western technology, but only two of them decided to return home. He appointed foreigners to important positions in his government, but Europeans continued to find Russia a strange and sometimes dangerous place, where "bearded, long-haired men dressed with barbaric and sordid magnificence, wearing furs in the height of summer," as one diplomat found. It was a place where even the clocks were odd: instead of the hands moving around the face, the face of a Russian clock revolved behind a stationary hand. A visiting English doctor who requested cream of tartar with his dinner was summarily executed for suspected sympathy with the Tatars.

All of Boris Godunov's industry and attempts at modernization came to nothing, largely because of bad luck. The crops failed catastrophically in 1601 and again the following two years. Russia was ravaged by famine, and when swarms of hungry peasants huddled into Moscow searching for food, they brought the plague with them. Then from across the Polish border came a threat to Boris's supremacy as czar. A man, whose true name has never been known, rode toward Moscow at the head of a motley army of Russian and Polish adventurers and demanded the throne, claiming to be the czarevitch Dmitri. The claim was transparently false—the real Dmitri was indeed dead—but Boris's enemies among the boyars used the interloper as a convenient excuse to try to oust Boris. As Boris turned to meet this challenge, he suddenly died, probably of a heart attack. Boris's death signaled the beginning of a chaotic period that the Russians called the Time of Trouble.

For the next eight years, the royal house of Russia was the setting for a series of tangled intrigues and murders. Astonishingly, the so-

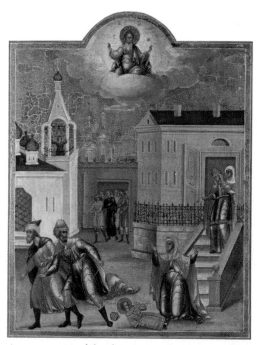

An assassin and his henchmen flee after stabbing Ivan IV's youngest son, Dmitri, who lies mortally wounded in this fanciful painting. The boy in fact died mysteriously in 1591, and after Boris Godunov took the throne, boyars opposing him charged that he had contrived to murder Dmitri. Godunov was probably innocent, but his reputation, then and later, was of a man obsessed with regicide.

called False Dmitri, with the connivance of the boyars, entered Moscow and ascended the throne. The boyars strangled Boris's wife and forced his daughter to become Dmitri's mistress. But after only a year, Czar Dmitri outlived his usefulness as the puppet of the boyars. They murdered him, stuffed his ashes into a cannon, and fired them back toward Poland.

The throne shuttled back and forth among three claimants, including yet another False Dmitri. Russia slipped into anarchy, and the people yearned for a strong and stable royal house. Once again a national convocation met to select a new czar. In January 1613, after three days of prayer, fasting, and deliberations, the assembly offered the crown to Mikhail Romanov, the son of the Romanovs whom Boris Godunov had forced into religious seclusion. The Romanovs were popular among the common people, who remembered how Mikhail's great-aunt Anastasia had curbed the dreadful wrath of her husband, Ivan the Terrible.

The new ruler was a sickly boy of sixteen, so poor he had to borrow money to pay for the two-hundred-mile trip to Moscow and so inexperienced in kingship that the first public ceremony he ever attended was his own investiture as czar. The founder of the house of Romanov—which would stand for three hundred years as the symbol of autocracy—picked his way through a desolate country, fearful of his own safety in the face of marauding bands of brigands who had transformed central Russia into a vast no-man's-land.

His coronation, however, was a grand affair. The bells of the Kremlin's Tower of Ivan the Great rang joyously to announce the crowning of the new czar, as Mikhail, dressed in golden robes too heavy for his frail body to carry with ease, received the regalia of his majesty: the bejeweled and sable-trimmed crown of Monomakh—a furry cap that the Russians believed had come down from the Byzantine emperors—an orb studded with diamonds and pearls, and a scepter of fine Russian gold.

Mikhail found the duties of his office as heavy as their symbols, and, either through lethargy or good sense, he left the running of the empire to his advisers. But Mikhail was as fortunate as Boris God-

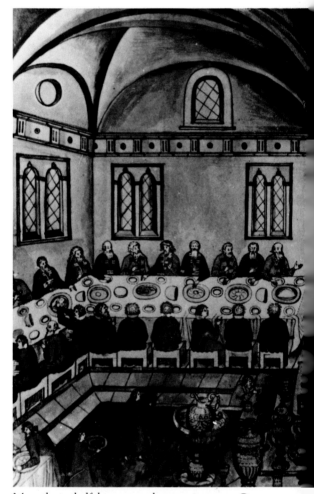

More than a half dozen attendants wait to serve Czar Mikhail as he presides in regal solitude over his coronation banquet in this seventeenth-century drawing. The feast took place in the Palace of Facets, the vault-ceilinged Kremlin structure where the czars traditionally held court.

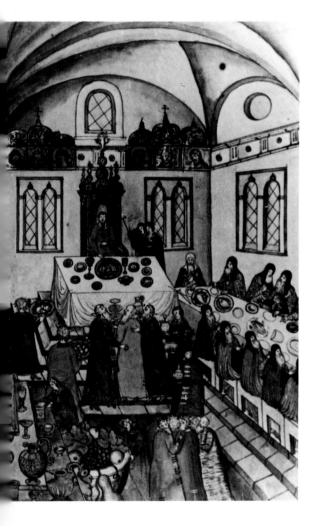

unov had been unlucky. Peace and a measure of prosperity came to the land. Mikhail had a long and, for a czar, uneventful reign. When he died, in 1645, the house of Romanov was firmly established, and his son Alexei ascended without dispute.

In the centuries to come, when Russians would look to the czar as a source of hope and a symbol of stability, they were no doubt conjuring up a vision of the pious Alexei, known to history as the Gentlest Czar. Actually Alexei possessed a complex, often self-contradictory character. Renowned for his compassion, he was also capable of terrible brutality. His inquiring intellect reached out tentatively to Western ideas, yet personal contact with foreigners sometimes disgusted him. Although no czar ever took more delight in sumptuous display than Alexei did, his personal life was austere.

Alexei practiced the Orthodox faith with fanatical zeal. He rose at four in the morning for private prayer and devotional readings. Then there were family prayers with the czarina Maria, followed by a two-hour Mass with his advisers and still more devotional services throughout the afternoon and evening. On important holy days the czar prostrated himself as many as 1,500 times.

For all his piety Alexei had a voluptuous streak. At audiences he wore a jewel-studded robe and a gaudy crown that reminded one visitor of "bunches of glittering grapes." The czar's height—he was six feet tall—enhanced the effect of these imposing ornaments. One English envoy was awestruck by an audience with Alexei and wrote to the English king that "the czar like a sparkling sun darted forth most sumptuous rays, being most magnificently placed upon his throne, with his scepter in his hand and having his crown on his head. His throne was of massy silver gilt...and being seven or eight steps higher than the floor, it rendered the person of the Prince transcendently majestic." The envoy's report might not have been so sympathetic had he known why Alexei kept a gold basin filled with water by his throne. The czar always washed his hands after touching foreigners, who, the czar feared, might somehow contaminate him.

Alexei entertained his guests lavishly, presiding over fifty-course dinners at which gluttony and heavy drinking were commonplace.

TEXT CONTINUED ON PAGE 56

CUPS AND KOVSHI

Fine metalworking reached an extraordinary peak in seventeenth-century Russia, during the lengthy reigns of the first two Romanovs, Mikhail and Alexei. Workshops were established in the Kremlin armory, and normally itinerant master metalsmiths and jewelers were induced to stay. These artisans achieved unsurpassed excellence in the shaping and detailing of gold and silver and also made extravagant use of precious stones and intricate enameling. Virtually all of the objects that the czar touched, or that were brought into his presence, were crafted from precious metals and encrusted with gems. The profusion of treasures from the Kremlin ateliers was such that record keepers failed in their attempts to make note of them all.

Among the most intriguing of these pieces are the drinking vessels, for they followed a distinctly Russian tradition. To the eyes of Western envoys at state banquets, the most unusual was the *kovsh*. This odd vessel, below, which looks more like a dipper than a beverage container, echoed the shape of the boats that plied the lakes and rivers of northern Russia. The boats in turn repeated the shape of those water bodies' plentiful swans and other waterfowl. Another exceptional vessel was the *bratina*. This Russian version of the loving cup, or toasting bowl, was passed from person to person, uniting all who drank from it in eternal brotherhood. In the elaborate ornamentation and shape of the bratiny on pages 52 and 55, and of the other vessels alongside them, the czar's craftsmen expressed their supreme skill.

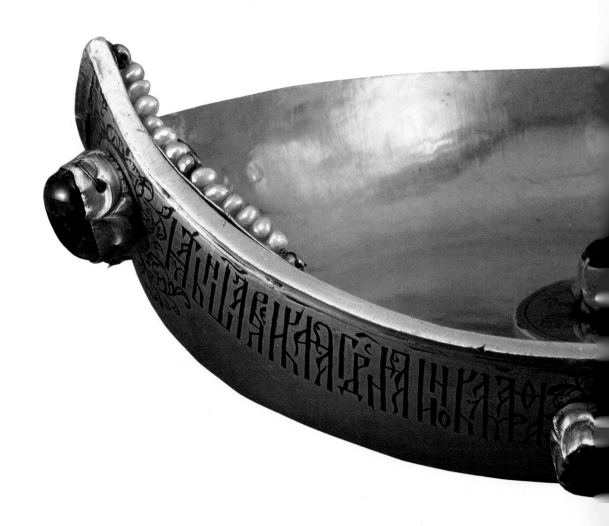

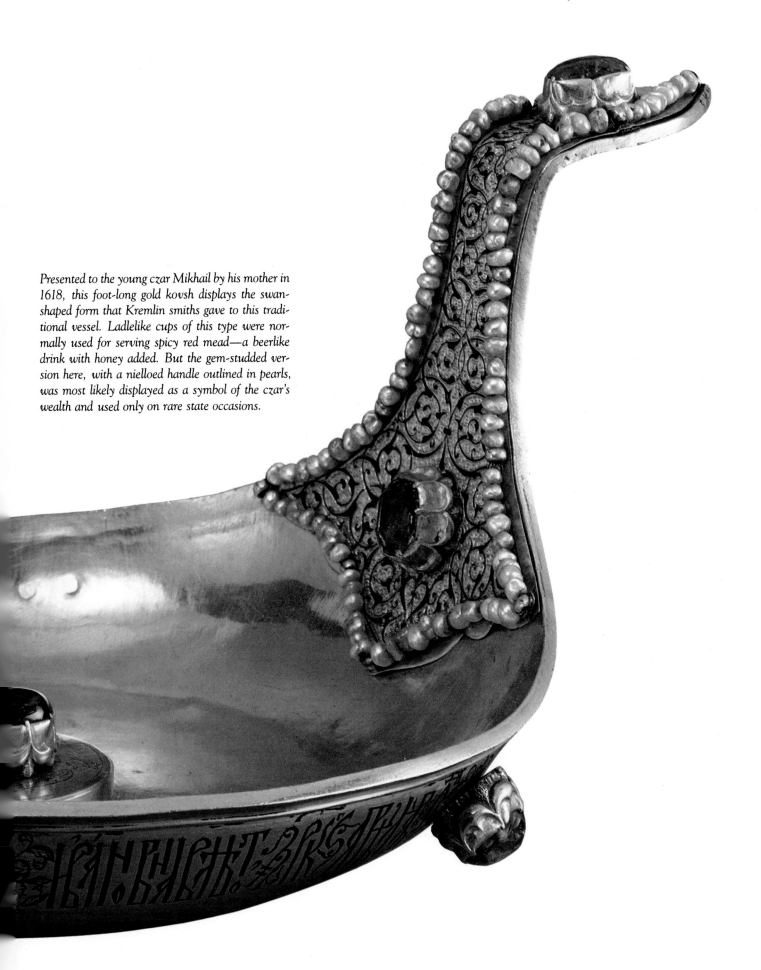

Presented to the young czar Mikhail by his mother in 1618, this foot-long gold kovsh displays the swan-shaped form that Kremlin smiths gave to this traditional vessel. Ladlelike cups of this type were normally used for serving spicy red mead—a beerlike drink with honey added. But the gem-studded version here, with a nielloed handle outlined in pearls, was most likely displayed as a symbol of the czar's wealth and used only on rare state occasions.

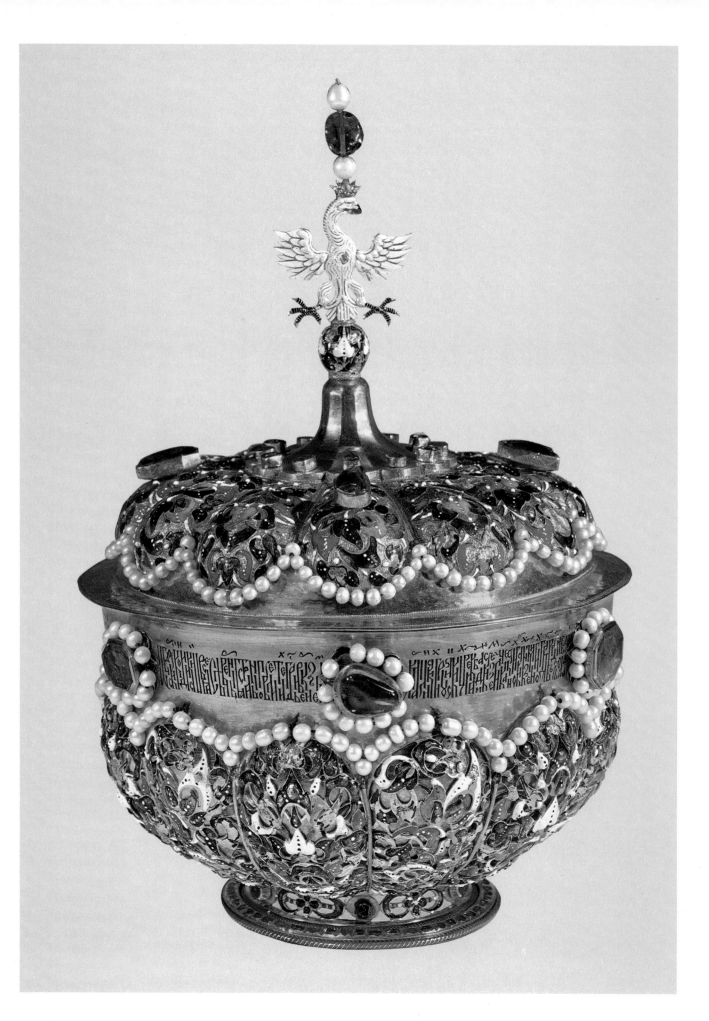

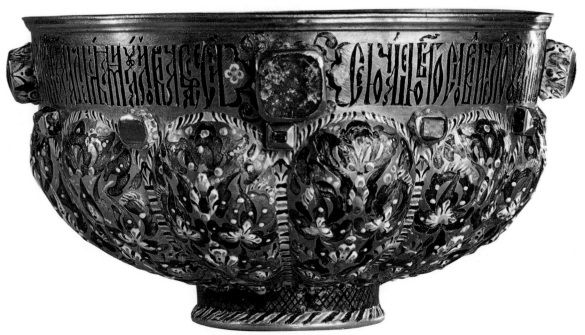

Given to Czar Alexei, Mikhail's son and successor, in 1653 by the powerful patriarch of Moscow, Nikon, this brightly enameled gold bowl set with jewels has a floral theme. Not only is the bowl itself shaped to look like the spreading petals of a blossom, but each petal shows an intricate pattern of flowers suggesting a bouquet.

Czar Mikhail sent the bratina opposite to King Ladislas IV of Poland in 1637 as a wedding present. The white eagle at the top was a Polish emblem. The elaborate enamel work, the perfect symmetry of the pearls, and the extraordinary gems all indicate that the czar instructed his craftsmen to produce an exceptional royal gift. The inscription around the cup's rim boasts Mikhail's titles as sovereign of Russia.

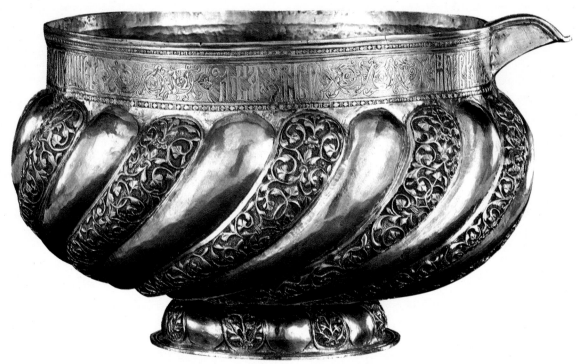

Gilded repoussé swirls alternate with plain ones on this globular silver container produced in 1644 for Vasili Streshnev, a boyar who for eight years supervised the Kremlin workshops. The spouted vessel was used to pour drinks into containers.

This seven-inch-high bratina from the collection of an influential prince is the handiwork of a seventeenth-century Kremlin master smith. He executed the striking, rounded bombé shape and the leafy tendril design in silver and then overlayed the result in gold. For a loving cup it has an appropriate rim inscription: "True love is like a golden vessel. It never breaks, and if it bends, reason will set it to rights."

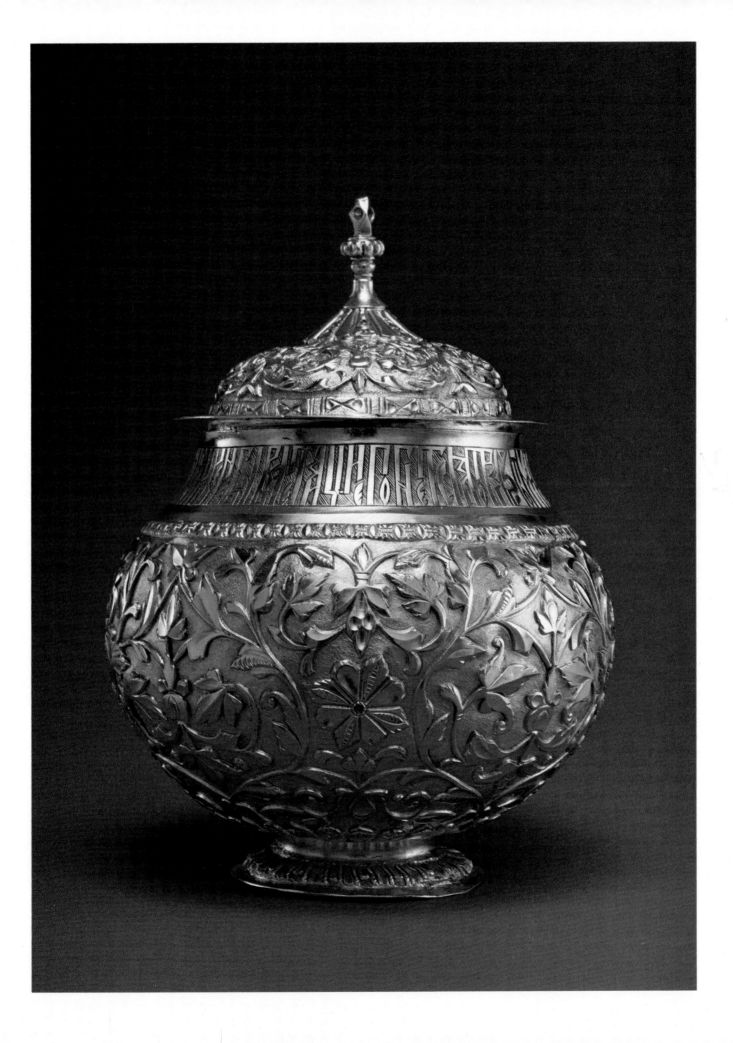

TEXT CONTINUED FROM PAGE 49

Foreigners were astonished to see the waiters running back and forth from the kitchen to the dining room to keep up with the voracious appetites of the Russian diners. Nothing amazed foreigners more than the Russian capacity for drink—"No one may leave the dining-room unless he be carried out dead drunk," discovered a diplomat. But of the robust dishes, usually served with large helpings of onions and garlic, offered at the czar's banquets, Alexei himself took little. He was content with a piece of rye bread and a single glass of wine or beer. It was reckoned that the czar fasted eight months of the year.

A seventeenth-century palace was usually a cold and drafty place. Alexei, with an unmonkish appreciation of creature comforts, warmed himself and his guests with an early form of central heating—a basement furnace sent drafts of heated air through a series of ventilators. The czar also introduced the idea of dinner music. An English guest said the music reminded him of "seven hogs on a windy day," but Alexei enjoyed it. Eventually the czar assembled a personal orchestra of German musicians.

Under Alexei the Kremlin armory bustled with painters, goldsmiths, armorers, and jewelers, busily fashioning gold and silver furnishings for the czar and exquisite, jewel-encrusted frames for icons. Alexei encouraged the icon painters of his studio to study Western paintings, with the result that they began to paint full-bodied figures in realistic perspective instead of the old-fashioned two-dimensional icons. Alexei's taste for Westernized religious art put him on a collision course with the conservative Russian clergy. Nikon, the patriarch of Moscow, ordered armed men to seize the new icons from public places and even from the homes of high officials. Nikon's men gouged out the eyes of the icons and paraded the ruined canvases through Moscow, with the warning that artists who continued to paint such offensive works would suffer the same fate as their paintings. Not satisfied with stamping out new ideas in art, Nikon set up his own political bureaucracy to carry out his conservative program. But Alexei struck back at the presumptuous cleric, banishing Nikon to an obscure monastery, where he slept on a bed of granite.

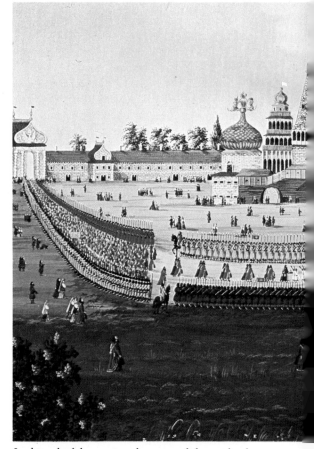

In this colorful seventeenth-century lithograph, clusters of spectators watch from afar and line the route as a massive procession approaches the Romanov palace at Kolomenskoye, outside Moscow. Built by Czar Alexei, the elaborately decorated structure was constructed entirely of wood and boasted 270 interconnected rooms, 100 onion-shaped domes, and 3,000 windows made of mica.

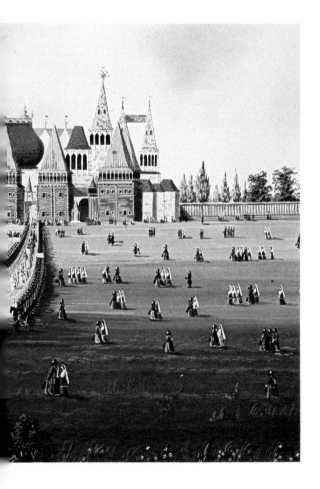

Alexei's treatment of Nikon was one of the czar's milder displays of temper. Several times in his reign Alexei inflicted savage punishment on those who dared to challenge his authority. On Alexei's orders the army massacred hundreds of residents in the northern town of Pskov in 1650, after starving people there intercepted a shipment of grain to Sweden. But it befell Moscow to endure the czar's most furious outburst. In 1662 the citizens of Moscow rioted to protest the government's substitution of copper coins for silver ones—a switch that caused ruinous inflation in the city. An angry crowd surged onto the grounds of Alexei's estate outside Moscow, demanding to see the czar. Alexei coolly strode out of his house and confronted the crowd. The boldest of the protesters took hold of Alexei's robe and entreated him to punish the officials responsible for the coinage. Alexei swore to investigate the matter, and the crowd seemed satisfied.

But a second, more militant group arrived, and they demanded immediate punishment of the officials. This time Alexei called out his guards, who hacked their way through the protesters, many of whom drowned in a nearby river in the rush to escape. In a rage Alexei ordered mass executions and mutilations—seven thousand Muscovites were put to death, and the czar's soldiers chopped off the arms or legs of fifteen thousand others. The surviving protesters tasted a bitter victory the following year when the czar restored the silver coinage.

Ironically it was Alexei, the Gentlest Czar, who legalized slavery in Russia. He decreed that certain peasants, known as serfs, were bound to work their entire lives on the estates where they were born. The children of serfs would also be the property of the estate owners. For centuries thereafter serfs were told that God had ordained their place in life. In fact Alexei created the slave class to gain political support from the landowning nobles.

In his last years Alexei loosened the tight bonds of his piety and enjoyed himself as never before. After the death of his first wife, he met a pretty seventeen-year-old, Natalya Narishkina, at the home of a friend. Enchanted, the forty-two-year-old czar called her his "little

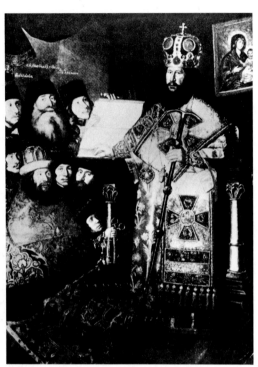

Patriarch Nikon instructs worshipers in this contemporary portrait. The forceful cleric attempted to reform the Russian service by restoring ancient Byzantine rites. His efforts—which included destroying icons and revising Orthodox texts—caused thousands to break with the Church.

pigeon" and proposed marriage at their second meeting. They were wed a year and a half later, when the bride was noticeably pregnant. About three months after the wedding Natalya gave birth to a strapping son, Peter.

Natalya brought gaiety and exuberance to the czar's life. The royal couple began to frequent the rowdy stage plays—blood-soaked tragedies and crude comedies—which the dour patriarch Nikon had once forced Alexei to ban. The players acted out gruesome tortures and murders to sound effects that included offstage cannon fire. Alexei enjoyed these entertainments so much that he sometimes sat in the theater for ten hours at a stretch. At the same time, however, the czar harbored a lingering fear that these diversions might be occasions of sin. So he sought his confessor's approval before building his own, private theater.

Alexei also staged theatrical performances in his country palace in the village of Kolomenskoye, near Moscow—a palace that itself resembled the flamboyant set for an exotic fantasy. Astonished courtiers called Kolomenskoye the eighth wonder of the world. The exterior of the palace was decorated with intricately carved wood, lavishly covered with gold. In the description of one foreigner, the palace seemed "so brilliant that it appears to have emerged from a jewel-box." Inside, Alexei decorated the walls not with glowering icons of saints, but with Western-style portraits of history's illustrious rulers, including Alexander the Great, Julius Caesar, and Darius the Great of Persia.

Alexei's greatest delight at Kolomenskoye was his throne room, where a startling sight greeted visitors. They found Alexei seated on his throne, flanked by a pair of mechanical lions made of gilded copper. At a signal from the czar, a man in a hidden chamber pumped furiously on a set of bellows, causing the lions to roll their eyes, open their mouths, and give out with a ferocious roar. The roar may have been a mechanical one, but the power it symbolized was real. Czar Alexei had tightened the Romanov grip on the crown and had bequeathed to Russia a son who would stride through the land like a lion.

REGALIA FOR THE CZAR

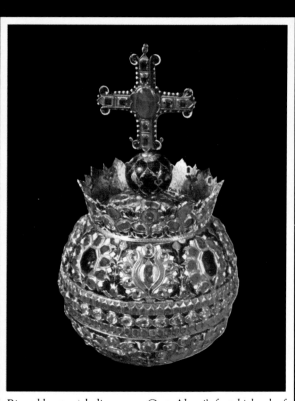

Ringed by a symbolic crown, Czar Alexei's foot-high orb of power presents a fiery display of rubies, diamonds, and sapphires on emerald-green enamel and gold.

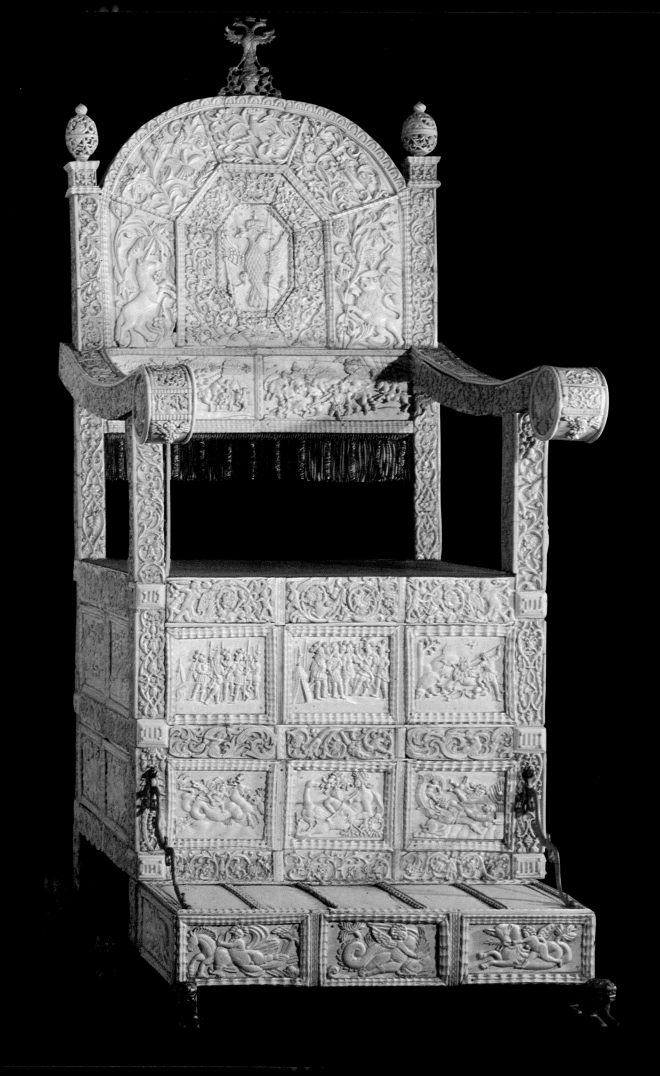

When Mikhail, the first czar of the house of Romanov, ascended the throne in 1613, most of the awesome array of crown jewels and robes of state amassed by previous czars had been squandered by pretenders or whisked away by invading Poles. Making up for this dearth of regal trappings became a major preoccupation of Mikhail and his son Alexei.

The older, important emblems of a czar's legitimacy and continuity with his predecessors did survive—the so-called Ivory Throne and the crown of Monomakh. Legend traces the elaborately carved throne, opposite, to the 1472 wedding uniting Ivan the Great with the niece of the last emperor of Constantinople—an event regarded as making the czars heirs to the Byzantine imperial line.

Of much greater significance, the cap of Monomakh (on page 62 and in detail on page 63) was the hereditary headpiece of the Russian rulers, the crown placed on each sovereign when he was declared czar and autocrat of all the Russias. Though its origins are uncertain, the cap—like the throne—carries a Byzantine

provenance. Beginning with Ivan IV the czars attributed the helmetlike ornament to Constantine IX Monomakh, an eleventh-century emperor who reputedly gave the cap—his own crown—to his grandson, a Russian prince in Kiev. The prince, also named Monomakh, passed on the helmet, and with it the power it represented, to the Moscow rulers.

These two pieces aside, however, the sumptuous and distinctive badges of office date from the sixty-three years that Mikhail and Alexei reigned. Mikhail spent hours on end in the Kremlin armory overseeing workers, who created a richly jeweled, exquisitely detailed scepter, orb, and crown for him (pages 68–73) and also embellished plainer, historic pieces. Alexei by contrast obtained his striking pieces from foreign sources. He commissioned a Greek jeweler in Constantinople to make his spectacular orb (page 59). And in return for granting a lucrative trade concession to Armenian merchants, the czar obtained the priceless and aptly named Diamond Throne (page 74 and in detail on page 75).

The oldest surviving monarchical seat of the czar, the pristine Ivory Throne, opposite, is an outstanding example of medieval handiwork with about 150 ivory panels in crisply carved relief mounted on its wooden frame. On the backrest panels a unicorn and a lion—both rearing rampantly—flank the czarist double-headed eagle, while just below them the czar's troops lay siege to an enemy city. Other panels bear mythological, biblical, and historical scenes along with vignettes from everyday life and arabesque designs. The gilded imperial eagle atop the backrest was the addition of a later Romanov.

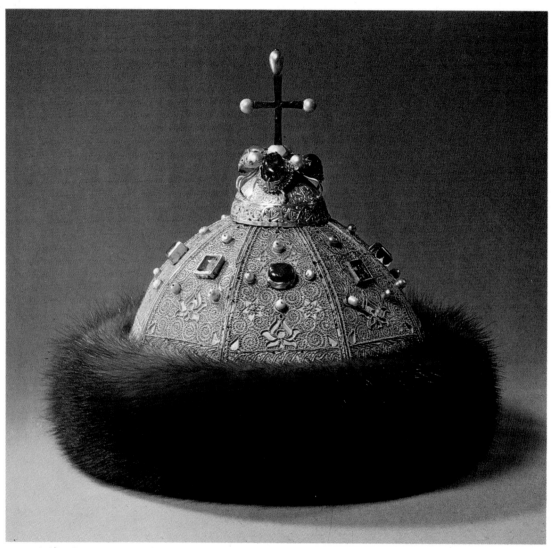

Encircled by the finest sable, the crown of Monomakh was crafted by unknown—probably non-Russian—metal-smiths from gold and precious stones. Large gems and pearls top the crown's upper dome—enlarged opposite—apparently added in the sixteenth century when the crown was already three hundred years old. The pie-shaped sections radiating from it are overlaid with lacy filigree work and set with an emerald or ruby surrounded by pearls.

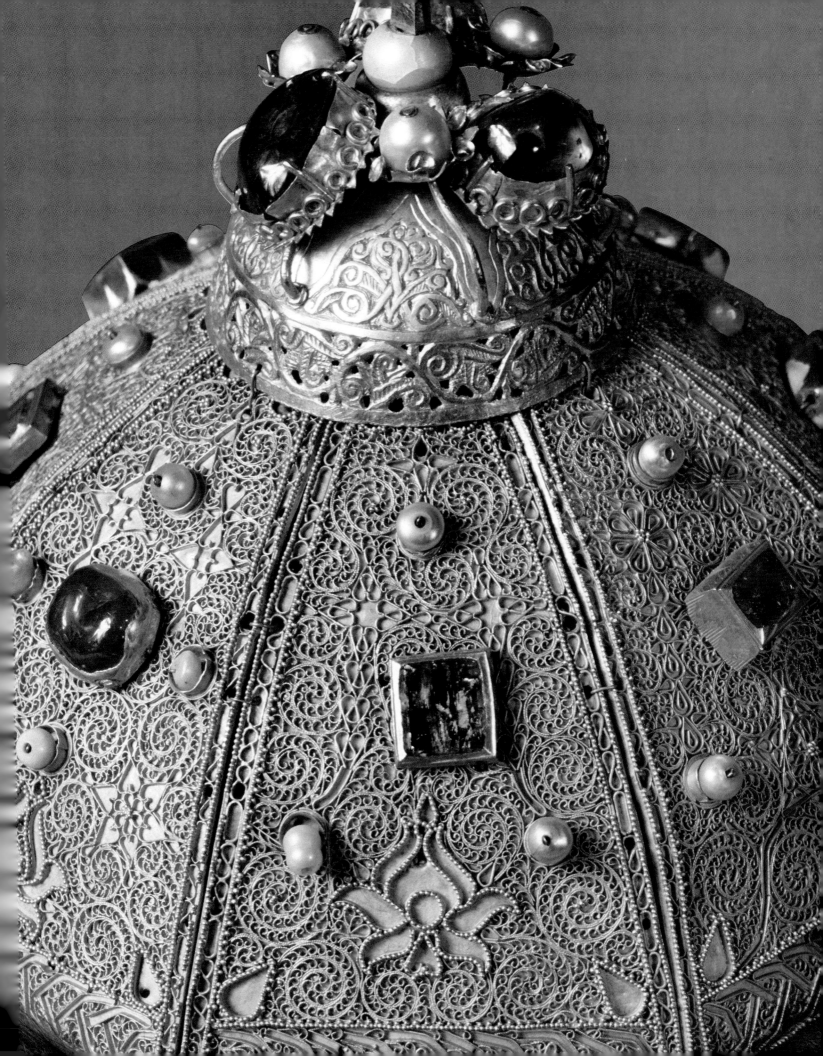

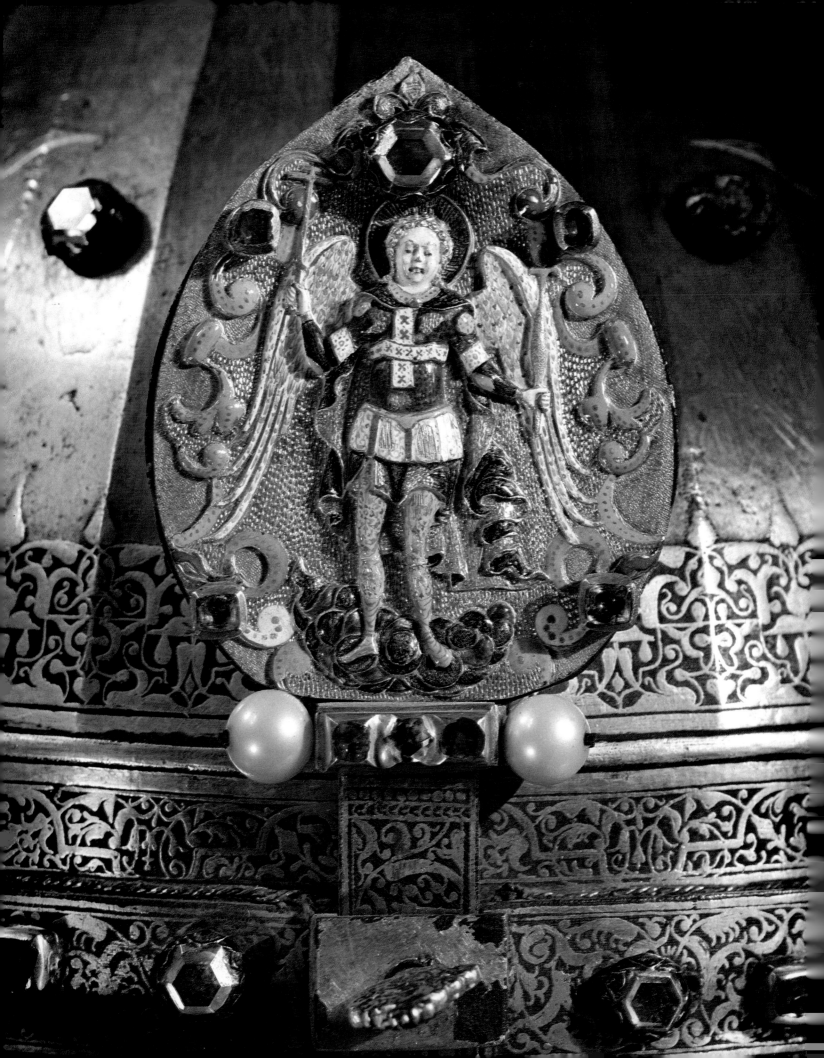

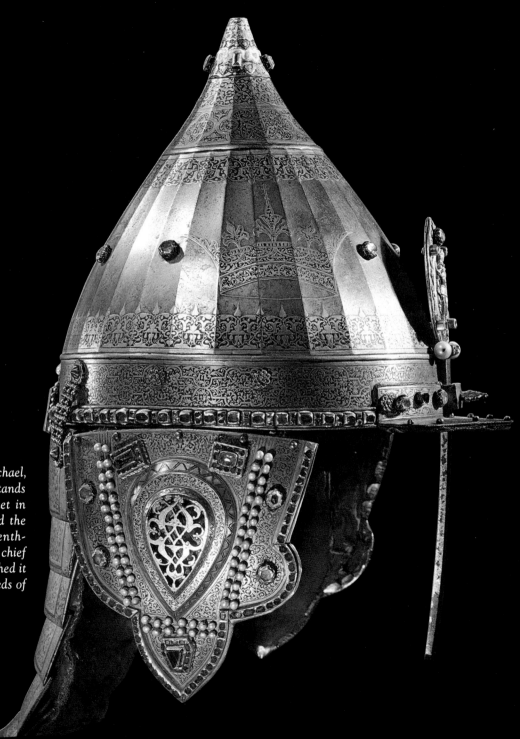

The enameled figure of the archangel Michael, opposite, leader of the heavenly armies, stands out on the face of the conical dress helmet in profile at right. Kremlin tradition linked the helmet with Alexander Nevski, a thirteenth-century military hero, and in 1621 the chief goldsmith for Mikhail Romanov reembellished it with gold friezes, complemented by hundreds of gemstones in raised settings.

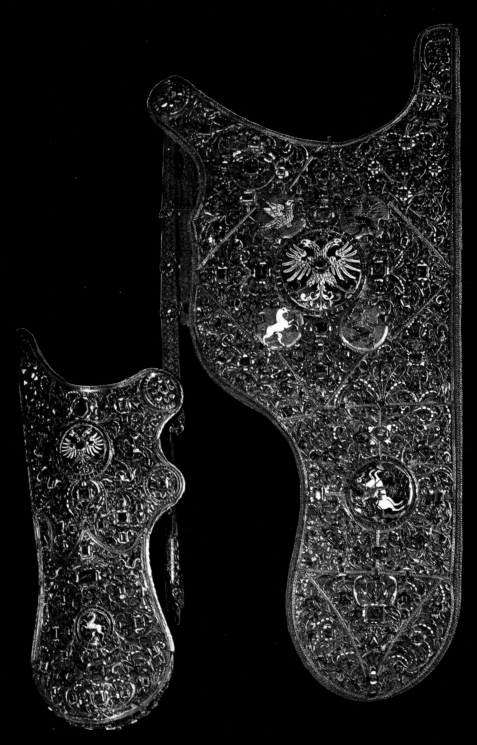

Part of Mikhail Romanov's grand robes of state, this gold saadak—*a combined bow case and quiver—was displayed next to a high-ranking boyar on great occasions. Artisans at the Kremlin decorated each piece with precious stones, enamels, and animal figures. The double eagle, in the detail opposite, is an emblem of royal power; the bird above it symbolizes happiness, the unicorn below, fortune.*

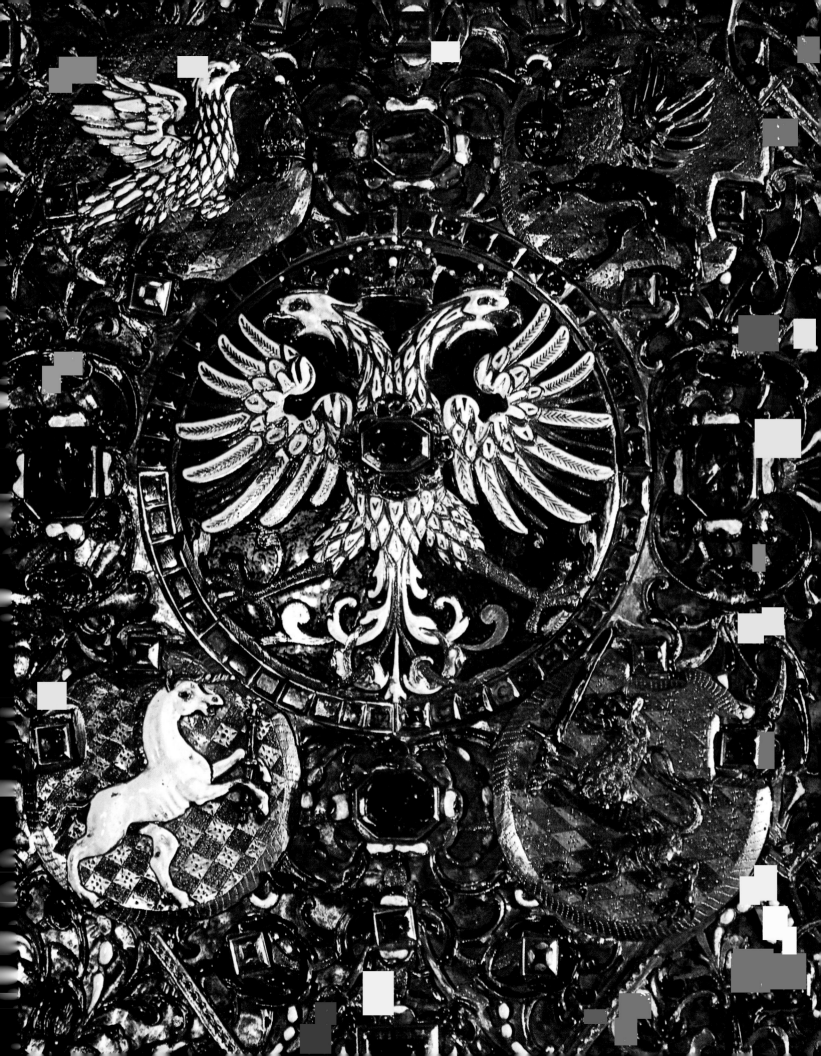

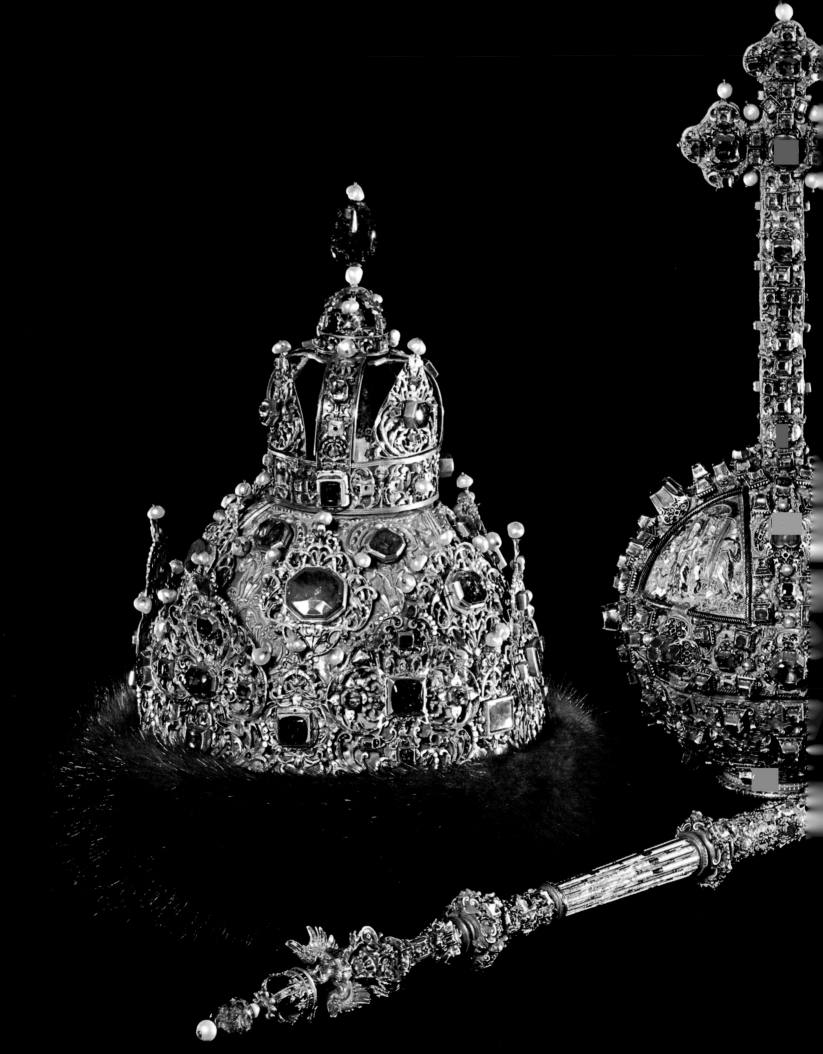

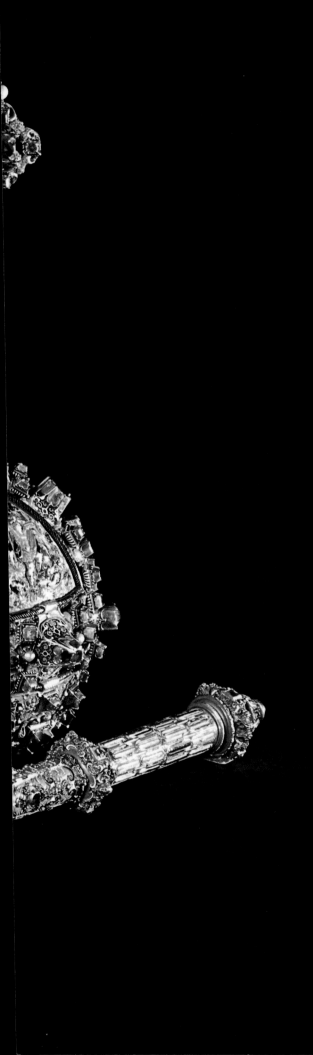

These blazing ornaments—an orb, a scepter, and a crown—are the principal pieces of Czar Mikhail's state regalia. At least twenty craftsmen, some of them invited from Germany, labored on them for more than a year, using gold and gems supplied from the royal treasury. The five-pound crown contains more than 150 precious stones—emeralds, rubies, sapphires, and pearls—set in gold, much of which is openwork in an elaborate design called gorodki. A sable collar encircles the base, and at the peak is a miniature three-winged crown, topped by another, tinier crown supporting a large emerald. The scepter and orb appear in detail on pages 70–73.

Polychrome gems and enamels glitter on chased gold along this section of Mikhail's scepter. At upper right opposite, near the top of the scepter, eagles' talons clutch a floral arabesque unfolding around an emerald.

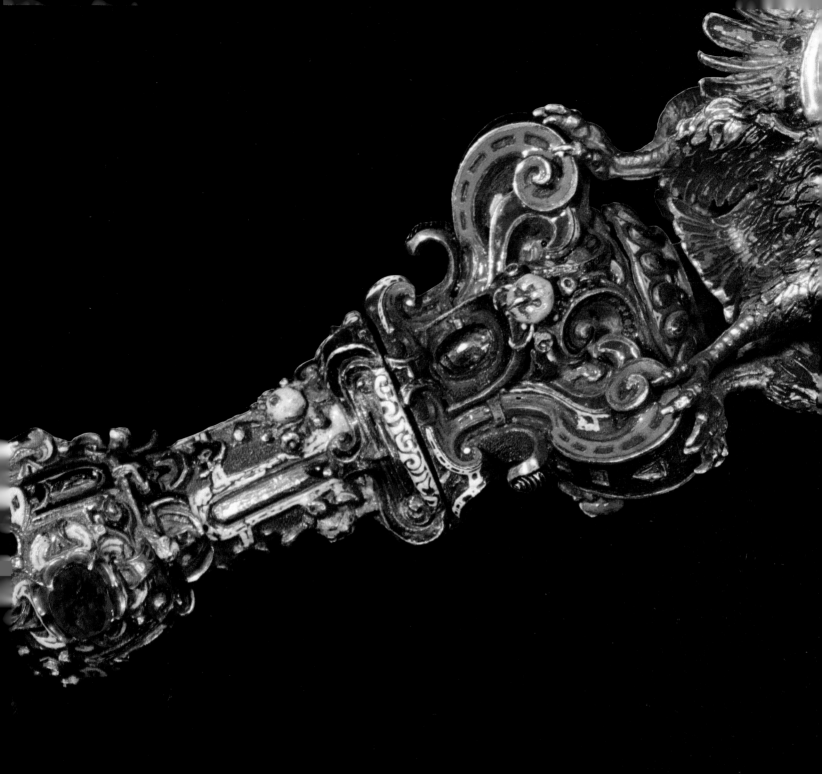

OVERLEAF: *Beautifully worked in translucent enamels, these two triangular panels, which decorate part of the czar's gold orb, portray incidents from the life of the biblical king David. The scene on page 72 is of David's victory over Goliath, who lies fallen as David raises the giant's sword to behead him. In the other scene foot soldiers and a horseman in gold armor escort the triumphant David into Jerusalem.*

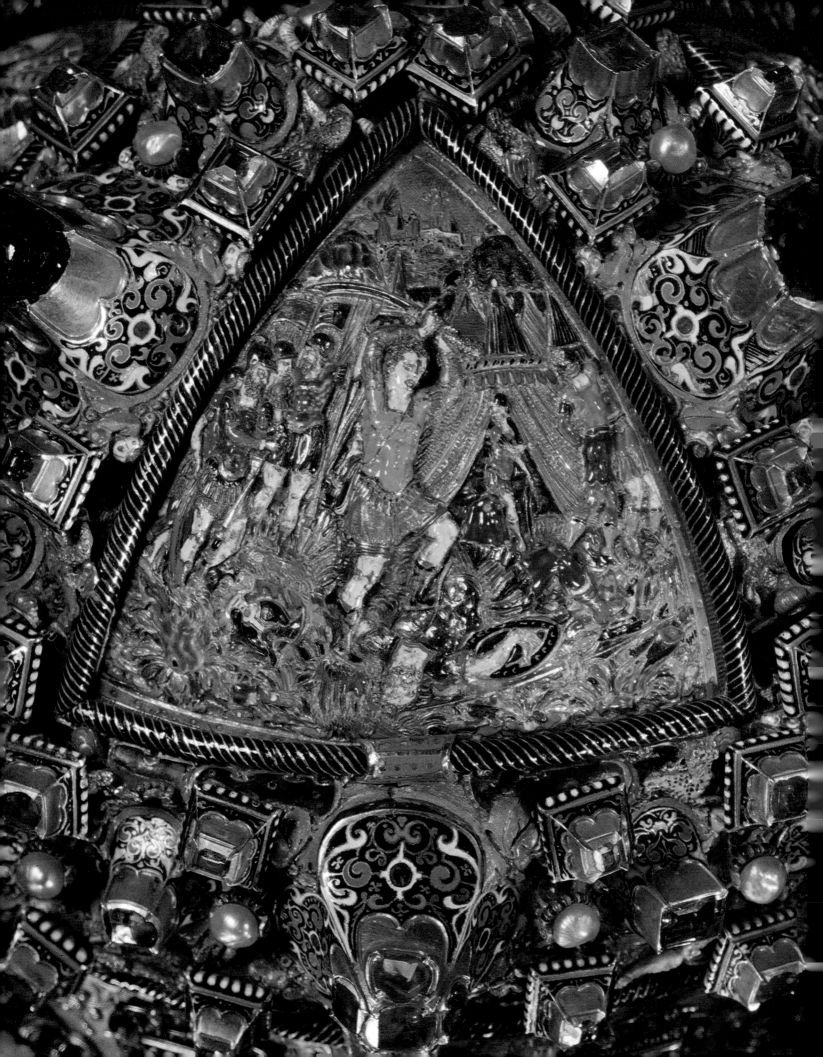

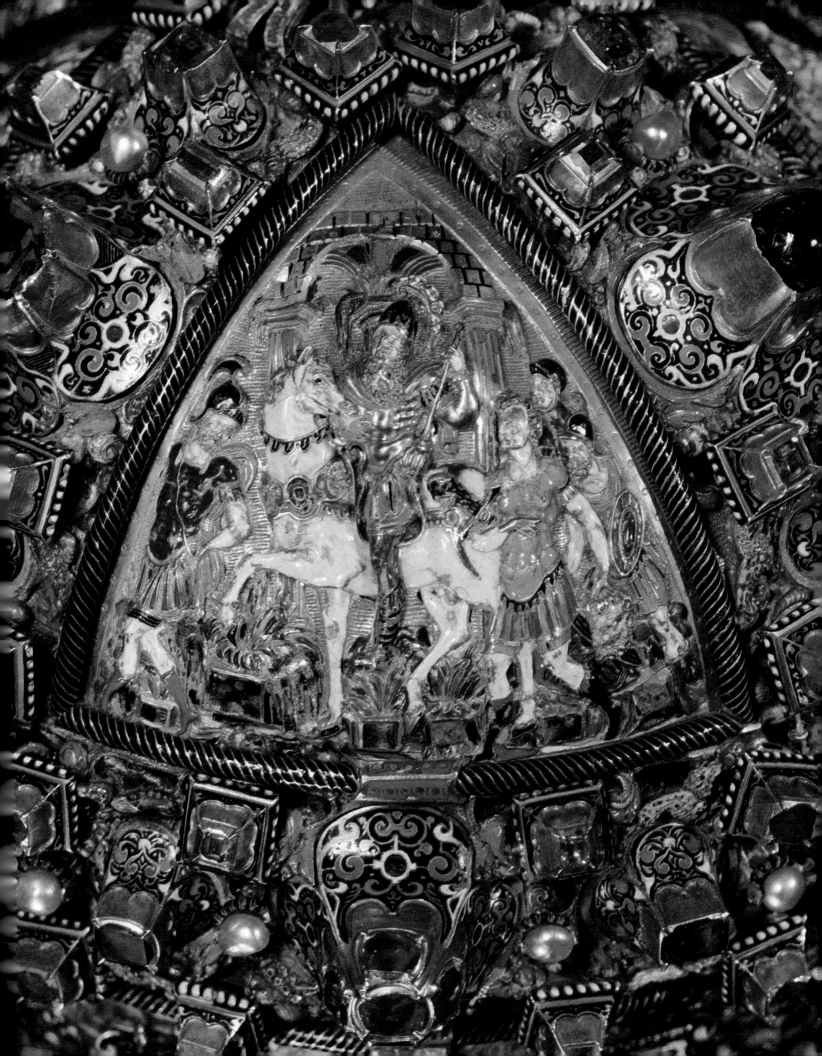

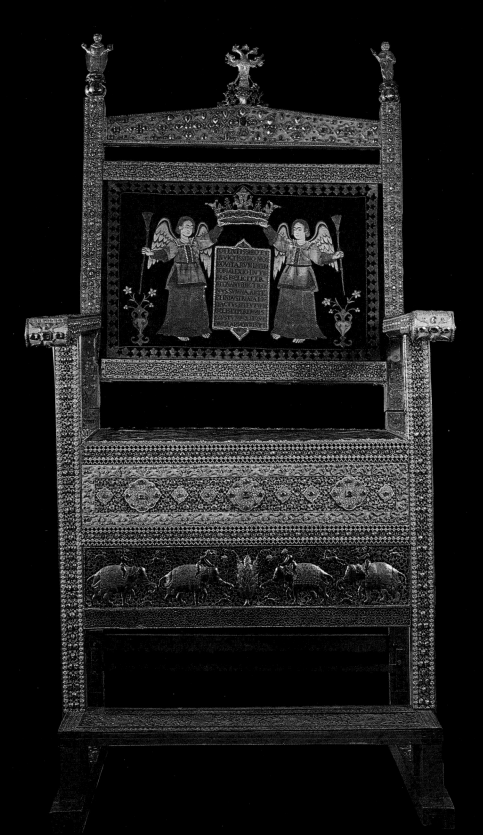

Rich gilt, encrusted with nearly nine hundred diamonds and several hundred other precious stones, covers most of the so-called Diamond Throne, at left, which was made in Persia and presented to Alexei Romanov in 1659. The front panel, in detail opposite, bears four elephants in repoussé and, above it, medallions formed from rubies, diamonds, and Persian turquoise. On the backrest two embroidered angels support a crown. Between them is a shield with a Latin inscription proclaiming that the throne will bring the czar happiness and glory.

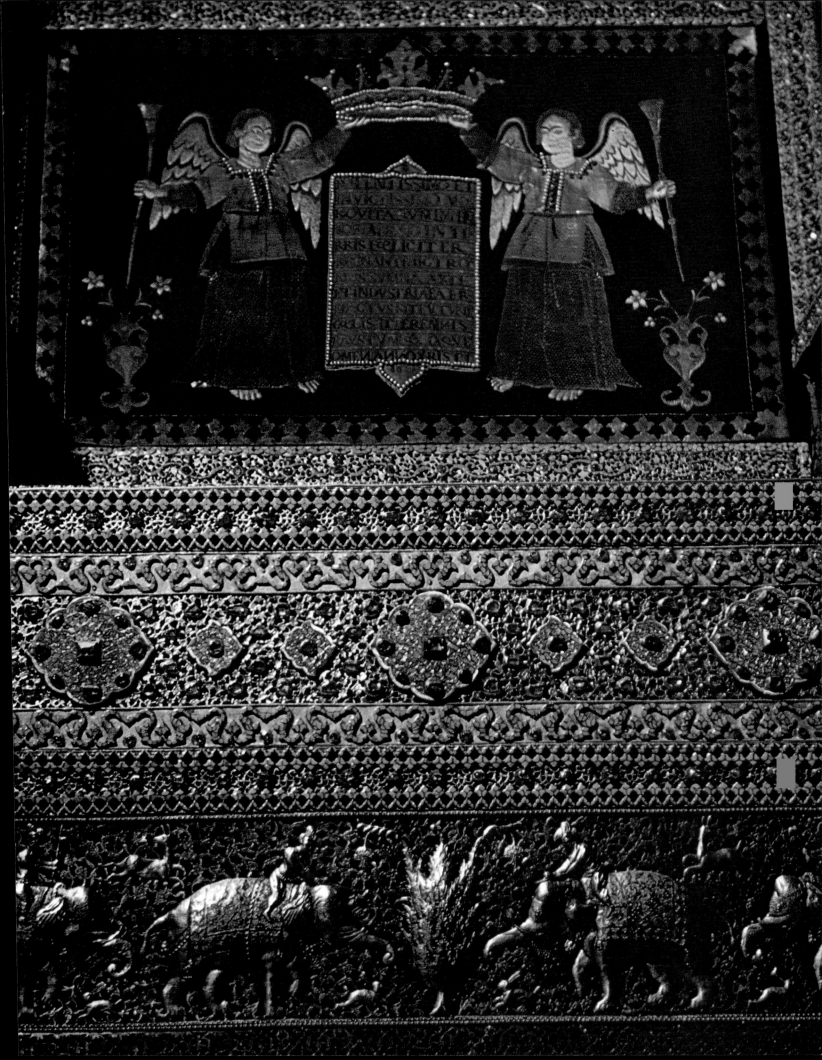

III

PETER THE GREAT

LOVE OF THE WEST

T he Great" is an honorary title that subjects frequently conferred upon their kings in the same offhanded manner kings lopped off the heads of subjects. The designation has a handsome ring and carries a certain cachet, but is not of itself necessarily meaningful. In the case of Peter I, however, the sober test of history has served to confirm the popular judgment. Everything about Peter—his size, his passion for learning, his gift for statecraft, his taste for cruelty—was great. Peter's contemporary Louis XIV of France may have shone more brightly than any monarch in Europe, but it was Peter who cast the longer shadow.

This magnificent, flawed paragon of kings began life under the most auspicious of circumstances. Peter's birth in 1672 set off a national celebration: bells rang out from 1,600 Moscow steeples, cannons roared, and Czar Alexei—the delighted father—ordered up a 200-pound gingerbread cake to help celebrate. As a baby Peter was the image of a pampered prince. He slept on Turkish velvet in a cradle covered with gold embroidery, and one of his first picture

Peter I, known as Peter the Great, forced his country into a modern mold in the eighteenth century. A Dutch painter made this portrait of the armored czar in 1697.

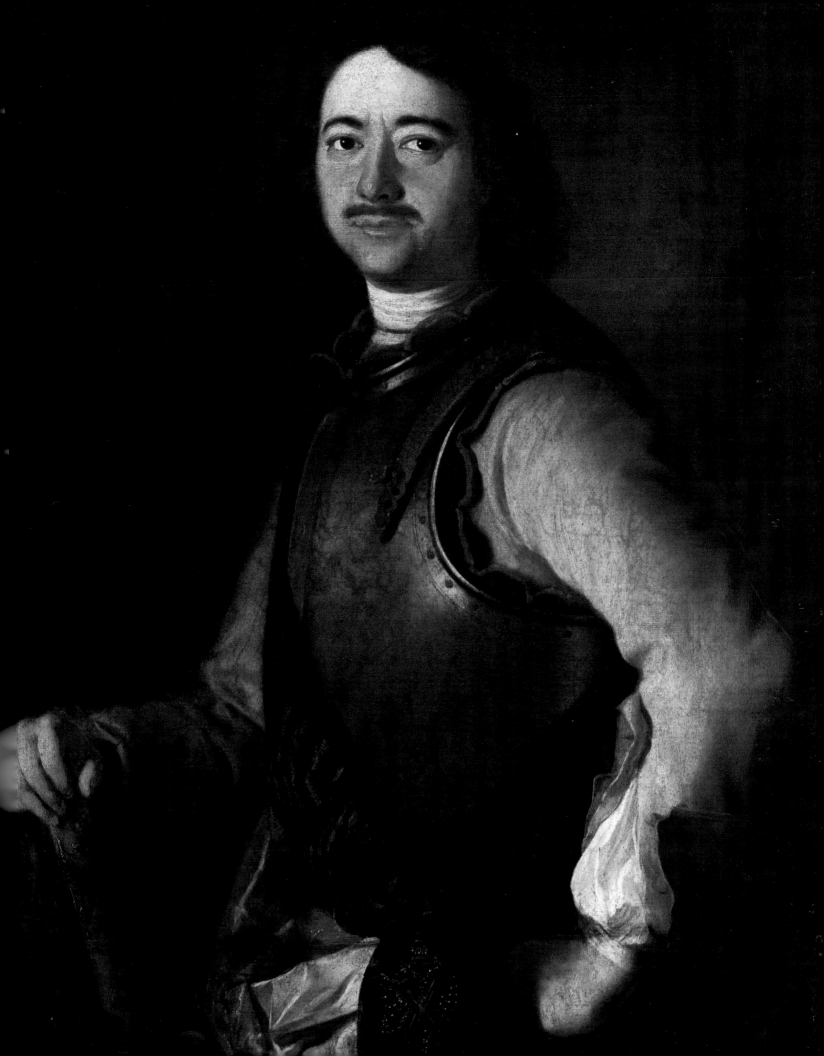

A young Peter plays military strategist on horseback in the seventeenth-century watercolor above. Aware from an early age that many would like to oust him from power, Peter herded his friends into make-believe armies and pitted them against one another.

books was crafted by Russia's most distinguished icon painters. Peter was driven around the city in a gilded carriage drawn by four ponies and was constantly attended by a retinue of dwarfs carefully selected to play with the young czarevitch.

This exotic fantasy was crushed under the realities of Russian power before Peter was four years old. Czar Alexei died suddenly, and the royal house had to endure yet another paroxysm of mayhem and terror. Peter's half-brother Fëdor became czar and ruled as little more than an adolescent puppet of his courtiers for six years, spending most of his time at divine services. After Fëdor III's death, in 1682, an assembly of representatives passed over the two children of Alexei who were next in line, Ivan and Sofia, and gave the crown to Peter, with his mother, Natalya Narishkina, acting as regent until he came of age. The assembly had failed to consider the ambition of Sofia, whose innocent-looking face disguised an iron resolve.

Sofia wielded considerable influence with the *streltsy,* a contingent of infantry created by Ivan the Terrible that had become an independent military force within Moscow. She used that influence to provoke the streltsy into a three-day riot that devastated the city. A mob of mutinous streltsy poured into the Kremlin and, in front of Peter's eyes, grabbed their commander and hurled him over a staircase onto the upraised spears of rioters below. The butchery of the rioters was wanton and widespread but fell with particular ferocity on Sofia's perceived enemies—the family of Peter's mother. Two of Peter's uncles were slaughtered. Rioters tortured one of them, then hacked him apart and trampled the pieces into the ground. This orgy of murder finally subsided when the streltsy proposed that Peter and Ivan be co-czars, with Sofia as regent. Sofia said the idea must have come from God and agreed to serve. But the horror of the streltsy revolt left permanent scars on Peter. "I cannot bury the memory of those days," he said years later, and for the rest of his life Peter's giant body was subject to periodic convulsions.

As regent Sofia informally but effectively banished Peter to the countryside outside Moscow. He was denied the traditional education of a czarevitch in Latin and theology, and, although he became

a good reader in Russian, his writing was always erratic. Nonetheless, the young prince was fortunate to grow up away from the bloody intrigues of Moscow. And, in a musty imperial storehouse, he made one of the happiest discoveries of his life—a small English sailboat. With the help of a Dutch boat maker, Peter mastered the art of sailing—and a teenager who before had known only barges lumbering along the Volga and the Don rivers began to dream of great oceans and swift navies.

He was recalled from these diversions by his mother in 1689 to enter into an arranged marriage with Evdokiya Lopukhina, the devout daughter of a conservative aristocratic family. Peter dutifully went through the ceremony, but the marriage was not a great success. One decorous British historian felt it necessary to describe Evdokiya as "beautiful but stupid." Peter soon tired of her and found he much preferred enjoying himself with the Europeans in Moscow's foreign quarter, where he acquired a liking for Western ways.

Sofia doubtless had plans to make her regency permanent. She assumed the title *gosudarynya*, or "sovereign," but while she and her lover, Prince Vasili Golitsyn, were competent enough administrators, they were unlucky in military matters. When Golitsyn's military campaigns in the Crimea ended in disaster and a huge number of casualties, Sofia found the power she had reached for so ruthlessly was slipping away.

Her loyal supporters in the streltsy conspired to put Sofia on the throne; but word of the planned coup leaked out. Peter, still haunted by the memory of the bloody streltsy riots of his childhood, fled for his life. But the army rallied around him; Peter was able to oust Sofia from the regency in 1689 and dispatch the unhappy lady to a nunnery outside of Moscow.

Peter was ready to become czar, but Russia was scarcely ready for him. Although the Russians were accustomed to quixotic czars, nothing had prepared them for the whirlwind that was Peter I. Far from being a remote figure, Peter as often as not could be found getting uproariously drunk with his European friends in the foreign quarter. Instead of staying in Moscow, he personally journeyed to the

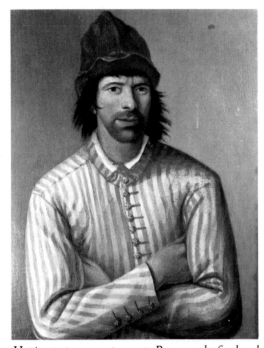

Hoping to pass as a peasant, Peter sought firsthand, practical learning during his travels through Europe from 1696 to 1698. Though he fooled few, the conspicuous czar did apprentice as a shipbuilder in Holland, where he may have posed for this portrait.

Bronze medallions like this one proved that a man had paid his beard tax.

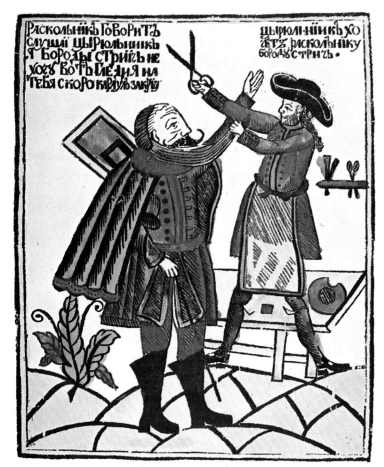

A nobleman loses his beloved beard to Peter, who personally shaved his courtiers.

OFF WITH THEIR BEARDS

After touring Europe's elegant courts, Peter the Great returned to Moscow in 1698 determined to emulate all he had seen. Among the things he had noticed in the progressive West was that men went beardless. To the czar, beards suddenly symbolized all that was backward and barbarous about his country, so he returned home and lunged at his noblemen like a mad barber. The Orthodox Russians loved their long beards, which they considered not only manly, but godly: a virtuous man, they thought, should look like a biblical prophet.

Not content with shaving his courtiers' beards, Peter passed a general tonsorial law and posted state barbers at the gates to Moscow to shave bearded visitors to the city. Any man who arrived at the czar's banquets with a beard, left with his chin exposed—if he resisted, Peter gouged out the hair with a knife or ripped it out with his hands. The czar exempted only priests and peasants from the law and imposed a tax on others who made special pleas to keep their beards.

Many nobles resorted to bribery, but the czar's scissored squadrons usually caught up with them. Shorn and ashamed, once-shaggy Russians saved their whiskers for their coffins—hoping to wear them in heaven.

Crimea to lead his forces against the Tatars, who were allies of the Ottoman Turkish Empire. Gaining an easy access to the world's oceans formed the bedrock of Peter's foreign policy. He went to war against the Tatars and Turks to break their grip on the Azov Sea, through which Russian ships could reach the Black Sea and the Mediterranean.

To capture the fort at the city of Azov, which guarded the entrance to the Azov Sea, Peter realized that he needed a sizable fleet. Since Russia had no navy to speak of, Peter created one on the spot. He brought down more than thirty thousand carpenters to hammer and saw through the winter of 1695–1696, and by June he had a fleet of thirty vessels that cut off Turkish supplies. Azov fell to Peter the next month. On his triumphant return to Moscow, Peter had still more surprises in store for his subjects. There were no prelates in the parade and no holy icons held aloft over the marchers to acclaim divine intervention. Azov was Peter's victory, not God's. The czar marched under a victory arch supported by sculpted figures of the Roman god of war, Mars, and the hero Hercules.

Then Peter set out on his glorious adventure. Determined to learn Western ways firsthand, he gathered an entourage of some 250 cronies to tour Europe. They had a grand time. Peter spent a night drinking with Augustus II of Poland, where the two monarchs held a contest to see who could crumple up the most silver plate with his hands. The czar and his group of traveling companions made social gaffes aplenty during their tour. He was not comfortable using knives and forks at the dinner table, and once while dancing with the electress of Brandenburg, he felt the stays in the lady's corset and commented that German women had devilish hard bones. During their visit to England, Peter and his friends stayed at the home of essayist John Evelyn. They chopped up every single chair in the house for firewood. The portraits in Evelyn's picture gallery were reduced to tatters by the Russians' target practice. And they all but flattened the hedges, which the fastidious Evelyn had spent the better part of forty-five years laying out. The Russians had discovered three wheelbarrows, something they had never seen before, and

invented a game in which they raced each other into the shrubbery.

But if Peter was hard on upholstery, he was learning what he had come to the continent to find. Traveling incognito under the name Peter Mikhailov, he worked as a laborer in a shipyard in Holland. He later showed off his calluses with the pride Louis XIV reserved for his emeralds. "My rank is that of pupil," he declared, "and I need masters." If anyone, high or low, had knowledge or a skill to impart, Czar Peter I was eager to learn from him. He studied geometry, military engineering, microscopy, architecture, and mechanics. He also learned to cobble shoes and pull teeth. He became so delighted with dentistry that his courtiers learned never to complain of a toothache in his presence, for the czar usually kept a pair of pliers handy and was always ready to show off his skill at extraction.

Peter was on fire with Western ideas, but as he was preparing to proceed to Venice, he had to cut short his continental tour when he received news from Russia that the streltsy were in open revolt, trying once again to bring Sofia into power. By the time Peter got back to Russia, loyal army generals had suppressed the revolt. The czar wreaked his vengeance on the streltsy with a ferocity that had not been seen since Ivan the Terrible. After the usual torturing and breaking of bones, nearly one thousand streltsy were executed by either the noose or the ax, and their bodies were left to dangle above Red Square as a little civics lesson on the dangers of dissent.

Peter had also lost patience with his wife. Evdokiya failed Peter in two important ways. She bored him, which was unfortunate; but what he could not forgive was that she held rigidly to conservative religious views. He took their son, Alexei, away from her and forced Evdokiya to take the veils of a nun. A few years later Peter married a Livonian servant girl captured in a battle with the Swedes and crowned her Empress Catherine I.

Peter's abrupt repudiation of his wife and his mass execution of the streltsy foreshadowed the upheaval that he had in store for Russia. He caused turmoil with a series of revolutionary political and social changes. Peter swept away the old government departments—all eighty of them—and substituted a more manageable thirteen de-

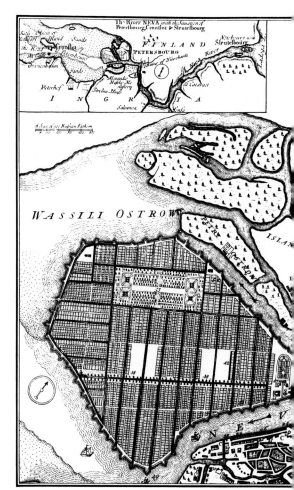

From the city that Peter built—St. Petersburg, which was named after the apostle—the czar's navy had a ready launch, via the Neva River, into the Baltic Sea. Streets, parks, and plazas, which an eighteenth-century cartographer delineated in the map above, brought order to the hostile wild.

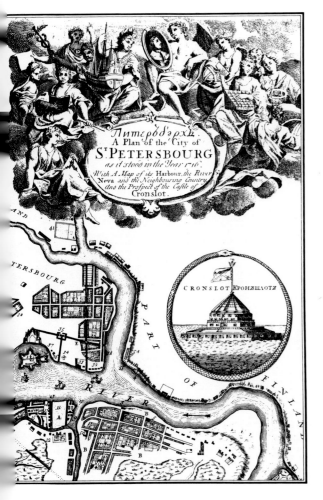

partments. To staff this new bureaucracy, and to obtain a pool of officers for his modernized army, Peter decreed that all men of landowning families could be called into government or military service at any time.

To foster trade Peter created an upper class of wealthy merchants and professionals who enjoyed exemption from government service and the privilege of settling wherever they wished. The lower order of laborers, officially designated as "commons" in Peter's system, had to remain in their towns. On the farms the serfs continued to be the slaves of the landowners, bound to live out their lives on the estates where they were born.

Peter presided over the modernization of Russia like a handyman who has a thousand things to do and is forever behind in his chores. He maintained a furious schedule, dashing from one end of the realm to the other to try out some new civil experiment. Even in winter, traveling in a light sled with teams of relief horses waiting for him along the way, the czar often covered one hundred miles a day. At home in Moscow there was no rest for Peter either. He would appear in his study at three in the morning and send messengers throughout Moscow to rouse officials from their beds in order to come and hear the czar's latest idea.

A stream of innovative ideas flowed from Peter's study. With one reform he brought Russia literally up-to-date. The Russian calendar counted years from 5508 B.C., the supposed date of the creation of the world, calculated from information in the Bible. Peter pushed through the adoption of the calendar, used in much of Europe, that counted years from the birth of Christ. Russia's coinage, in Peter's view, was more of a hindrance to commerce than a help. Most of the coins in circulation were foreign, validated for use in Russia by a stamped letter M, for Muscovy. To make change merchants had to hack a coin into pieces. Peter instituted a rational system of coin values, opened a mint, and within three years had several million of the new coins in use.

The czar's busy hands remade even the venerable Russian alphabet. Peter discarded several letters and signs he considered obsolete

and gave the surviving letters a fresh, more readable look. To bring the Russians themselves up-to-date, Peter opened vocational schools, as well as schools of mathematics, navigation, engineering, medicine, and artillery and established a Russian naval academy.

Peter brought to bear all of his energy, imagination, and raw imperial power on his most grandiose scheme—the creation of his long-dreamed-of seaport, St. Petersburg. Unable to enlist European allies in his struggle with the Turks, Peter had been forced to give up the city of Azov. Peter then turned his gaze to the north—to the Baltic Sea, which was largely in the hands of Sweden. To gain entry to the Baltic, Peter embarked on the Great Northern War, a costly twenty-one-year conflict during which Peter himself fought side by side with his soldiers and sailors. By 1703 the Russians had cleared a small corridor to the Baltic along the Neva River. There Peter decided to build his city.

The whole idea was from the start a madcap scheme that should never have succeeded, and Peter was probably the only monarch in history who could have managed it. The site was dreadful—a set of marshy islands in the meandering Neva River, which was frozen six months out of the year. Although Russian troops had occupied the territory, it technically belonged to Sweden, and the war was still going on. Russia would have to battle the Swedes, the terrain, and the weather for Peter to have his city.

He built a fortress and defense perimeter to hold off attacking Swedes and then started construction. Some 150,000 men—Russian construction workers, Swedish prisoners of war, and convicts—scrabbled away at excavations with such primitive equipment that they had to carry dirt off in their shirts. Thousands died, and it was said that St. Petersburg was a city built on human bones. Peter brooked no obstacle. When stone and masons were in short supply, he passed an edict forbidding the construction of any stone buildings in Moscow. A city needs people as well as buildings to flourish, but the delta of the Neva was scarcely a resort area, and few highborn Russians shared Peter's love of the sea. To populate the city Peter passed a new edict requiring every Russian nobleman to build a

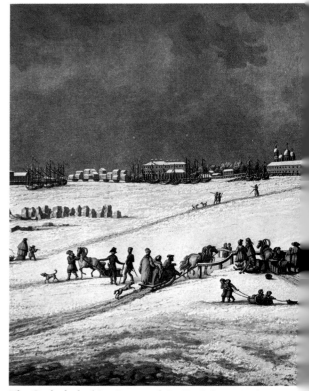

The Cathedral of St. Peter and St. Paul dominated the horizon above the city of St. Petersburg, famous for its long, bitter winters. The Neva River was the scene of seasonal chores: in the foreground at right, women have dug a hole in the ice to wash clothes.

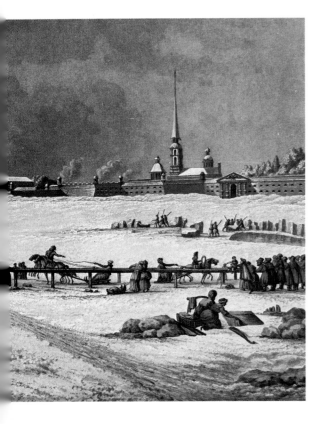

house in St. Petersburg. The nobles grumbled, but they came. Many of them found that construction costs were so high in that frosted boomtown that building a single town house in St. Petersburg cut their fortunes in half.

Peter further boosted St. Petersburg's population simply by declaring it to be Russia's new capital. To keep their jobs, hordes of civil servants and their families had to troop north from Moscow, 350 miles away. Within ten years St. Petersburg grew to a city of nearly thirty-five thousand buildings and some eight thousand birds—imported from Moscow—who sang in a forest of transplanted trees. Peter lavished particular attention on the gardens of St. Petersburg. In the midst of planning a battle, Peter took time off to remind an aide that he wanted a shipment of fragrant blooms sent from the south to St. Petersburg. Thanks to Peter's fascination with mechanical contrivances, the parks and gardens of St. Petersburg were awash with fountains, including some surprise ones. These looked like statues of mushrooms, but if a visitor should step on the wrong stone, he got squirted in the face.

Peter lived simply in his paradise. Unlike his father, Czar Alexei, Peter seldom hosted lavish banquets. He preferred picnics where each guest paid for his own food. He dressed in work clothes or in a soldier's uniform, donning courtly finery only on the most important holidays. Indeed Peter was one of the rare monarchs of the time who seemed honestly to wish little for himself. He did not hunt or gamble. He rode in a plain, two-wheeled carriage and did not mind that the St. Petersburg palace of his chief adviser looked far more regal than anything the czar lived in.

Peter spent his happiest hours at Mon Plaisir, a small, single-story pavilion that stood within view of the sea on the grounds of Peterhof, his retreat outside St. Petersburg. Mon Plaisir was a rude dwelling by the royal standards of the day, but it did offer a convenience unusual in the homes of the mighty. The kitchen was next to the dining room, and Peter's cook could pass the food directly through a window. A guest at Mon Plaisir noted that Peter the Great was probably the only king in Europe who ever got a hot meal.

Peter the Great is the fat cat and his subjects are the music-making mice in this detail from The Mice Bury the Cat, a popular lubok—*a print that Russians made from wooden blocks. Printed after the czar's death, the irreverent lubok above implied minimal mourning for Peter.*

No Russian epic seems complete without a tragedy in the last act. Peter's was played in 1718. The czar's weak-willed son, Alexei, had inherited much of his mother Evdokiya's sentimental piety, but none of his father's interest in such pursuits as warfare, engineering, and science. For this lack of manliness, Peter despised his son. Alexei often fainted when Peter summoned him to his chambers. Once Alexei even shot himself in the hand so that he would have an excuse for not finishing a mathematics assignment Peter had given him. Worst of all, Alexei unwittingly became the rallying point for reactionary boyars and clergymen who detested Peter and his reforms. They looked to Alexei to undo the changes that Peter had wrought in Russia.

In 1716, when Alexei was twenty-six, he fled to Austria to escape his terrifying father. For eighteen months Russian diplomats cajoled and threatened Alexei; but he refused to return home. Finally he consented to go back after Peter sent a letter swearing to receive him lovingly and to let him live in peace. Instead Peter turned Alexei over to the torturers. Peter was in no more danger from his son than he was from his tailor, but the czar had a keen eye for conspiracy and suspected that his son might be involved with conservative plotters.

Under torture Alexei's fragile spirit broke, and he admitted to treason, undoubtedly to save himself further suffering. A special tribunal sentenced the czarevitch to death. But before the sentence could be carried out, Alexei died in his cell from the torture.

Peter outlived Alexei by seven years, his health rapidly deteriorating from venereal disease, heavy drinking, infection, and simple exhaustion. Peter died on the morning of February 8, 1725, praying to God "to receive...this great soul."

The world has never lacked for evaluations of Peter the Great. Some churchmen of Peter's era saw him as the antichrist of the Bible, presaging the end of the world. An English newspaper of the time described Peter as "the greatest Monarch of our Age...whose actions will draw after him a Blaze of Glory, and Astonishment, through the latest Depth of Time." A nameless peasant of Russia, upon hearing of Peter's death, said simply: "There was a Czar. What a Czar!"

WINDOW ON
THE WEST

*Peter, towering over the coat of arms blazoned on this bal-
cony at Peterhof palace, near St. Petersburg, could look
over his gardens—toward the West he admired.*

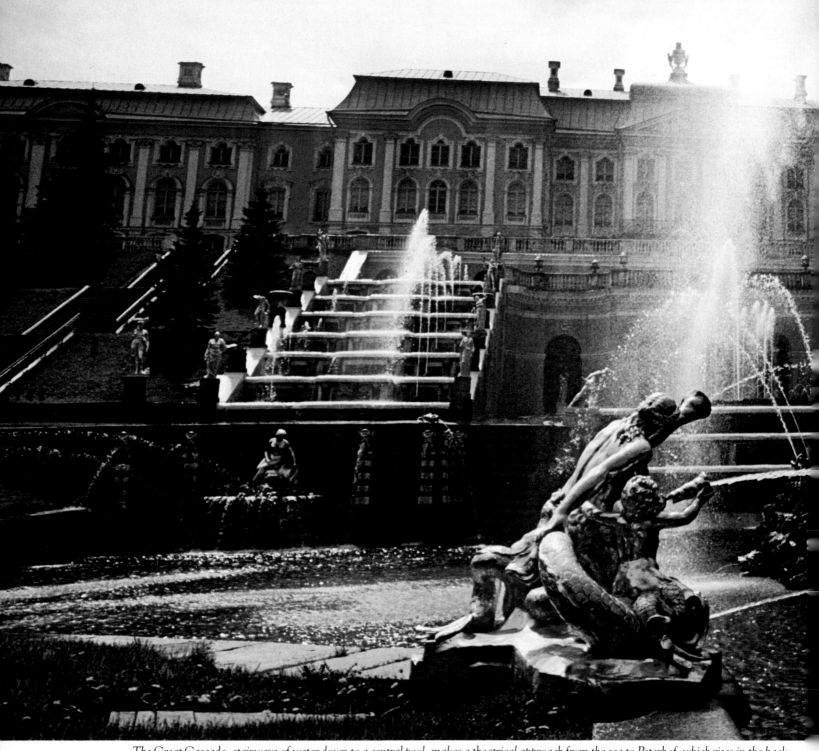

The Great Cascade, stairways of water down to a central pool, makes a theatrical approach from the sea to Peterhof, which rises in the back-

If Peter the Great was to plunge Russia into the modern world, he had to make his country look the part. In 1703 the czar abandoned Moscow, bastion of all he wanted to change, and built St. Petersburg—a new, European-style capital complete with palaces, gardens, and fountains. Nearby, Peter also built what would become his favorite estate, Peterhof. Both were close to his beloved fleet at sea, looking west from the junction of the Neva River and the Gulf of Finland. The most spectacular creations of his reign, the port city and Peterhof signaled to all that the czar and his people had arrived in the eighteenth century.

Though the site Peter chose was impractical —the mouth of the Neva was a frozen marsh overrun with wolves—no hardship stopped him from rolling up his imperial sleeves and getting to work. After whacking down a few trees himself, the czar directed over 150,000 workers to

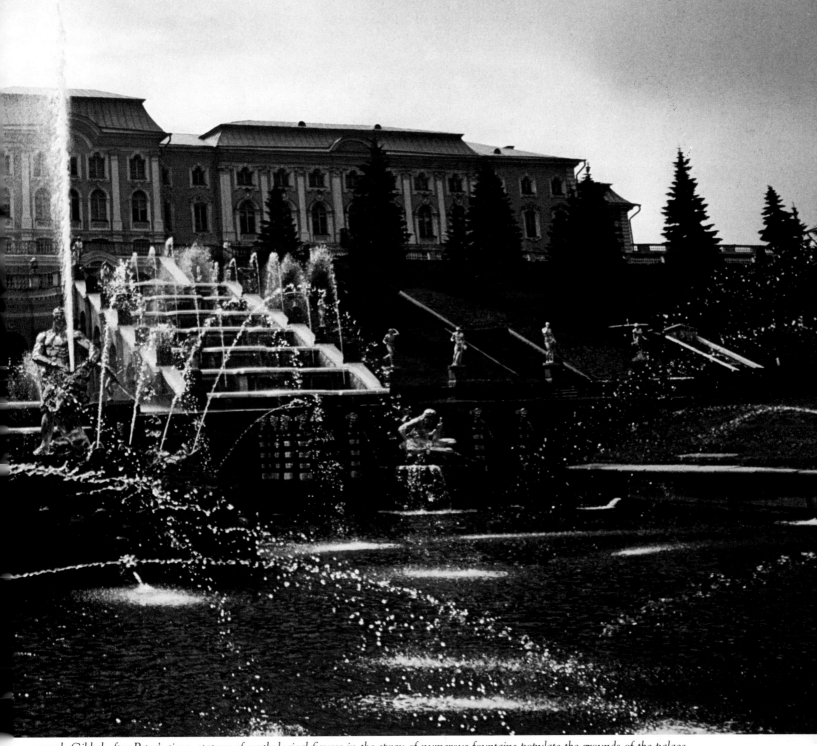

ground. Gilded after Peter's time, statues of mythological figures in the spray of numerous fountains populate the grounds of the palace.

carry out his specifications for buildings and parks. The army of laborers, many of whom were prisoners and conscripted peasants, drained the grounds, dug canals and pools, and raised immense buildings in record time—all the while suffering from cold and hunger. Within seven years Peter had a new capital and an ornate, baroque palace that vied with the kingly residences he had envied in Europe.

Peter took special delight in the complex Peterhof waterworks he designed, which fed fountains so grand and numerous as to overwhelm the palace there. Jets of water playing around statues of mythological heroes thrilled the czar. But Peterhof was much more than a czar's pleasure palace: for Peter and his successors, many of whom made elaborate additions to his handiwork, this audacious edifice and its dreamlike grounds opened Russia, strategically and symbolically, to the West.

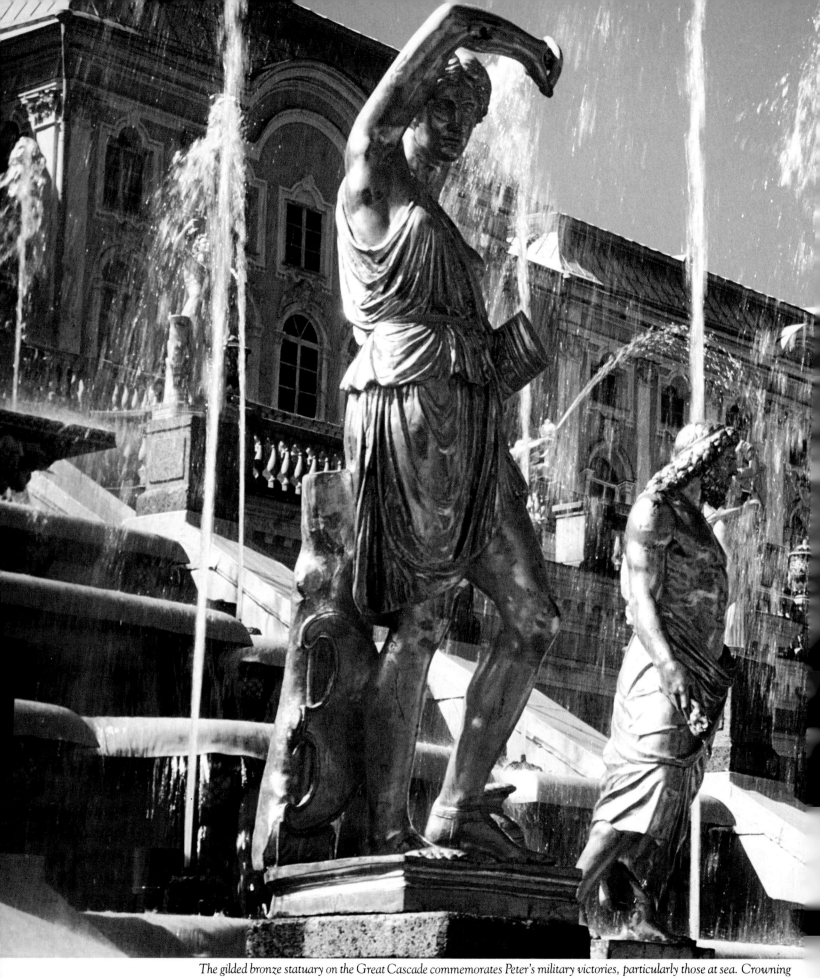

The gilded bronze statuary on the Great Cascade commemorates Peter's military victories, particularly those at sea. Crowning

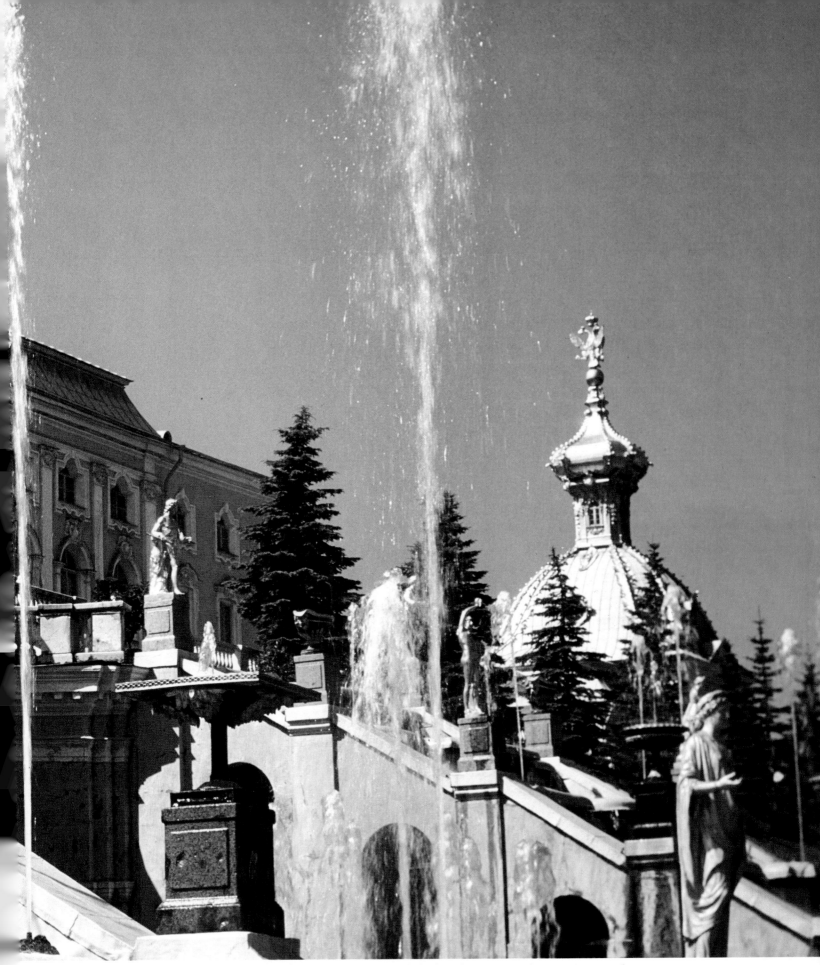

the pavilion at right above is the imperial double-headed eagle that Peter set high above his country's glittering new capital.

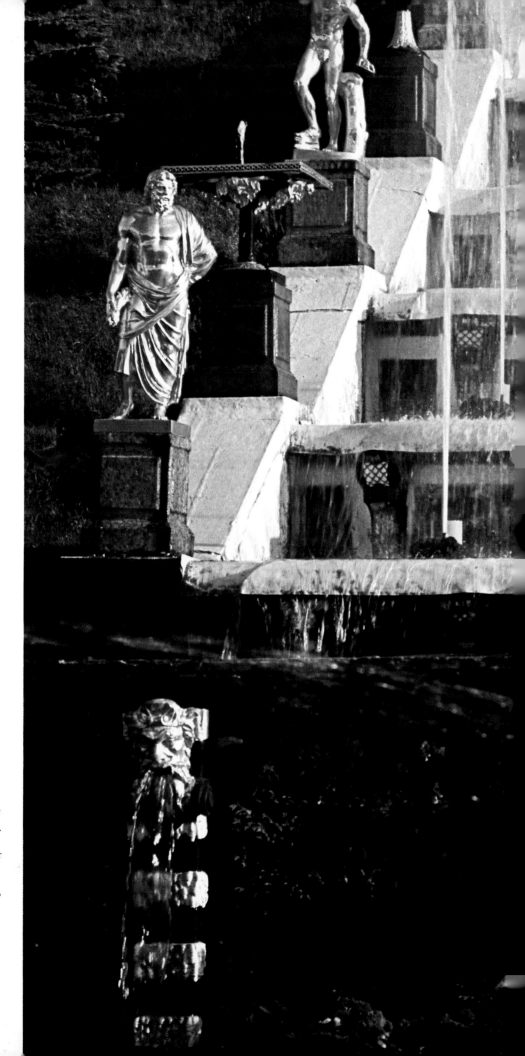

A golden, goddesslike figure crouches beneath one of the twin stairways of Peterhof's Great Cascade. As the centerpiece of Neva Fountain, the statue personifies the river, which flows into the strategic Gulf of Finland. English, Dutch, and Russian sculptors made lead and bronze statues, both kinds gilded, for the palace's waterworks.

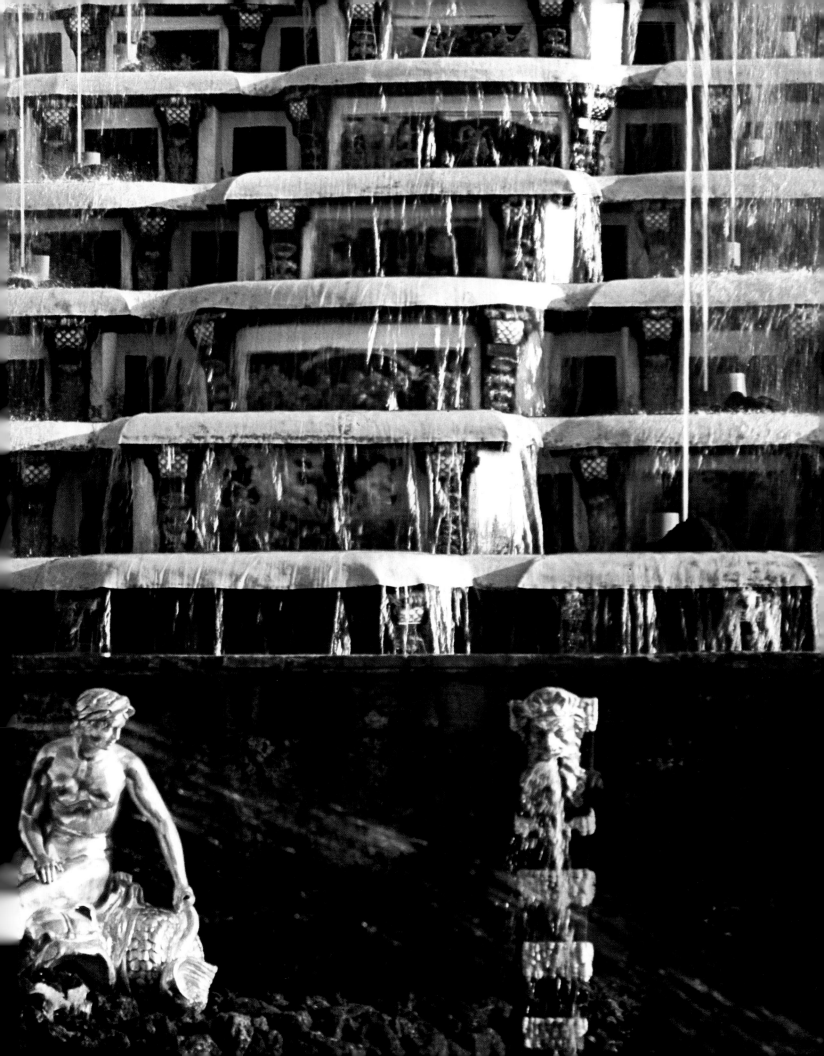

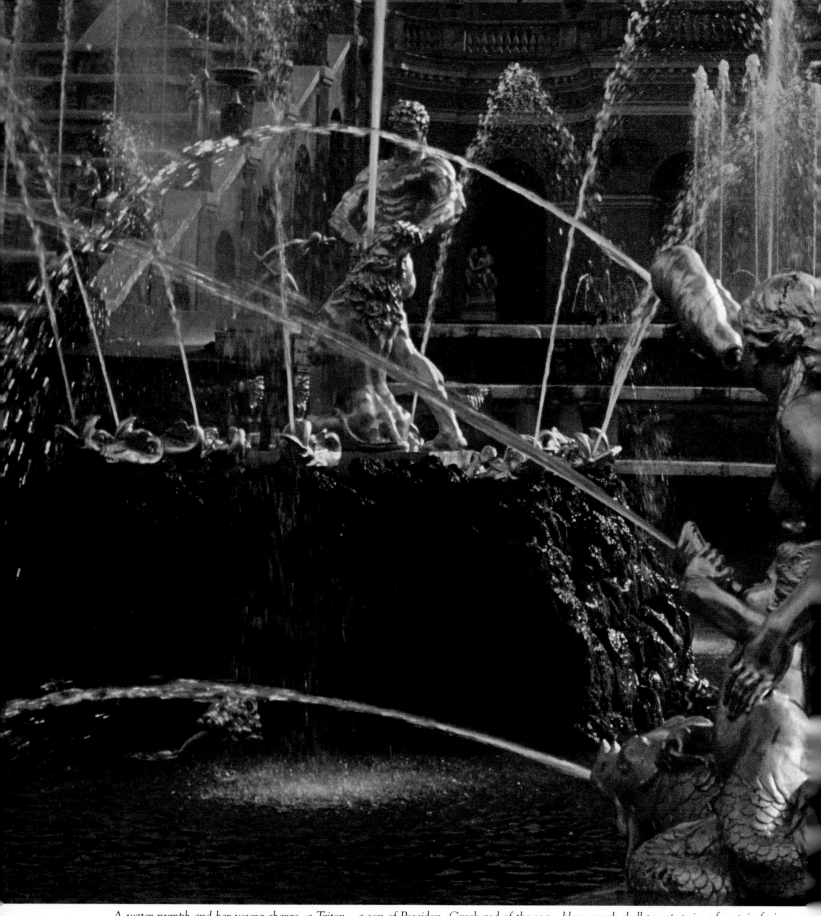

A water nymph and her young charge, a Triton—a son of Poseidon, Greek god of the sea—blow conch shell trumpets in a fountain facing

Peterhof. The water spraying from the shells—and from the mouth of the sea monster the Triton rides—may have reminded the czar of the sea.

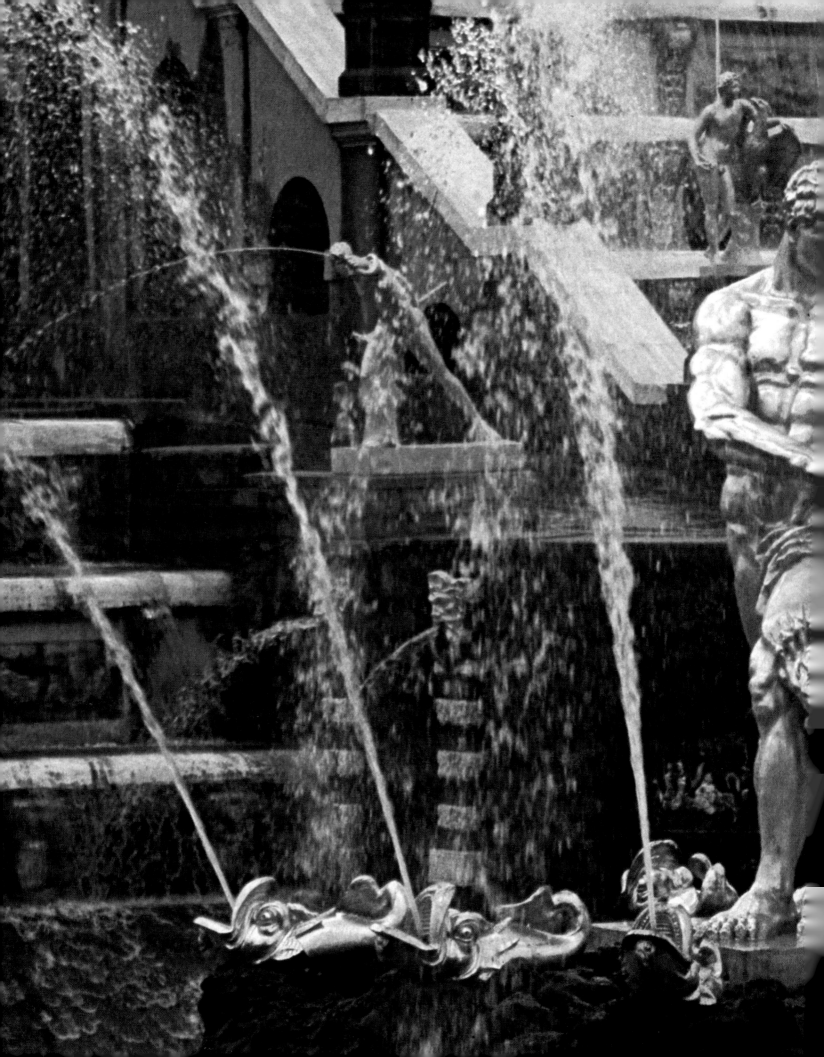

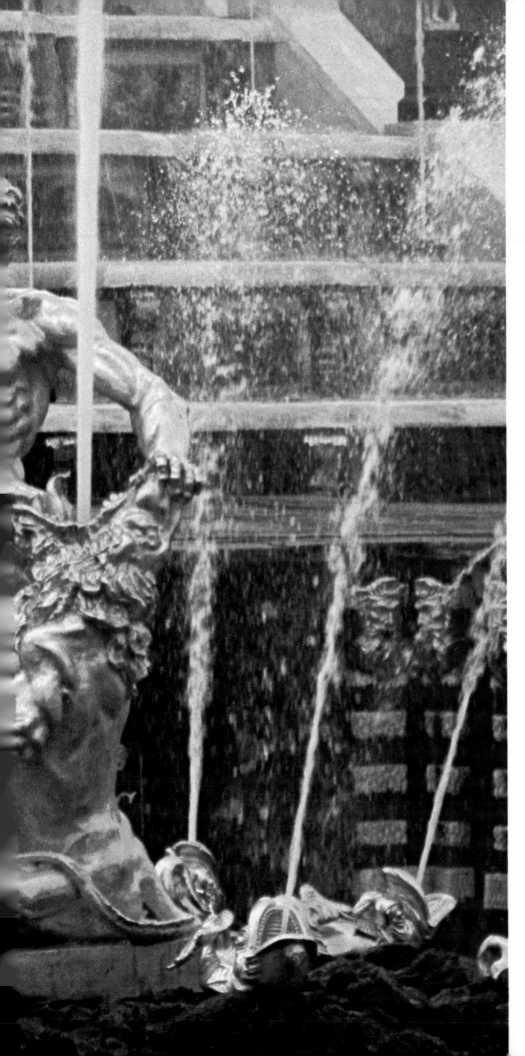

Spouting dolphins circle the biblical hero Samson in this fountain that is dedicated to the might of Peter. The curly haired giant strong-arms a roaring lion in this largest and most powerful fountain at Peterhof: the lion shoots water nearly seventy feet into the air. The Russians thought of Peter the Great as their Samson, an apt analogy after the czar wrested control of all the Baltic from the Swedes in 1709.

OVERLEAF: From Peterhof palace, over the heads of statues and sprays of fountains, Peter the Great looked west—toward the world of culture and progress that he wanted to bring to Russia. The architects who built the entrance to the sea harbor and the Samson, or Great, Canal leading to it, worked with plans that Czar Peter himself had drawn.

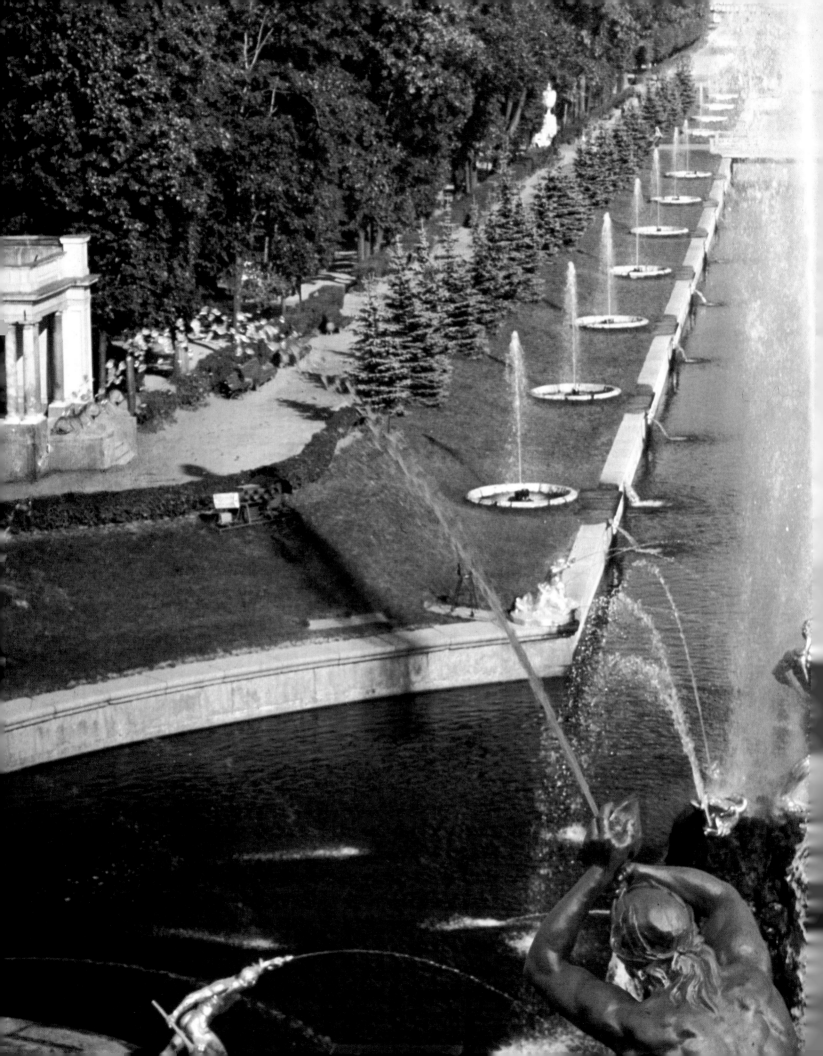

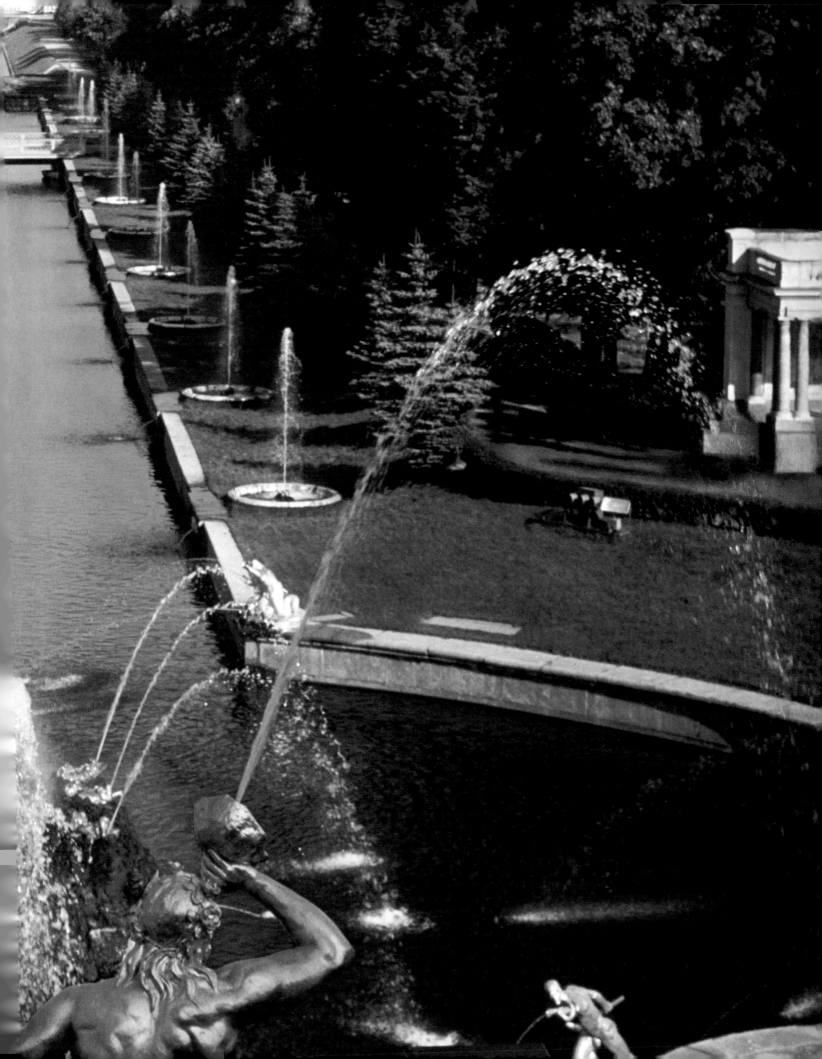

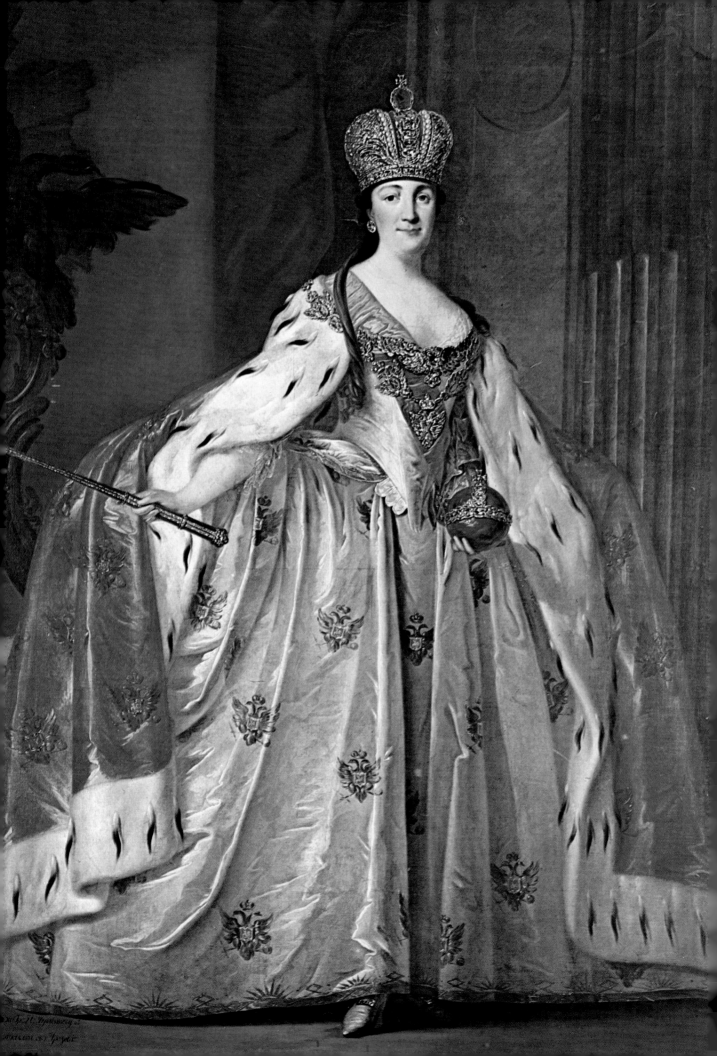

IV

CATHERINE THE GREAT

MADAME QUICK WIT

Domestic tragedy had always been a primary motif of the house of Romanov, but during the first half of the eighteenth century, the family's despair reached operatic proportions. In the fifteen years following the death of Peter the Great, in 1725, the throne was occupied by four supremely unlucky sovereigns. Peter's widow, Catherine I, survived her husband for only two years before she succumbed to the effects of venereal disease and alcoholism. Czar Peter II, son of the murdered Alexei, died of smallpox while still in his teens. Empress Anne, daughter of Ivan V, ruled for a decade before dying most painfully from a kidney ulcer. And Ivan VI, another descendant of Ivan V's, who was proclaimed czar at the age of two months, was deposed at the age of fifteen months. His only offense was to be holder of the crown when someone more powerful than he had use for it—Peter the Great's daughter Elizabeth.

Elizabeth was the only one of Peter the Great's children to have any starch. She engineered a coup in which St. Petersburg's guardsmen carried her through the snowy streets of the city to the Winter

Hair falling over one shoulder, Catherine II of Russia poses in the robes and crown of the empire she seized from her husband, Peter III, in 1762.

Palace, where they proclaimed her empress. Elizabeth ruled for twenty years. She was an energetic and wise sovereign, but she is remembered mainly for bringing Russia one of the land's most brilliant, audacious, and fiery autocrats, Catherine II the Great.

Elizabeth had neglected her duties in one important way—she never produced an heir. She faced up to the problem of the succession by naming her nephew as the heir—he would reign as Czar Peter III—and by scouring the courts of Europe for a suitable wife for the young man. After examining the various candidates, Elizabeth decided upon a German princess from the small realm of Anhalt-Zerbst. She was called Sophia, but she used Catherine, the name she was christened upon entering the Russian Church.

The match could not have been a worse one. Peter was a true degenerate—ugly, cruel, and oafish. In contrast the sixteen-year-old Catherine was pretty, bright, and well educated. She endeared herself to the court by becoming thoroughly Russian. She learned to speak the language, if always with a slightly comic German accent, and embraced the Russian Orthodox faith. She also fulfilled her most desired function by giving birth to a male heir—though the father was probably not Czar Peter, who most likely was impotent, but one of Catherine's lovers.

Indeed in all matters Catherine outshone her pathetic husband. Her wit, her keen intelligence, her eagerness to accept Russian life all made her popular at Peter's expense. After Elizabeth died, in 1762, Peter hatched an ill-conceived plot to banish his strong-willed wife, whom he called Madame Quick Wit. But in a power struggle between the two, Peter was badly overmatched. "I must reign or perish," Catherine declared, and she organized a counterstroke. Aided by palace troops bound to her by ties of genuine affection, Catherine rode into St. Petersburg dressed in the uniform of an officer of the guards and was declared empress. Peter saw no point in resisting and, as one European leader put it, "allowed himself to be overthrown as a child is sent to bed." He abdicated and went, under guard, to his country estate. A few days later he was beaten to death under mysterious circumstances, and Catherine announced with a

Sumptuously clad and raised on a dais, Catherine accepts the adulation of church elders and other attendants at her coronation in the Kremlin's Cathedral of the Assumption. After the ceremony the empress further inspired her subjects by handing out money and granting amnesties to prisoners.

straight face that Peter had died from natural causes.

Catherine understood that as a German usurper she stood on slippery ground. With the genius for public relations that was to mark much of her rule, Catherine moved to burnish her image as a true Muscovite. She planned her coronation to be a spectacle dear to the Russian heart. She set out from St. Petersburg to the old capital of Moscow in an enormous procession that required nineteen thousand horses. Along the way Catherine ordered that 600,000 silver coins be tossed to the crowds that lined the road. For her coronation, in September 1762, she dressed in a gown of golden silk with imperial double eagles embroidered on her skirt. Over this she wore an ermine mantle crafted from four thousand pelts. She marched solemnly to the Cathedral of the Assumption, where fifty-five clergymen were waiting to do her honor. With a bold gesture Catherine placed the crown on her head herself.

The crown was another of those masterworks of regalia for which the Russians were famous. Catherine had given the court jewelsmith Jérémie Posier free access to the Romanov treasure-house. Posier wrote in his memoirs, "I picked out the biggest stones, diamonds as well as colored gems...and I thus obtained the richest object that ever existed in Europe." The crown was indeed a stunning affair, concocted of some 5,000 diamonds weighing 3,000 carats, numerous pearls, and a 415-carat ruby Czar Alexei had purchased from a Chinese emperor almost a century before. In spite of Posier's best efforts at lightness, the crown weighed five pounds. By the time of the fireworks display that evening, the woman from Anhalt-Zerbst seemed the most regal, the most Russian of monarchs.

Catherine came to the throne ablaze with energy and ideas for remaking Russia. Like Peter the Great six decades before her, Catherine expressed her imperial visions through monumental building projects. She presided over the rebuilding of St. Petersburg and Moscow and laid down plans for either the renovation or creation of 416 other cities and towns. Forsaking the ornate Russian style of architecture, Catherine imported foreign architects who built in the imposing neoclassical mode that was then popular in

In this nineteenth-century engraving, three Cossacks, armed with lances and sabers, prepare to enter battle on their fiery mounts.

RUSSIA'S PEASANT WARRIORS

Among the Russian peoples, the Cossacks were unique. Made up of adventurers, draft dodgers, runaway serfs, and other fugitives, they settled in the remote forests and steppes, where they formed independent communes. In the fifteenth century the Cossacks had established themselves as expert horsemen and guerrilla fighters when they fended off attacks by the fierce nomads called Tatars. The name Cossack derives from *kazak*, probably the Tatar word for "frontiersman."

A succession of czars had employed Cossack troops for such critical tasks as patrolling borders and opening the rich eastern wilderness—the region of Siberia. But while some

Cossacks ornamented the crown, others were thorns in the czar's side. Cossack bandits preyed on peaceable subjects, czarist enemies found sanctuary in Cossack villages, and pretenders to the throne found Cossack partisans. Most disturbing was a series of bloody peasant rebellions in which Cossacks participated. In 1773 the Cossack chief Emelyan Pugachev led the greatest of these uprisings against Catherine the Great, devastating eastern Russia before her army prevailed. The cataclysm encouraged Catherine to effect more control over the restless Cossacks and to tighten the bonds of serfdom, leaving an oppressed nation seething with unrest.

Europe. Catherine's new palaces and official buildings boasted rows of classical-style columns that evoked the glories of ancient Rome and Greece. She transformed St. Petersburg from the cozy port city of Peter the Great into a massive capital city of granite. In a letter she admitted that she suffered from a "mania for building. . . it is a disease like drunkenness."

Alongside St. Petersburg's cold and drafty Winter Palace, Catherine built her own personal retreat. This residence—a gracious palace she referred to as the Hermitage, from the French word meaning "place of seclusion"—was constructed partly to house an ever-growing collection of paintings. Before long even more edifices had to be added to accommodate her buying mania. Catherine was not particularly interested in the aesthetics of art, but she was supremely interested in national prestige. Since European courts were increasingly being judged by the quality of the art they possessed, Catherine was determined that Russia would have the best. The empress went on an art-buying spree, instructing her ambassadors to be on the lookout for bargains.

Soon she was buying entire lots for shipment to St. Petersburg. For example, one purchase consisted of nine paintings by the Dutch master Rembrandt van Rijn and six works by another great Dutchman, Sir Anthony Van Dyck. In 1778 she bought an immense collection amassed by the Englishman Sir Robert Walpole, carrying it off in the face of angry objections raised in Britain about national treasures being allowed to leave the country. Like so many of Catherine's accomplishments, her art collection was put together on an epic scale. Beginning with a dozen or so pieces, the imperial collection grew to almost four thousand paintings.

Catherine's art collecting and building projects produced the desired effect—she convinced refined western Europeans that Russia was a cultivated place, worthy of honor among the family of civilized nations. She made of St. Petersburg a showplace that foreign visitors compared to Paris. Nowhere did society glitter, quite literally, as it did in St. Petersburg. The British ambassador attended a banquet where diamonds were served with dessert and remarked,

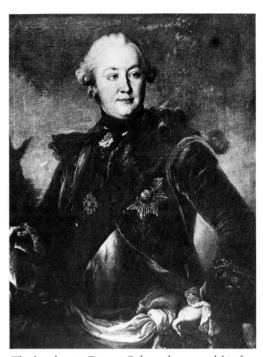

The handsome Grigori Orlov, above, and his four brothers led a faction of the Russian army that Catherine used to dethrone Peter III. Orlov was also Catherine's lover—one of the at least twenty she had. When she grew tired of him ten years later, he fell into depression and madness.

TEXT CONTINUED ON PAGE 110

A profile of herself, showing the long chin that some considered unlovely, is carved in this square-cut emerald that Catherine presented to her lover Grigori Orlov. The stone of almost twenty carats is set in diamonds.

GIFTS GIVEN AND RECEIVED

Catherine II was born to aristocratic parents of embarrassingly modest means. Growing up in Germany she knew few luxuries, and when, at fifteen, she was summoned to the court of Russia, her father sent her off with only three everyday dresses to meet the empress Elizabeth, her future aunt-in-law. Through inherent shrewdness Catherine herself became empress eighteen years later, and the once ill-provided girl surrounded herself with luxury.

Court society in the Russian capital of St. Petersburg initially mistrusted Catherine's foreignness. To win its confidence she adopted the Russian language and religion and learned to intrigue, politically and romantically, in the best local style. She observed, too, that Russian aristocrats made far more voluptuous use of their wealth than did their German counterparts. For example, her mentor Elizabeth owned thousands of gowns, many of them never worn.

Catherine quickly learned to copy Elizabeth's extravagance, most noticeably in presenting an array of fabulous jewels and jeweled objects, such as the two pieces at left. She combined generosity with keen political purpose, for she spread such treasures among lovers, correspondents, and political allies—who were often one and the same. The recipients of these favors often returned them in kind. However, as befitted this iron-willed empress, one of the finest gifts she received—the horse trappings overleaf—was not given out of love, but as tribute from a ruler she vanquished in war.

Grigori Orlov's brother Alexei received this gold snuffbox with a bejeweled mount from a grateful Catherine. Its enamels commemorate a Russian naval victory over the Turks led by Alexei in 1770.

In the vain hope of reviving their affair after it had faded, Orlov gave Catherine the diamond opposite— the fourth largest in the world. Weighing 193 carats, the great stone is mounted on her imperial scepter amid lesser, yellow brilliants.

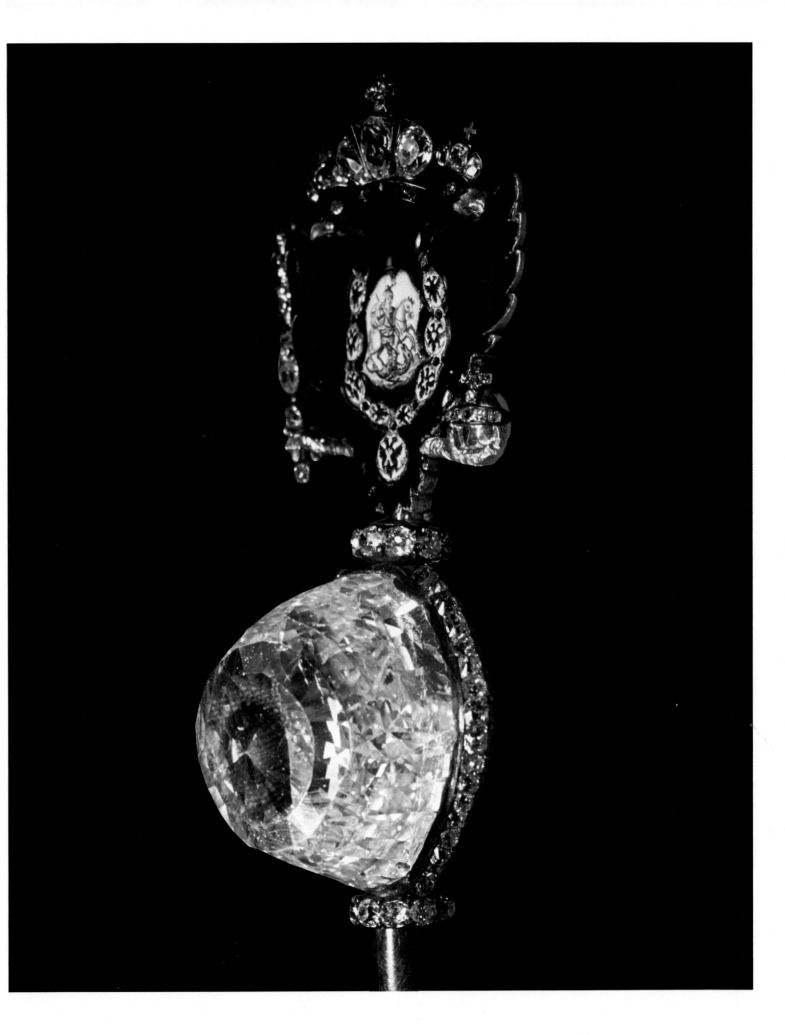

Turkish crescents, enameled leaves and flowers, and a glowing pink stone decorate a gold plaque sprinkled with white gems—part of an ornate horse harness presented to Catherine in 1775 by Sultan Abd al-Hamid I of the Ottoman Empire. The two had just made a treaty concluding the first Russo-Turkish war.

The bouquet of diamonds set off by one huge topaz, opposite, was attached by its pin and chain to the forehead band of a horse's bridle. It crowns the suit of gear, which also included silver horseshoes and nails, that Abd al-Hamid I gave Catherine.

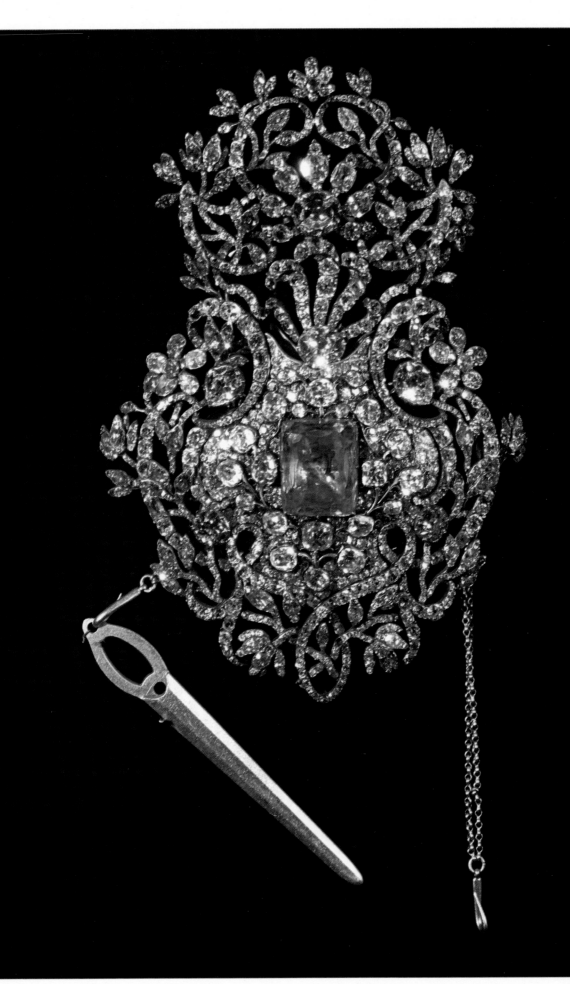

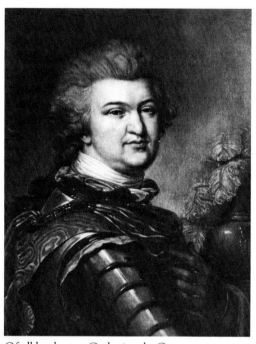

Of all her lovers, Catherine the Great was most passionately and enduringly attached to Grigori Potëmkin, above, a Ukranian giant ten years her junior. Catherine made the charismatic Potëmkin a prince and her chief counselor on state matters.

TEXT CONTINUED FROM PAGE 105

"It surpasses everything that can be conceived." Foreign envoys, accustomed to opulence at state functions, were equally stunned by the Russians' splendor. "Many of the nobility were almost covered with diamonds," one observer noted. "Their buttons, buckles, hilts of swords, and epaulets were composed of [diamonds]; their hats were frequently embroidered. . . with several rows of them; and a diamond star upon the coat was scarcely a distinction."

The diplomatic dispatches of envoys in Russia, aside from containing descriptions of the glitter and gaiety of the St. Petersburg court, also spread delicious gossip about Catherine's many sexual exploits. Depending on who was counting, and almost everyone did, the empress conducted at least twenty love affairs. Catherine did little to quiet the scandal. "My heart," she admitted, "cannot rest content, even for an hour, without love." These affairs, which ranged from brief flings with handsome guardsmen to romances lasting years, produced a number of illegitimate children. Three of them she bore to Count Grigori Orlov, a striking officer of the guards who made himself so much at home in the palace that an envoy noted, "He lacks nothing but the title of Emperor." Catherine and Grigori slathered each other in love and luxury. Catherine gave him a small portrait of herself set in diamonds, which he wore over his heart, as well as more substantial tokens—several palaces and estates with six thousand serfs. Orlov in turn once presented her with the most spectacular bauble any man has ever given a woman: the 193-carat Orlov Diamond, which according to legend had been stolen by a French soldier from the eye of an Indian idol.

But the great love of Catherine's life was Grigori Potëmkin, a soldier, politician, poet, lover, builder, artist, administrator, and debauchee, all of a heroic scale. He would often receive envoys in a fur robe and slippers and run his fingers through a pile of unpolished gems while an aide read to him from ancient Greek literature. Potëmkin had an appreciation for the splendid gesture. When a lady at a dinner party soiled her evening slippers, he sent a hussar—a cavalryman—on a fast horse to Paris to get her another pair.

Potëmkin once hosted a famous party at which magnificent enter-

tainments were lavished on an intimate group of only twenty-four couples. The guests danced to an orchestra of three hundred musicians, then repaired to Potëmkin's private theater, where his company of actors and dancers performed. Potëmkin's crowning touch was the announcement that dinner was ready: the guests were called to the dining room by a Persian servant who appeared riding on top of a mechanical elephant encrusted with emeralds and rubies.

Potëmkin's services to the crown went far beyond romance and hosting parties. He was a canny statesman who guided Catherine's policy of enlarging Russia's territories. And Catherine was a vigorous expansionist. Twice she warred against Turkey to acquire land in the south, and in 1793 she annexed the Ukraine from Poland. Then in 1795, Russia, Austria, and Prussia wiped Poland off the map: each nation seized a portion of Polish territory, with Catherine taking the lion's share. All together Catherine added over 200,000 square miles of land to Russia during her reign.

Catherine's imperial star shone most brightly in January 1787, when she journeyed south with an entourage of European diplomats and dignitaries to visit the Crimea, which she had seized from Turkey on Potëmkin's advice. Potëmkin had taken charge of colonizing the Crimea with Russians and organized the grandest of grand tours to show off the empress's new land. A gala caravan of almost two hundred sledges proceeded south from St. Petersburg. At the Dnieper River the party boarded a flotilla of boats designed to look like ancient Roman barges, each equipped with its own orchestra. Along the way the party passed new towns that Potëmkin had built and others that were mere stage sets, erected far enough away so that the guests could not tell they were fakes. Potëmkin's ruse gave rise to the phrase "Potëmkin village"—meaning a magnificent hoax.

Catherine enhanced Russia's prestige in Europe not only through conquests and ostentation, but also by cultivating European intellectuals. European thinkers of the eighteenth century brought about the so-called Age of the Enlightenment. They advocated a rational, humanistic view of the world rather than a religious outlook and backed politically liberal causes. Catherine carefully read the con-

Ragged Crimean peasants peer around the corner of a log cabin at a neatly arrayed peasant family whom Catherine inspects from her coach. The empress toured the recently annexed Crimea in 1787. Potëmkin, whom she had appointed governor of the region, contrived such charming but artificial scenes to persuade her that the region was prospering.

AN IMPERIAL STRIDE!

Russia

Constantinople.

In a contemporary English cartoon poking fun at her imperialist bent, Catherine leaps over a crowd of other European monarchs to get from a rock labeled "Russia" (at left) to the city of Constantinople. Catherine and Potëmkin dreamed of driving the Ottoman Turks from Constantinople and making it the capital of a new, Christian empire.

troversial works of the leading Enlightenment figures, such as the renowned French philosophers Voltaire and Montesquieu. Voltaire, with whom she corresponded until his death in 1778, dubbed Catherine "the Great" and became her champion among the European intelligentsia. He even defended her for the murder of Peter III, which he dismissed as "some bagatelle about her husband."

Catherine, however, proved a disappointment to the liberal philosophers of the Continent, who looked to her to become the model ruler for the Age of the Enlightenment and relieve the plight of the Russian serfs. When she was young Catherine expressed political opinions that would have landed her in one of her own jails had she not been the empress, and she once drew up a proposed legal code so liberal that France's Louis XV banned its publication. But Catherine relied heavily on the support of Russian aristocrats to retain her power. Whenever she felt her prestige being threatened, her response was to grant ever more oppressive powers to the landlords.

When the decades of Enlightenment philosophizing and political agitating culminated in the French Revolution of 1789, Catherine was horror struck. Liberal theorizing was one thing, but the overthrow and execution of the French king was quite another. Catherine banished the bust of her beloved Voltaire to the lumber room, and her final days were darkened by fears of the spreading contagion of revolution. Like many other great monarchs with long reigns, Catherine was beginning to outlive her times.

Much against her iron will, the lusty queen grew old. Her teeth were gone, and—grown fat with age—she often had to be pushed around the palace in a wheelchair. Catherine suffered a massive stroke on November 6, 1796 and died thirty-six hours later.

In a typical display of forethought and organization, Catherine had written her own epitaph, which was found among her papers after she died. Like many of Catherine's proclamations, it was somewhat self-serving, but doubtless an accurate reflection of what the empress felt about herself and how she wished to be remembered: "She forgave easily, and hated no one. Tolerant and undemanding, of a gay disposition, she had a republican spirit and a kind heart."

CANVAS
BY THE YARD

A *prized purchase of Catherine's,* The Return of the Prodigal Son—*by the Dutch master Rembrandt van Rijn*—*hangs in the Hermitage, her phenomenal art gallery.*

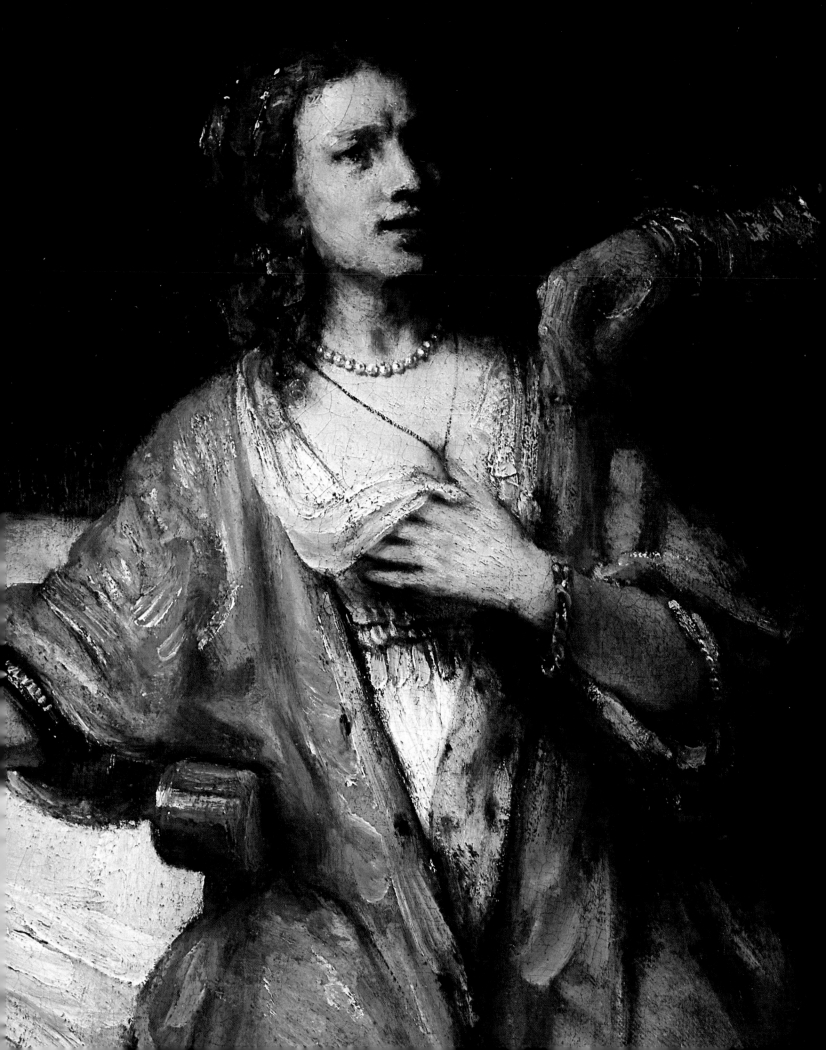

Out of affection for her adopted land and the desire for self-glorification, Catherine II became, in her own word, one of the most "gluttonous" art collectors of her time. The paintings here and on the following pages are but a part of the vast collection of artworks she brought to Russia during her thirty-four-year reign.

Catherine gained Russia's throne at a moment when art collecting, formerly exclusive to princes and pontiffs, had spread to the monied middle class as well. Competition for fine art became fierce, prices soared, and a new kind of connoisseur—the art critic—came to dictate collecting trends. Undaunted by her ignorance, Catherine plunged into the tumultuous market and began buying not just single artworks, but often whole lots of splendid paintings.

In 1763, one year after her coronation, she purchased from a German merchant 225 canvases that included the brilliant works here by four European masters. The lot had been destined for Frederick II of Prussia, but Catherine's bid secured it. Boldness and good fortune, which had served her in making this first major art purchase, were to serve her again and again as her appetite for pictures increased.

PORTRAIT OF AN OLD MAN,
Anthony Van Dyck

PORTRAIT OF A YOUNG MAN HOLDING A GLOVE, Frans Hals

JOSEPH ACCUSED BY POTIPHAR'S WIFE,
Rembrandt

THE LOAFERS, Jan Steen

OVERLEAF: *In a detail from* The Loafers, *directly above, a dozing woman and her companion with his clay pipe enact one of the scenes of everyday life that were the Dutch painter Jan Steen's speciality. Steen's attention to detail, which made him so popular, undoubtedly appealed to Catherine, who sometimes rejected paintings for lack of verisimilitude.*

For generations worldly western Europeans had sneered at Russia's barbaric provincialism. The hope of discrediting them doubtless spurred Catherine's interest in fashionable western European paintings. Of the many objects she acquired abroad, these obsessed her like no others. She pored over painting catalogs and, from her St. Petersburg palace, cultivated a network of art world intelligence. The French and German savants with whom she corresponded, as well as Russian ambassadors, travelers, and friends throughout Europe, were to alert her to impending sales and act as her agents. High prices, she let them know, were not a deterrent.

One of her scouts, Prince Beloselsky, learned that a group of pictures owned by the deceased count Heinrich von Brühl was available. A trusted minister to the king of Poland and Saxony, von Brühl was also, some claimed, practiced at fraud. When he was put in charge of acquiring pictures for the king's museum in Dresden—then part of Saxony—he reputedly picked up a number of masterpieces for himself. Without verifying that rumor, Catherine told Beloselsky to offer an extravagant sum for the group. It was accepted, and she received these luminous Antoine Watteau and Philips Wouwerman canvases and this heroic Peter Paul Rubens, along with other Dutch and Flemish works and several thousand drawings.

In the same year—1769—Catherine's architect completed his plans for a building to house the collection. She called this the Hermitage, or "place of seclusion," for she would happily spend solitary times there, amid her increasing treasure of oil-colored wood and canvas.

THE EMBARRASSING PROPOSAL, Antoine Watteau

A VIEW NEAR HAARLEM, Philips Wouwerman

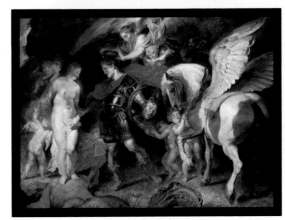

PERSEUS AND ANDROMEDA, Peter Paul Rubens

OVERLEAF: *In this detail from Rubens' mythological painting* Perseus and Andromeda, *above, the Greek adventurer Perseus takes the arm of the Ethiopian princess Andromeda, whom he has rescued from a sea monster. The head of another monster, the dreaded Medusa, is fixed to Perseus' shield.*

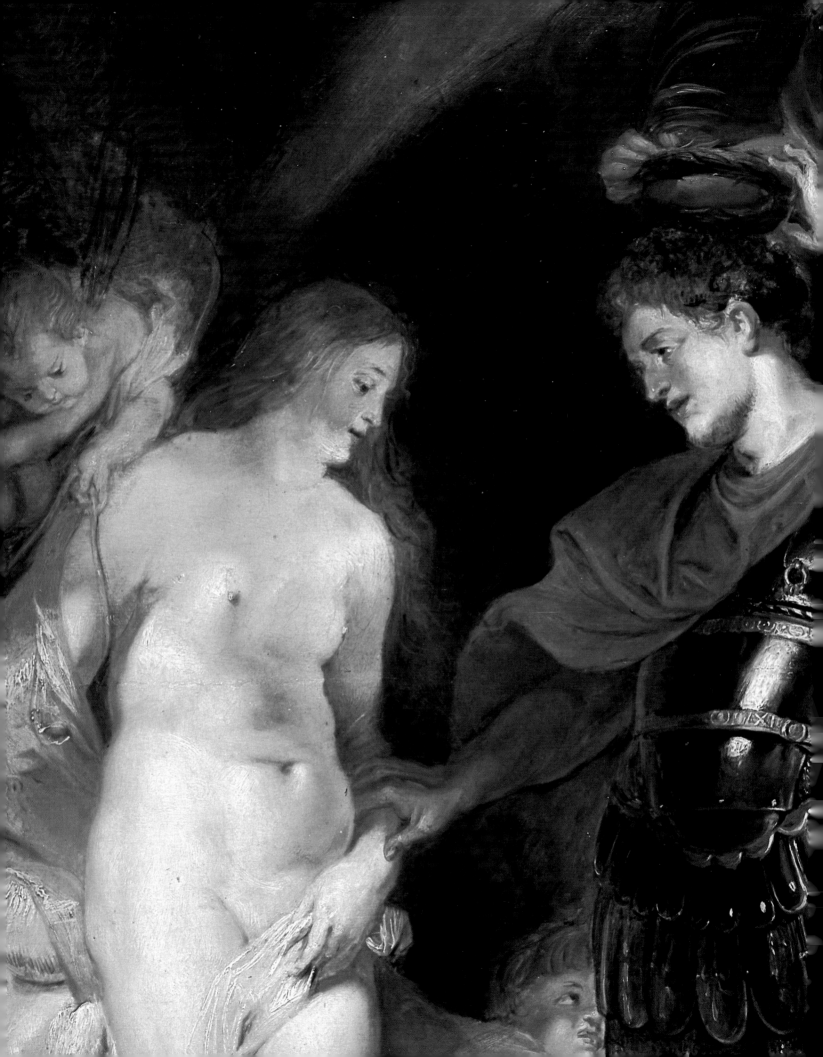

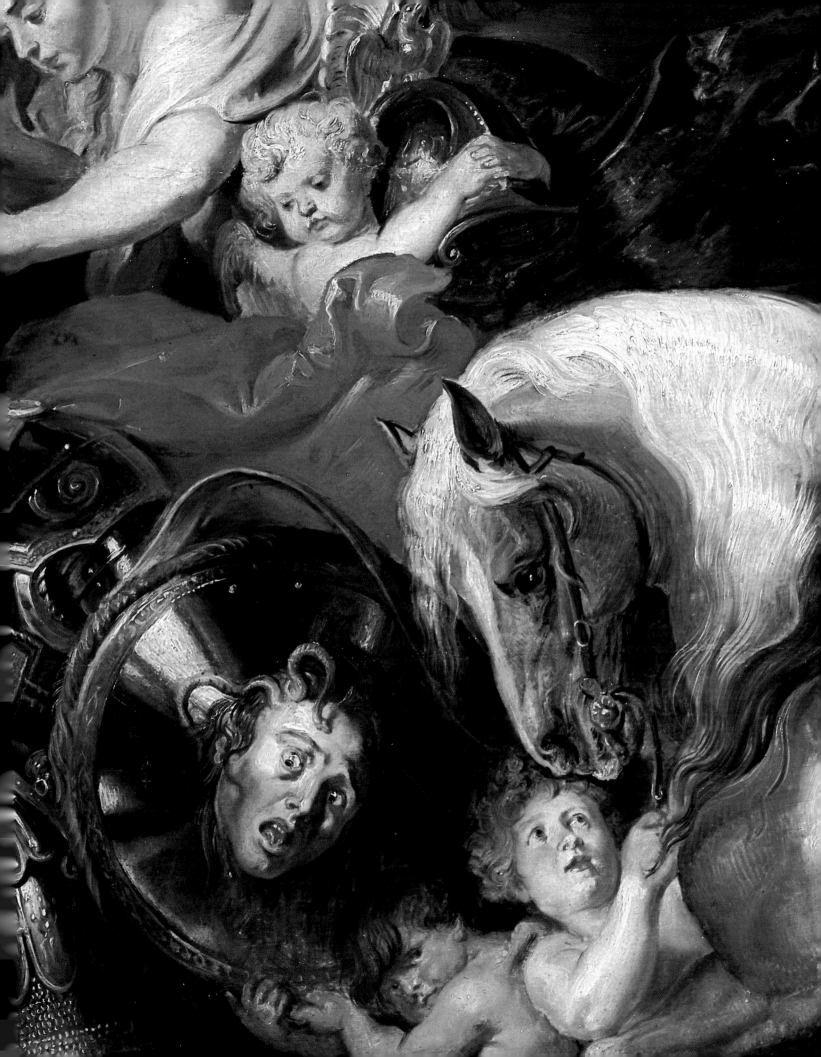

POPE INNOCENT X, Diego Velazquez

PORTRAIT OF AN OFFICER, Frans Hals

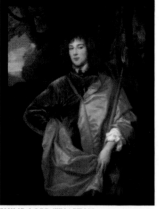

PHILIP, LORD WHARTON,
Anthony Van Dyck

MORNING IN THE HARBOR, Claude Lorrain

THE CARTERS, Peter Paul Rubens

PORTRAIT OF A YOUNG MAN, Frans Hals

ELIZABETH AND PHILADELPHIA
WHARTON, Anthony Van Dyck

Throughout the 1770s and 1780s, the empress of Russia remained a force in the European art market: an excitement as well as a threat. Though she grew ever more argumentative about quality and cost, Catherine was still willing to pay premium fees for what she wanted. Wherever her agents turned up, prices climbed, but still she managed to carry away important works from under the noses of rival collectors. Such a one was Horace Walpole, the English man of letters, who went to Paris in 1771 in pursuit of a famous French colletion of pictures—several of which are shown on pages 124–127—only to discover that Catherine had claimed them all.

About six years later Walpole sustained a harder blow. The portraits by Sir Anthony Van Dyck, the paintings by Diego Velazquez, Claude Lorrain, Frans Hals, and Rubens here, and other pieces in the Walpole family's beloved collection, were sold to Catherine by Walpole's lunatic nephew. Though Catherine paid a huge sum, she got a bargain. Some canvases, such as the Velazquez at left, went for a fraction of their probable market value.

Like all Catherine's biggest transactions, the Walpole sale was made by clandestine arrangement, not public auction. The public, however, shared the elder Walpole's despair. Parliament, the British legislative body, had considered buying the pictures for the nation, and the press called its failure to do so an act of "barbarism." Catherine may have smiled on hearing this charge—one so often leveled against Russia—made elsewhere for a change.

Detail from *ELIZABETH AND PHILADELPHIA WHARTON*

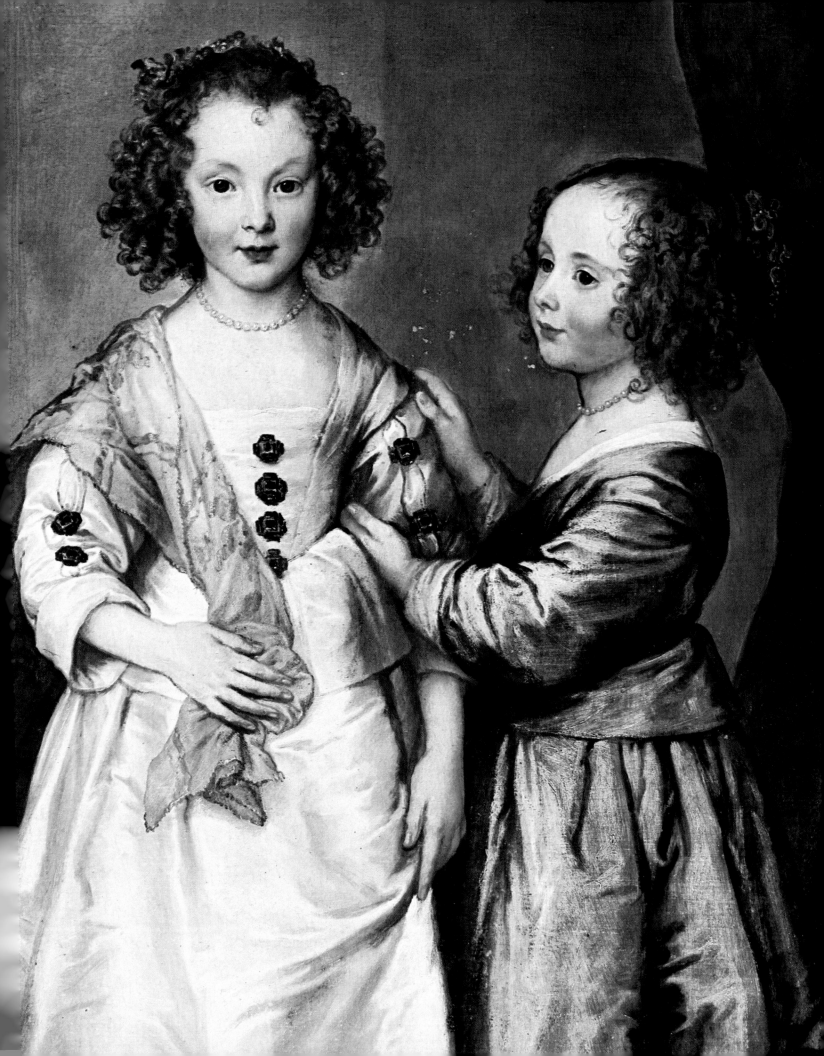

THE HOLY FAMILY, Raphael

PORTRAIT OF AN ACTOR, Domenico Fetti

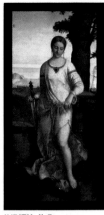

JUDITH, Il Giorgione

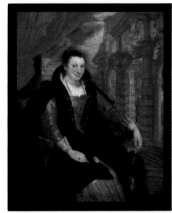

ISABELLA BRANT, Anthony Van Dyck

THE BIRTH OF VENUS, Nicolas Poussin

GIRLHOOD OF THE VIRGIN, Guido Reni

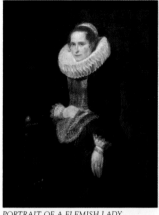

PORTRAIT OF A FLEMISH LADY,
Anthony Van Dyck

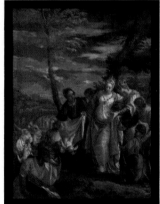

THE FINDING OF MOSES, Paolo Veronese

DANAË, Rembrandt

One of Catherine's canniest art advisers was Denis Diderot, the politic French writer and philosopher, who had wide acquaintance among France's art collectors and congnoscenti. Catherine had purchased Diderot's voluminous library at a time when he needed cash. She also offered him an annual stipend, and the grateful Diderot set himself to anticipating each imperial whim. He found her other books, a cut-rate sculptor, and opportunities for art investment— the greatest being the pictures Pierre Crozat, a wealthy banker, had left at his death in 1740. The selection shown here—five pictures by the Italian painters Raphael, Domenico Fetti, Il Giorgione, Guido Reni, and Paolo Veronese, three by the Dutchmen Rembrandt and Van Dyck, and one by the French artist Nicolas Poussin—hint at the breadth of Crozat's taste.

In 1771, Diderot closed the deal with Crozat's heirs and instantly raised a protest from his countrymen, who were outraged at the loss of national treasure to Russia. The philosopher and his empress were unrepentant. He remarked that "taste and wisdom are going north"; Catherine sent him a gift of sable furs and continued her cheerful pillage of Europe. When, in 1790, she finally renounced her craze for painting acquisition, the Hermitage gallery contained the largest collection on the continent.

OVERLEAF: *In a detail from Danaë, Rembrandt's version of the Greek legend of Danaë, the picture's namesake rests on cushions, her full body modeled by golden light. Danaë's father, whose face emerges from the background gloom, has imprisoned the maiden to prevent her conceiving a son. According to prophesy her child will murder his grandfather.*

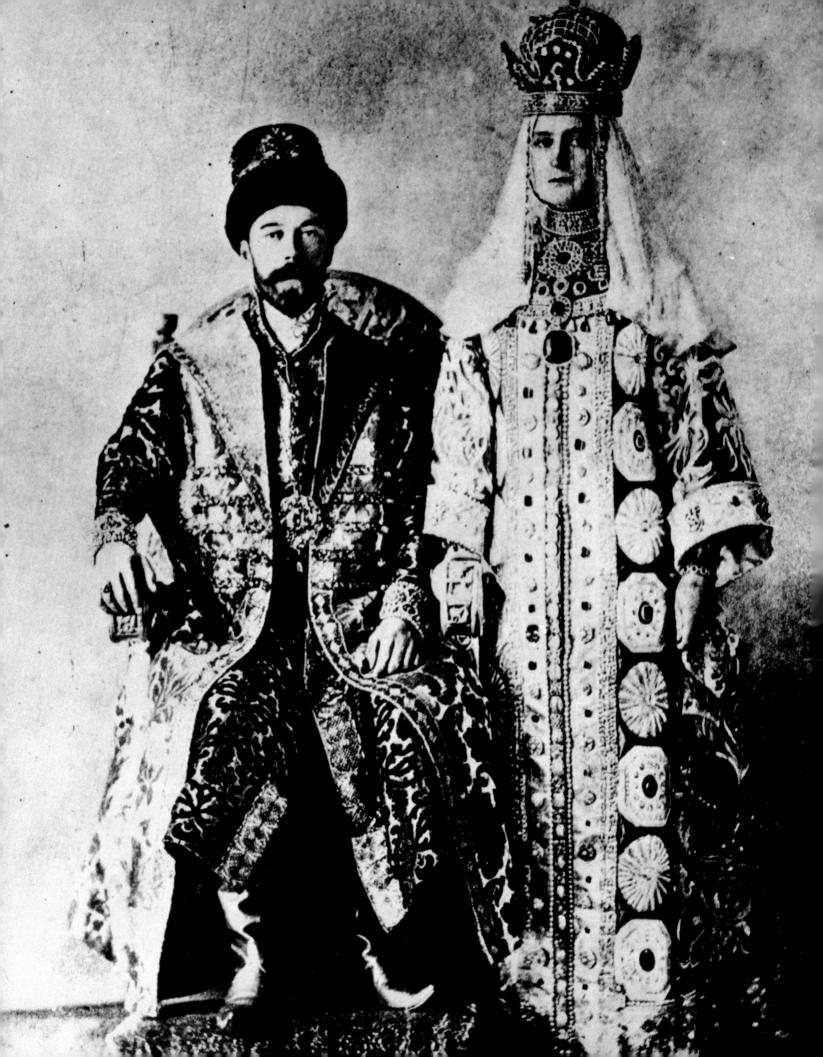

V

NICHOLAS AND ALEXANDRA

WITH SURPRISES BY FABERGE

W hen Nicholas Romanov received official word that he was to be crowned as czar following the death of his father, Alexander III, he wept. "I am not ready to be the Czar," the twenty-six-year-old prince said. "I know nothing of the business of ruling. I have no idea even how to talk to the ministers." For a moment Nicholas thought of renouncing the crown, but he knew his duty, and, on November 1, 1894, he steeled himself for the "ordeal which I have always dreaded."

Shy and indecisive, the young czar had never shown any enthusiasm for stepping into his father's shoes. Even as an officer in the army, he was so mild mannered that people began referring to him as the "little colonel." And the disdainful Alexander, a gruff, blunt bear of a man, had seldom given his son any opportunity for learning "the business of ruling."

Lacking in experience, and without the formidable personality of his predecessor, Nicholas II at the same time inherited a nation that for decades had been seesawing between reform and repression.

Nicholas II, a compassionate family man but a reluctant ruler, poses in state robes with his beloved wife, Alexandra, who tried in vain to strengthen his resolve.

Catherine the Great's grandson Alexander I, who had taken the throne in 1801, had at first been a true reformer. He pardoned political prisoners, abolished the government's secret police, and, most significantly, granted landowning privileges to fourteen million peasants indentured to the state. His efforts at reform had to halt in 1812, when the French dictator Napoleon Bonaparte launched a massive invasion into Russia. After the French had been defeated, however, Alexander became a hard-line conservative. His sudden shift spurred the formation of secret political societies whose members embraced liberal ideas blowing over from western Europe. One of these groups staged a revolt in December of 1825 to prevent the accession of Alexander's successor, the reactionary Nicholas I. The Decembrist uprising, as it was called, failed to halt Nicholas. However, it left a deep impression on Russian society, leading to both more police terrorism and the spread of revolutionary feeling among the educated classes.

Nicholas's son Alexander II proved to be one of the most liberal czars. In 1861 he took the momentous step of abolishing serfdom. But though technically freed, the peasants had to buy any land they wanted to own, and millions of them remained chained to the estates of the landowners. Emancipation, as well as other reforms of Alexander's, satisfied neither liberals nor reactionaries. Students rioted, a wave of terrorist attacks swept Moscow, and in 1881, after several unsuccessful attempts, a hand-thrown bomb fatally maimed the czar. His shattered body was taken to the palace, where his family—including his grandson Nicholas, then thirteen years old—watched the proud man die.

Further efforts at reform ended with Alexander III, who came to power as industrialization was beginning to transform Russia, particularly with the laying of thousands of miles of railroad. Ruling by sheer force of will, the czar tightened censorship and limited the power of local governments. Russia by then contained 130 million citizens, and Alexander managed to antagonize members of almost every class—peasants, the intelligentsia, and a swelling urban working class that increasingly could not afford to buy the goods that it

Illuminated by electric lights and candles, the city of Moscow, with the Kremlin at center, glows radiantly for the 1896 coronation of Nicholas. During the festivities, however, at least a thousand people died in a mass stampede that many Russians saw as an omen that the reign would be tragic.

was producing. Alexander died, and Russia entered the modern age teetering on the edge of revolution.

The youthful Nicholas II, however, was more preoccupied with his new wife, Alix, later Alexandra, than with bringing order to his empire. In the history of royal romance, it is unlikely there has ever been a love match so filled with rapture and disaster as that of Nicholas and Alexandra. A German princess and granddaughter of Great Britain's Queen Victoria, Alix of Hesse-Darmstadt first met Nicholas in 1884, when she was twelve and Nicholas sixteen. They met again some years later, fell in love, and married shortly after Alexander III's death.

Alexandra—the name she took upon converting to the Orthodox faith—had great need of Nicholas's love, for there was scarcely another person at court she could call a true friend. Serious and aloof, the thin-lipped czarina made no secret of her dislike for St. Petersburg's frivolous court life. "The heads of the young ladies… are filled with nothing but thoughts of young officers," she complained. This was true enough, but hardly the sort of sentiment to endear her to a fun-loving aristocracy. Alexandra seemed not to care. She had Nicholas, and the two of them loved each other without stint, even as the empire collapsed around them.

At the czar's coronation, in May 1896, he committed his first major blunder. In a traditional celebration, about 500,000 people gathered in a meadow outside Moscow to watch the festivities and partake of free beer. When a rumor spread that there would not be enough beer to go around, the crowd panicked, and more than one thousand people were trampled to death. At first Nicholas and Alexandra wanted to cancel the ball that night, which was sponsored by the French ambassador. But Nicholas let himself be talked into proceeding as planned, lest he give offense to the French—who had gone to great expense, bringing precious silver, porcelain, and paintings from the national collection, as well as thousands of roses shipped fresh for the occasion. And so, while Moscow hospitals were still choked with the injured, and wagons carted away the dead, Nicholas and Alexandra took the first dance. Even though Nicholas

Marius Petipa, virtual dictator of Russian ballet for half a century, created over fifty works.

BALLET RUSSE

Like many Russian court traditions, classical ballet began in France—the nation that dominated European royal taste. After 1850, French ballet declined, but the czars of Russia adopted the art as their own, subsidizing an imperial ballet school in St. Petersburg that produced the world's most brilliant dancers. Under Nicholas II, ballet reached its zenith, playing twice weekly to sold-out houses in the Maryinsky Theater. The ballet company had 180 dancers, and before Nicholas's marriage the reigning ballerina was his mistress. The person most responsible for ballet's prominence was French-born Marius Petipa, master of the imperial school from 1862 to 1903. In addition to training a host of performers, Petipa also collaborated with such great composers as Peter Ilyich Tchaikovsky to create full-length masterpieces—among them *The Nutcracker* and *Swan Lake*—that set new standards for dance all over the world.

Members of Petipa's company portray snowflakes in an 1892 production of The Nutcracker. *Petipa*

was adept at staging intricate dances using a large ensemble.

later remunerated the families of those who had died, the Russian public perceived the royal couple as cold, indifferent monarchs.

Although conscientious about his duties, Nicholas came to the throne with no plans and no philosophy, other than to rule as "dear sainted papa" would have ruled—for which he often relied on his father's ministers. When he did engage himself directly in government affairs, it was usually with horrific results. One of the more spectacular instances was in 1903, when Nicholas became convinced that "a small victorious war," as one of his ministers put it, would cool revolutionary ardor at home. Expanding into Asia was a dream of many Russians, so Nicholas engaged in some military adventurism against Japan, sending Russians to seize Korean forest lands also prized by the Japanese. Envoys of the Japanese emperor warned Nicholas he was risking war, but he waved them away. The full Japanese response came in February 1904, as vessels of the Japanese navy steamed unannounced into the Russian-leased naval base at China's Port Arthur and smashed the Russian fleet as it lay at anchor. It was the first in a series of humiliating defeats. The Japanese pushed the Russian army out of Korea. Then in May another Russian fleet, which Nicholas had summoned from the Baltic Sea, was almost completely destroyed in one of the greatest naval upsets in history, known as the battle of Tsushima.

Tragedy abroad was mirrored by tragedy at home. On a Sunday in January 1905, some thirty thousand workers and their families, led by a visionary priest, Father Georgi Gapon, marched through St. Petersburg to present a petition to the czar protesting labor conditions. They were met instead by soldiers who opened fire, killing or wounding one thousand of the marchers. Another casualty was the ancient belief that the czar was the God-appointed protector of the people. A few days later Father Gapon declared: "There is no czar. Between him and his people lies the blood of our comrades." The day became known as Bloody Sunday, the czar became known as Bloody Nicholas, and the czarina as that German woman.

Violence and assassination again became commonplace in Moscow and St. Petersburg. One of the first to die was Sergei

TEXT CONTINUED ON PAGE 138

Cousins George V of England, second from left, and Nicholas II, right, looked uncannily alike. This photograph, in a gilt and enamel Fabergé frame, also includes the Prince of Wales, left, and the czarevitch, Alexei.

FAMILY SNAPSHOTS

The popular medium of photography fascinated the last Romanovs, especially Nicholas. Though often indifferent to practical affairs of state, he hired court photographers to record all state ceremonies and had prints given as souvenirs to the participating dignitaries. Above all, the czar delighted in pictures of his family, to whom he was utterly devoted, and even kept a technician on duty at home to develop and print the photographs taken almost daily. In the evenings Nicholas, Alexandra, and their five children gathered to select photos for inclusion in green, leather-bound, gold-embossed albums. Nicholas, ordinarily an even-tempered man, created a scene whenever anyone spilled excess paste.

The most treasured images would be displayed by the hundreds around the house, dressed in elegant frames produced by members of the House of Fabergé, the court-appointed goldsmiths whose most famous creations were the imperial Easter eggs (pages 145–169). In addition to expert gold-work and a secret enameling process that yielded colors never reproduced elsewhere, Fabergé craftsmen also popularized the use of oxidized silver. The materials and designs would complement a specific photo and might reflect a personal taste, like Alexandra's preference for mauve-colored enamel. Each of the frames here and on pages 136–137 was thus doubly precious—an expensive object enclosing a cherished memento.

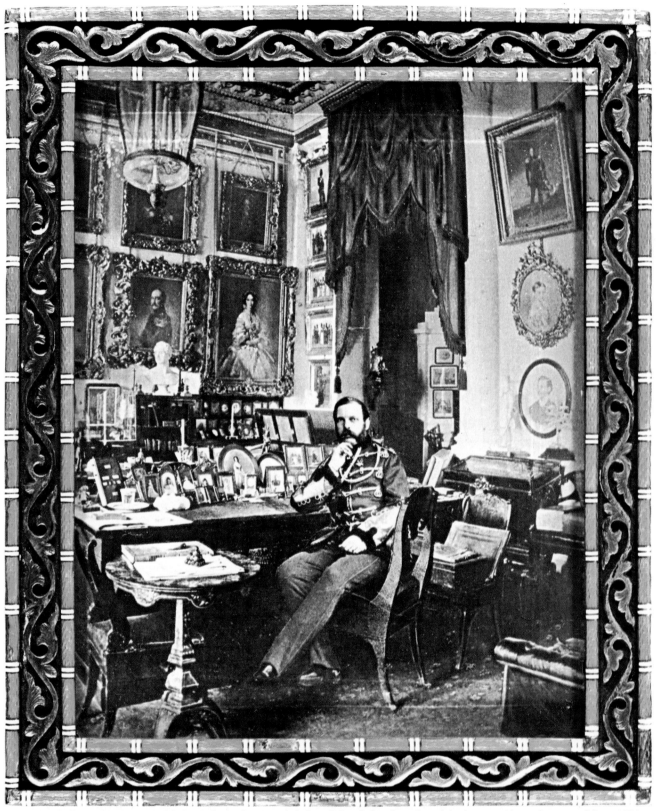

The clutter of photographs on the desk of Alexander III, Nicholas's father, belies the value of the frames. Alexander reigned from 1881 to 1894, just as the collecting of ornately framed family photographs became fashionable among the wealthy.

ALEXANDRA

TATIANA

MARIE (LEFT) AND ANASTASIA

OLGA

The photographs here of Empress Alexandra and her four daughters, each officially titled grand duchess, are opulently framed in the conservative style preferred by the imperial court. The decorative gold garlands and crossed arrows directly above, and the gleaming swags and festoons at right, are based upon ornamentation that had been used in Europe for centuries. These frames, all manufactured by the workshops of Fabergé, use only 4 of the 144 subtle shades of enamel available. Alexandra, opposite, wears a kokoshnik, a traditional headdress—perhaps to appear sympathetic to her subjects, many of whom sneered at her haughtiness.

TEXT CONTINUED FROM PAGE 133

Alexandrovich, the governor-general of Moscow, who was riding through the Kremlin when a revolutionary tossed a nitroglycerin bomb, which exploded in his lap. Some of his fingers, with the rings still on them, were found on a nearby rooftop. Nicholas and Alexandra dared not go to the funeral for fear of their own safety.

There was also personal tragedy. After producing four strapping daughters, in July 1904 Alexandra gave birth to a male heir, Czarevitch Alexei. The royal couple's joy was crushed ten weeks later, when they learned the boy suffered from hemophilia, a rare, hereditary disease that prevents blood from clotting properly, so that even a slight wound might prove fatal.

Increasingly the two beleaguered monarchs withdrew to the comfort of their personal residence at Tsarskoye Selo—or "the czar's village"—an eight-hundred-acre preserve of palaces and parkland fifteen miles south of the capital. Begun by Peter the Great's daughter Elizabeth, this "enchanted fairyland," as one visitor described it, was covered with trimmed green lawns and accented with all manner of exotic flourishes—obelisks, triumphant arches, monuments, and a man-made lake for boating. The park had an oriental cast to it, with a pink Turkish bath near the lake and a brilliant red and gold Chinese pagoda perched on top of a hill. The hill, like so much of Tsarskoye Selo, was artificial but charming to behold.

Of the two palaces on the estate, Nicholas preferred the relative simplicity of the neoclassical Alexander Palace, commissioned in 1792 for Catherine the Great. Its one hundred rooms were ornamented in the gold, crystal, velvet, and heavy gilt so enjoyed by generations of Russian monarchs. But Alexandra brought in quantities of chintz and sensible English furniture and redecorated the family wing to resemble a comfortable English country manor. She lavished particular attention on her boudoir and did it entirely in her favorite color, mauve. As she became more reclusive, the czarina sometimes stayed for days in this private room, reclining on mauve pillows and drinking in the heavy aroma of fresh violets and lilacs and roses. Among the many pictures in her room, the only one that was not either religious or a family portrait was a likeness of Marie

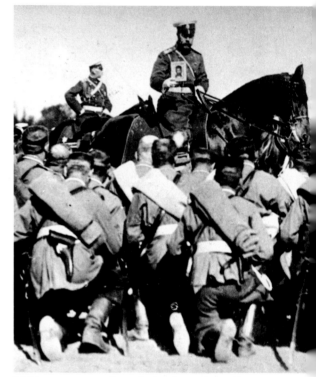

Holding an icon in his right hand, Nicholas blesses troops departing for the front during the Russo-Japanese War—a 1904 conflict, which he started in the hope that it would temper growing strife within Russia. Instead, Russia's swift defeat undermined the czar's hold over his subjects even further.

Antoinette, the devoted wife of France's Louis XVI and the last queen of a major European nation to be executed by the state.

The czar's family lived simply at the Alexander Palace. The atmosphere was relaxed and comfortably middle class as Nicholas read aloud after dinner while the ladies did their needlework. Spending so much time at Tsarskoye Selo tended to isolate Nicholas from the day-to-day running of his troubled empire. But possibly the czar, who enjoyed ending his day relaxing in a white-tiled bathtub and writing in his diary, did not care much.

For family excursions there was the imperial yacht, *Standart*, a sleek, 4,500-ton, steam-powered cruiser Nicholas had built in Denmark. Spacious enough to house the royal family, the ship's crew, a platoon of Marine guards, and a brass band and balalaika orchestra, the beautifully designed *Standart* ploughed the seas as if she were a trim sailing vessel. The ship was Nicholas's pride and the envy of his fellow monarchs.

The most sparkling of all the czar's treasures, however, were nothing so grand as yachts and palaces. Rather, they were the exquisite creations of court goldsmith Carl Fabergé, an exacting artisan who from his workshop in St. Petersburg achieved an international reputation as the master of the miniature. He could take a stem of gold and, by adding jade and moonstones, create an enchanting sprig of mistletoe. Under the master's direction, Fabergé craftsmen produced a stream of tiny delights for his customers—cuff links, cigarette cases, miniature parasols of ivory, and even a gold equestrian statue of Peter the Great.

Fabergé's most famous works were in the Easter egg collection he created for Alexander III and Nicholas II. The first of these, produced in 1884 as a gift from Alexander III to his wife, resembled an ordinary egg but contained a surprise. Inside the yolk was a tiny chicken sculpted in several shades of gold; inside the chicken was an imperial crown, which concealed a ruby pendant. Later eggs—Fabergé made close to sixty in all—held surprises ranging from miniature palaces to an exquisitely detailed model of the coronation coach, barely four inches long and outfitted with an upholstered

THE HOLY DEVIL

The keenest distress in the lives of Nicholas and Alexandra was the fate of their son, Alexei, who suffered from the potentially fatal malady of hemophilia. In her grief the czarina sought the aid of a self-styled holy man and healer who called himself Rasputin, one of the most fascinating characters that Russia has produced.

Of a peasant background, Rasputin was physically formidable: tall, bearded, and with pale eyes that were "at once piercing and caressing," according to an observer, who added that the mystic "carried with him a strong animal smell." Probably using hypnosis he not only soothed the czarevitch but also seduced countless women who came looking for salvation. Yet his imperial patrons never wavered in their devotion, and when the czar went off to the front in World War I, Alexandra gave Rasputin enormous influence in making political appointments.

Outraged monarchists, including Prince Felix Yussoupov, married to a niece of the czar, decided in 1916 to assassinate Rasputin. But the Holy Devil, as he had become known, took considerable killing. They first lured him to a cellar and offered him cakes and wine laced with poison. When that had no effect, Yussoupov fired several bullets into him. Rasputin fell, recovered, escaped, then collapsed in the snow. The conspirators dragged him to the Neva River, bound him, and pushed him through a hole in the ice. Yet so powerful was Rasputin that he loosed his bonds before the current finally swept him under.

Rasputin (seated) takes tea with an admiring group of society ladies in St. Petersburg. Though married and the father of three, the magnetic faith healer was a notorious womanizer, and even his wife declared: "He has enough for all."

interior and platinum-rimmed tires. Nicholas, holding these bejeweled fantasies in his hands on a happy Easter morning, must have found them especially pleasing. They were everything his unruly kingdom was not: neatly balanced, perfectly proportioned, comprehensible at a delighted glance—and they worked.

Following Father Gapon's march on Bloody Sunday, a swirl of revolution coursed freely throughout Russia. Students demonstrated, peasants in the countryside rioted, and a printers' strike in Moscow set off a chain reaction that culminated in Russia's first general strike, with millions of workers taking to the streets. Nicholas tried to stem the tide by issuing a document—the October Manifesto—granting civil rights and promising elections. But millions wanted still more concessions.

Nicholas had perhaps one last chance to save his crown. The czar was notably unsuccessful in the selection of his chief ministers, but with Peter Stolypin he found a man of acute perception and iron will. Stolypin accepted his office in 1906 and struck first at lawlessness, instituting a series of tribunal courts that had the power to execute sentences within forty-eight hours. Before the year was out, his courts hanged fourteen thousand revolutionaries and felons.

But with vigorous suppression Stolypin offered genuine reform. Although a strict conservative, he strove to create a constitutional monarchy similar to Great Britain's. He also made large tracts of crown land available for individual self-sufficient farms. If Russia could have gained the time and the peace needed for Stolypin's reforms to take hold, the giant apparatus of the Muscovite state might have held together. "Give us ten years," said one landowner, "and we are safe."

But Russia did not have ten years, nor did Stolypin. On a September night in 1911, as he was attending the opera in Kiev, the prime minister was shot by a revolutionary agent. He died four days later, the last truly forceful minister Nicholas would have. In another three years all of Europe was at war. Russia, which had little at stake save her sense of prestige, entered World War I as giddily as the other nations—yet no more prepared than she had been in the fight

against Japan. In the first year alone, the czar's army suffered nearly four million casualties.

During this desperate time Alexandra played her own unfortunate part. The czarina had a weakness for faith healers, and in 1905 she had turned to an unkempt but charismatic "holy man" called Rasputin, who claimed to have the power of healing. When the young czarevitch Alexei had what was most likely a natural remission, Alexandra took it to be a mystical cure affected by Rasputin. Although much of his tremendous energy went into seducing women, eventually Alexandra elevated him to a high, semi-official position. Then, to the outrage of royal relatives and dignitaries, the empress and the monk began to meddle in running the government, hiring and firing ministers on Rasputin's approval.

By the time of the world war, Rasputin's hold over Alexandra had become total, and through her he controlled Nicholas, who in any case had withdrawn even more from the task of ruling. The czar traveled to the war front, where he was little more than an observant bystander at military headquarters. Alexandra constantly wrote letters trying to prop him up. In one poignant, almost hysterical passage, she urged him to "be the Emperor, be Peter the Great, Ivan the Terrible...crush them all under you." Nicholas replied: "Tender thanks for the severe scolding...." and signed the note, "Your poor weak-willed little hubby."

In December of 1916, Alexandra sent Nicholas a particularly frantic message: "Our Friend [Rasputin] has disappeared." A few days later Rasputin's body was discovered in the frozen Neva River. A group of conspirators, who were led by the czar's nephew-in-law, had poisoned and stabbed the monk and then had stuffed him—still breathing—through a hole in the ice. Nicholas, returning to Tsarskoye Selo, seemed on the verge of a nervous collapse during the dreary weeks that followed. As the empire slipped away from him, Nicholas grasped all the more tightly to the aura of autocracy. Late in the war, the British ambassador, Sir George Buchanan, tried to warn Nicholas that he "must regain the confidence of your people." The czar put on an icy hauteur. "Do you mean that I am to regain the

Members of a ragtag mob prepare to burn Nicholas's portrait, an incident symbolizing the start of the Russian Revolution, in March of 1917. After insurgents took over the capital and then Moscow, the czar abdicated, ending the monarchy.

confidence of the people, or that they are to regain *my* confidence?"

Once before the end, though, his officious pose cracked in front of a visitor. "Is it possible," he asked, holding his head in his hands, "that for twenty-two years I tried to act for the best and that for twenty-two years it was all a mistake?"

On March 12, 1917, after several weeks of serious strikes and disorder, imperial Russia collapsed in a single stroke. Soldiers in the 190,000-man garrison at the capital, when ordered to shoot down striking workers, instead joined them in the streets. Nicholas, who was again at the front, immediately boarded a train when word of the uprising reached him. In the town of Pskov, about 150 miles from the capital, the czar of all the Russias listened as his generals advised him to abdicate. Nicholas quietly agreed and later signed a document abdicating not only for himself but also for his son. The appointed successor, Nicholas's brother Mikhail, declined the offer. After three centuries of absolute power, the Romanov dynasty was finished.

For the next sixteen months, the provisional government interned the ex-czar and his family as prisoner pawns. Alexander Kerensky, who became the new premier in July 1917, negotiated with France and Great Britain to accept the Romanovs as exiles. But both countries found the idea potentially embarrassing and begged off. With their lives in his hands, Kerensky decided to transfer Nicholas and his family from their beloved Tsarskoye Selo to a remote—and presumably safer—residence in Tobolsk, a backwater commercial city in western Siberia.

The family lived in modest comfort, but always with harsh reminders of their prisoner status as well as with new points of etiquette to learn. Nicholas's guards voted that officers could no longer wear epaulets, an order that extended to Nicholas, who wore his old colonel's uniform throughout most of his captivity. He gave up wearing epaulets when exercising in view of the guards; but he put them back on when he was in his room.

The fate of the Romanovs was sealed in November when Nikolai Lenin—whose real name was Vladimir Ilich Ulyanov—and the Bolsheviks, the most rabid party of revolutionaries, seized power

Dressed as an ordinary army colonel, Nicholas takes the sun with his children on a roof in a Siberian village, where the Romanovs endured almost a year of captivity. In 1918, leaders of the ruling Bolshevik party—fearing that the royal family would be rescued—ordered them executed.

from Kerensky in a swift coup. Cautiously at first, but then with growing boldness, Lenin and the Bolsheviks set about the systematic purge of Russian citizenry—monarchists, liberals, farmers, officers, tired revolutionaries, the lot. The elimination of the royal family was an administrative detail so minor in Lenin's calculations that when word was brought to him that it had been done, he barely paused in the reading of a new health law to acknowledge it.

In April 1918, soldiers took the Romanovs to Ekaterinburg, an unprepossessing community in the eastern Urals, and detained them in the home of a local merchant. The windows in the second story, where the czar's family stayed, were painted white so no one could see in or out. Their fate was still undecided. But in June rumors of plots to rescue the family circulated among workers and officials. All the guards were abruptly changed. On an early July morning, they ordered the entire group of prisoners—which included a family physician, a valet, a cook, and a maid—to the basement, where several guards shot or bayonetted all of them. The bodies were taken outside, sawed into pieces, and burned.

In the centuries when the czars had ruled supreme over the Eurasian plain, they had possessed riches and treasures beyond counting. They owned palaces without number and precious stones heaped so high the czar could roll in them like a child playing in a pile of autumn leaves. Restless, driven monarchs, they willed entire cities into existence by iron whim and then stocked them with paintings and statuary purchased by the museumful. Their religious art fired the spirit of the pious, and their regalia stunned the worldly. Yet the catalog of the treasures of the last czar, at his death, could have been written down on a single page of a coroner's report. A few jewels were discovered sewn into the linings of the women's clothes when the guards readied their bodies for the pyre. Additionally, there was a belt buckle belonging to the czar, and one to his son, as well as Alexandra's spectacle case, a single pearl earring, some shoe buckles, a fragment of a sapphire ring, a crucifix, a diamond-and-sapphire badge, and three small icons. The faces of the saints on each icon had been smashed in by rifle butts.

A case lined with silk and velvet holds one of the imperial Easter eggs produced by the House of Fabergé. The egg itself opens to disclose a tiny basket of flowers.

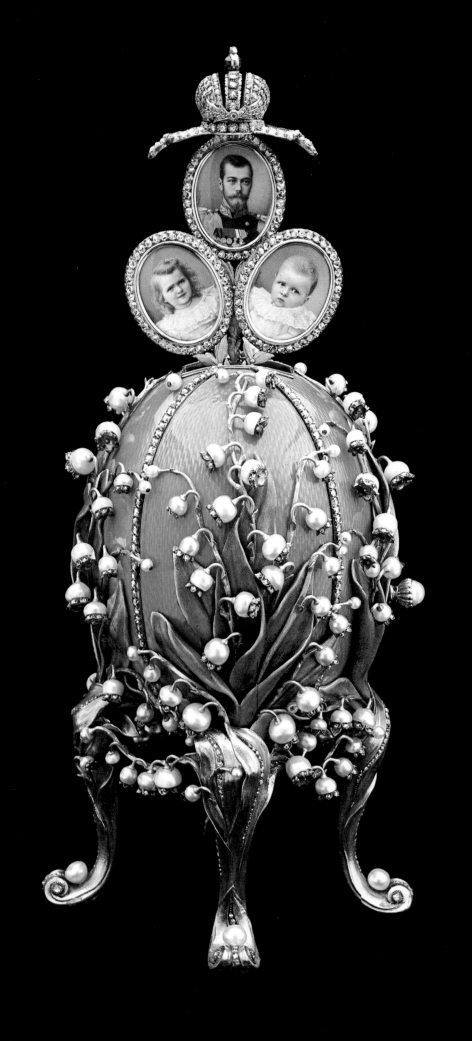

First and simplest of the imperial eggs from Fabergé, this naturalistically enameled shell conceals a gold yolk, which opens to reveal a delicately modeled, ruby-eyed gold hen.

Nothing more aptly expressed the glittering and illusory world the last Romanovs enclosed themselves in than the Easter eggs contrived for their amusement by court jeweler Carl Fabergé. Easter was the most important holy day in czarist Russia, and people at all levels of society marked it by exchanging eggs—symbols of the Resurrection. These gifts ranged from simple red-dyed eggs shared by poor folk to opulently jeweled gold versions handed around by the aristocracy. The presentation of ornately decorated eggs was not confined to Russia; the eighteenth-century French court at Versailles, for example, had made it an Easter habit. But few, if any, eggs were more spectacular than Fabergé's imperial creations, some of which appear here and on the following pages.

Czar Alexander III commissioned the first egg (above) for his wife in about 1884, the same year he gave a royal appointment to Fabergé, whose St. Petersburg firm had been purveying exquisite, ingeniously designed objects to European aristocrats for forty years. The Fabergé egg became an annual commission, continued after 1894 by Nicholas II, though he ordered two eggs each year, one for his mother and another for Alexandra. Beyond their materials, what made these treasures so stunning was the so-called surprise inside each one: a miniature animal, a model palace, a small portrait, or some other novel delight intended to provide a burst of pleasure. In all, Fabergé devised fifty-eight imperial eggs. Usually he delivered them personally each Easter to the palace, where they were opened amid an exchange of embraces and toasts. And afterward the family might continue to pass them about all through the day, so as to linger over the fantasies within.

A hidden mechanism causes this 1898 egg, adorned by lilies of the valley, to yield its surprise: miniature portraits of Nicholas II and his oldest daughters. Commissioned by the czar for his mother, then Dowager Empress Marie, the egg, topped by an imperial crown, is eight inches tall when open.

OVERLEAF: *The surprise inside this gold and green-enameled egg, which Nicholas gave to his mother in 1912, is a six-paneled folding screen showing regiments of which she was honorary colonel.*

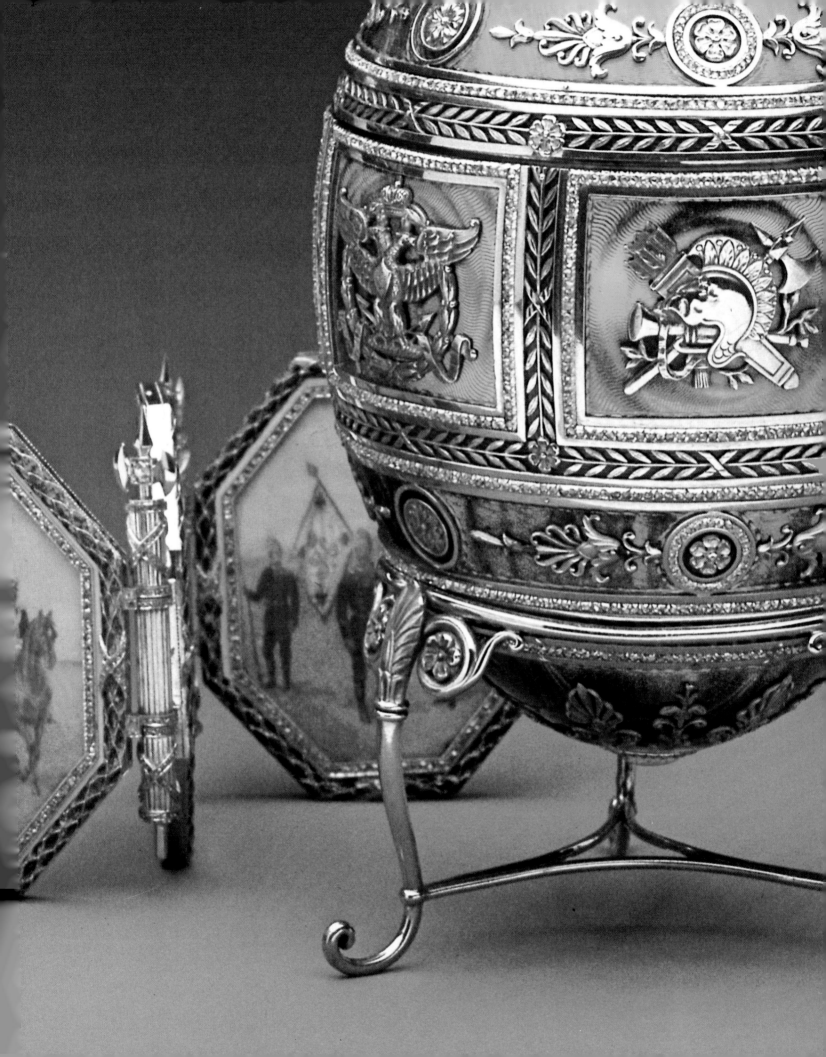

Slightly more than a foot high from base to tip, this egg of brilliant blue enamel on gold is one of the largest of Fabergé's eggs. When the clock in front strikes the hour, the grill on top opens and out pops the blue, green, and yellow enameled chanticleer (in detail opposite), which crows, bobs its head, and flaps its wings.

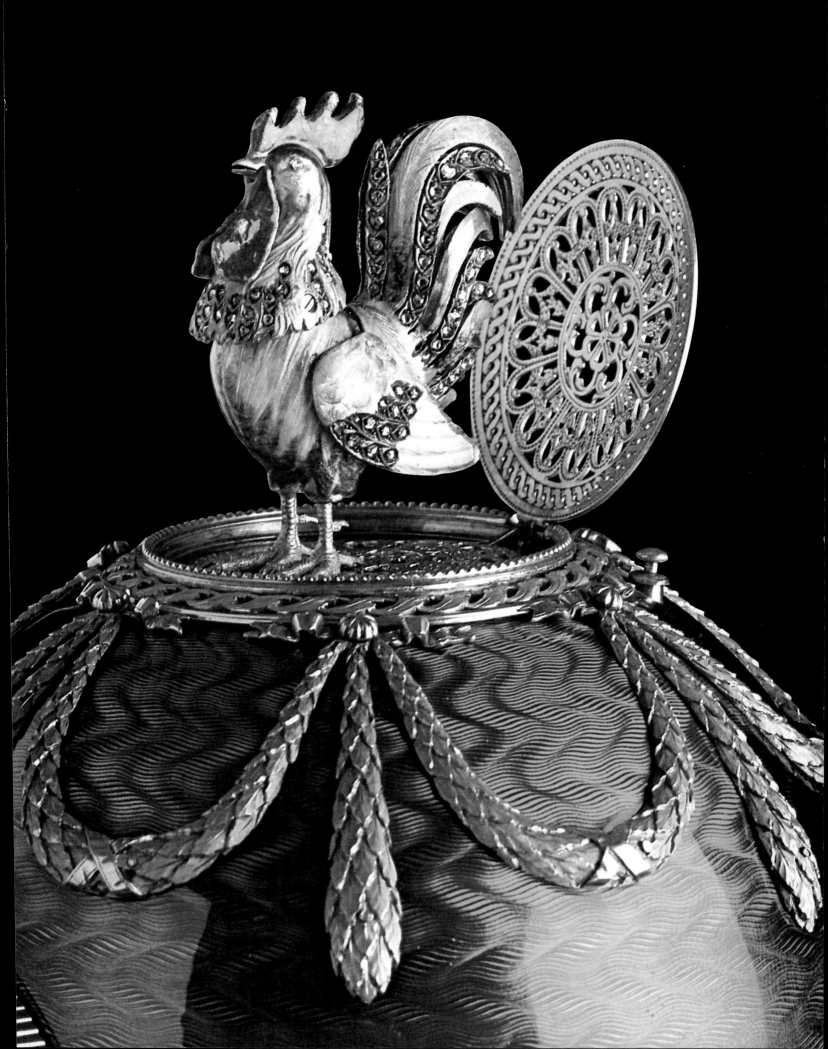

This egg for the dowager empress contains a detailed model of Gatchina Palace, her favorite residence, in four colors of gold.

Inside the egg-shaped globe of rock crystal opposite, a dozen miniatures portraying palaces that Alexandra had lived in or had visited revolve around a gold shaft. Nicholas gave his wife this superb creation in 1896, the year of his coronation.

Encircled by ten diamonds, Alexandra's monogram—made of rose diamonds and cabochon rubies in white enamel—surmounts the Coronation Egg. The yellowish shell and black imperial eagles (visible in the corners above) allude to the colors of her ceremonial gown.

The production of an imperial egg began in the office of Carl Fabergé, where the patriarch of the firm would lead a discussion with artisans and designers for each important commission. Fabergé made nothing himself; rather, his genius was for conceiving a piece, as well as inspiring and coordinating a body of outstanding craftsmen. After arriving at a design, Fabergé would then assign its execution to a head workmaster—a senior artisan in charge of a workshop, the essential unit of Fabergé's organization.

At the St. Petersburg headquarters, which expanded in the 1890s, there were ultimately four floors of workshops employing specialists in gold and filigree working, enameling, stonecutting, miniature painting, and in other mediums. Each shop had its master craftsmen, journeymen, and apprentices, as well as a number of ordinary craftsmen for such tasks as making the wooden cases that held every piece. As much as possible the operations on a particular piece were carried out in a single workshop, with the workmaster summoning any additional experts he required from other parts of the plant.

The success of a Fabergé creation did not rest on the ostentatious use of precious materials.

FOLDOUT: *Only three and eleven-sixteenths inches from front to back, the coach sits on a meticulously slung chassis outside the egg, itself a mere five inches long. On both pieces the enamel finish is translucent, achieved by fusing layers of clear enamel onto metal at very high temperatures. Patterns engraved in the gold appear through the carefully polished surface.*

FOLDOUT ——▶

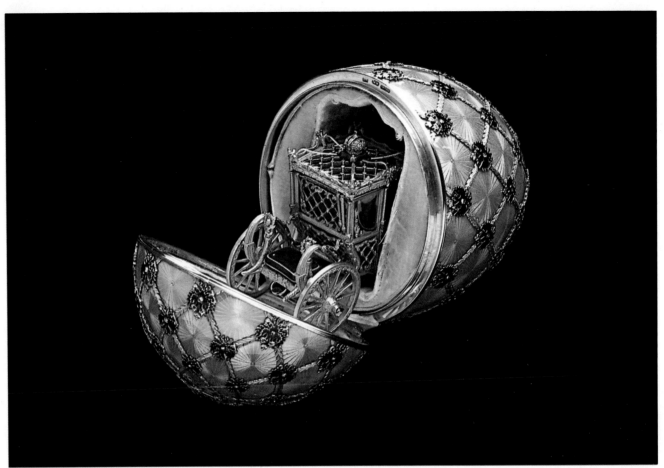

A precise replica of the imperial coach, executed in strawberry-colored enamel and gold, appears when the egg is opened. At the center of the roof glimmers an imperial crown of rose diamonds, which is guarded by diminutive gold eagles around the perimeter.

Instead, workmasters often chose readily available native stones, wood, and glass, which they transformed into objects enjoyed for their elegance and ingenuity more than for any extravagance. On many pieces the outstanding element was not gold or silver or diamonds but the enameling, notable for its smooth textures and astonishing range of colors.

The imperial eggs represented the summit of Fabergé invention and workmanship, not to mention an investment of hundreds of hours. Among the most ambitious efforts was the Coronation Coach Egg presented to Alexandra in 1897 (see foldout and the details here and on pages 160–161). Inside an elaborate shell, the surprise was nothing less than a perfectly articulated miniature coach. George Stein, the vehicle's craftsman, had worked as a carriage builder and studied coaches at a museum in St. Petersburg for this assignment. In creating the miniature he worked without the aid of a lens; apparently his eyesight was so keen he could detect a flaw in a diamond just by holding it up to the light. The coach took him fifteen months to complete. Such were the lengths taken by the House of Fabergé to ensure a masterpiece.

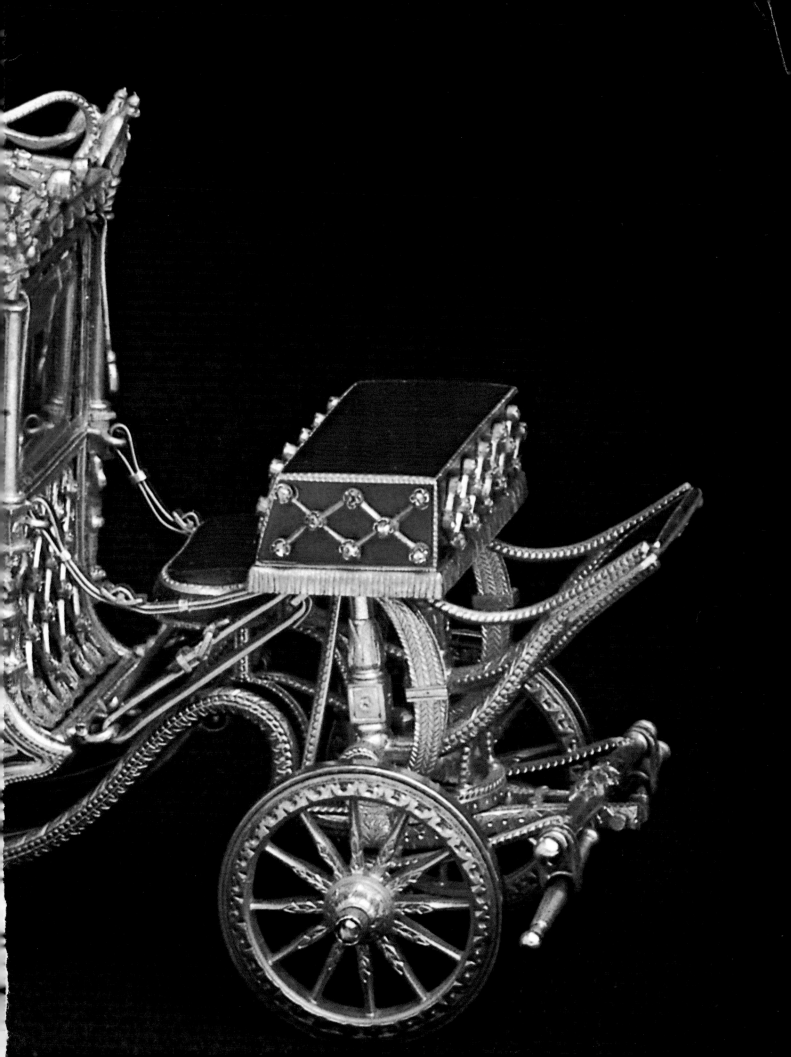

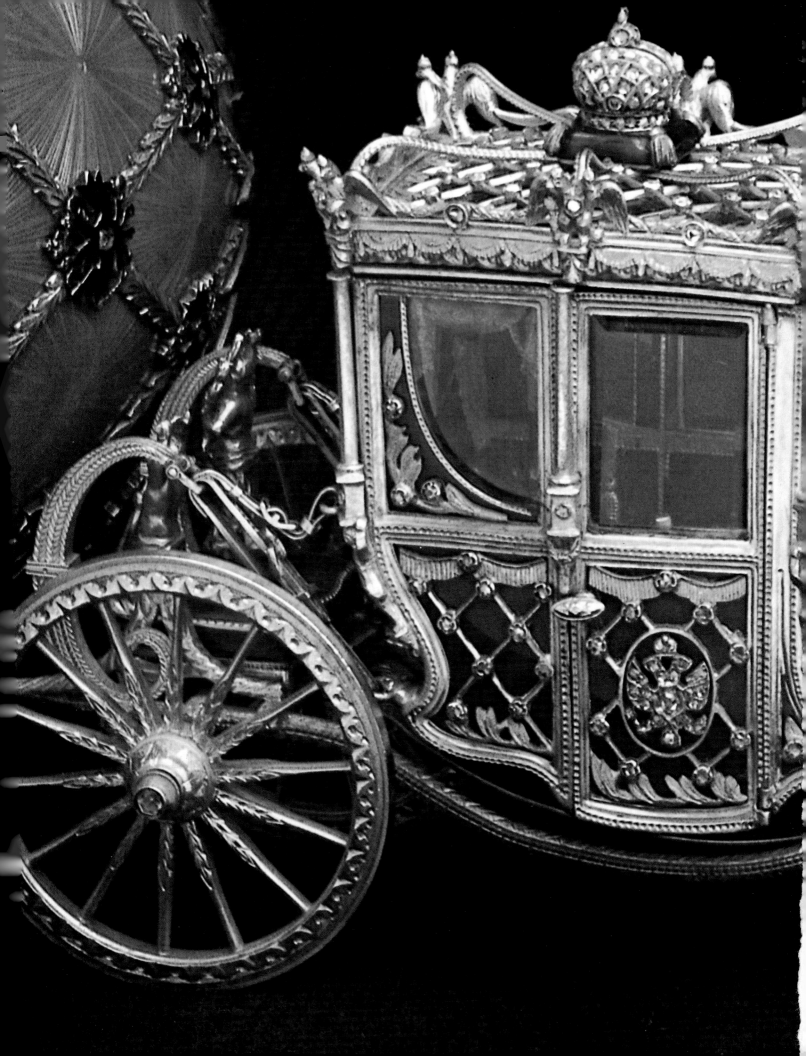

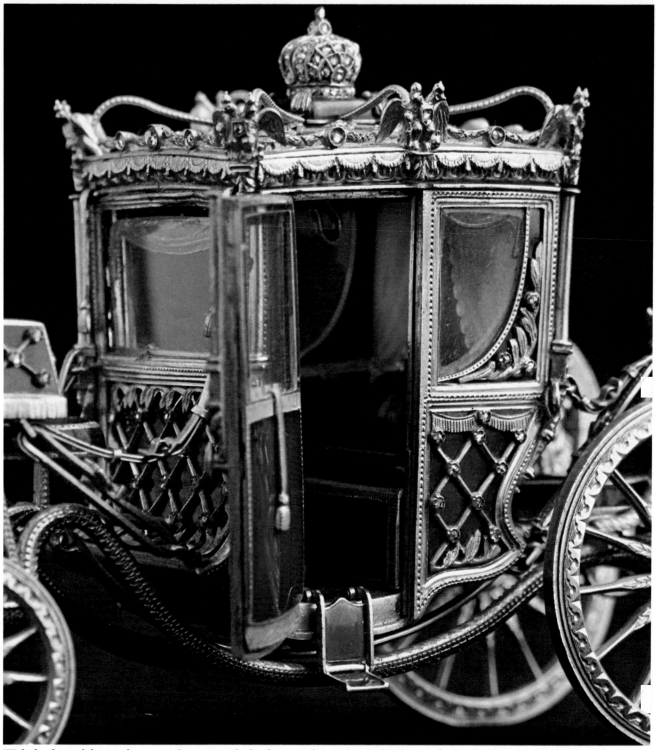

With the door of the coach open, a footrest can be let down. Other authentic details include the plush scarlet upholstery in the interior, engraved rock crystal windows, enameled curtains behind the seats, and (not visible here) a painted ceiling.

At the rear the coach displays an exquisitely crafted decorative fringe at the roof line, graceful tassels and flower emblems, and mythical figures that adorned the actual coronation coach. The gleaming bands around the tires are of platinum.

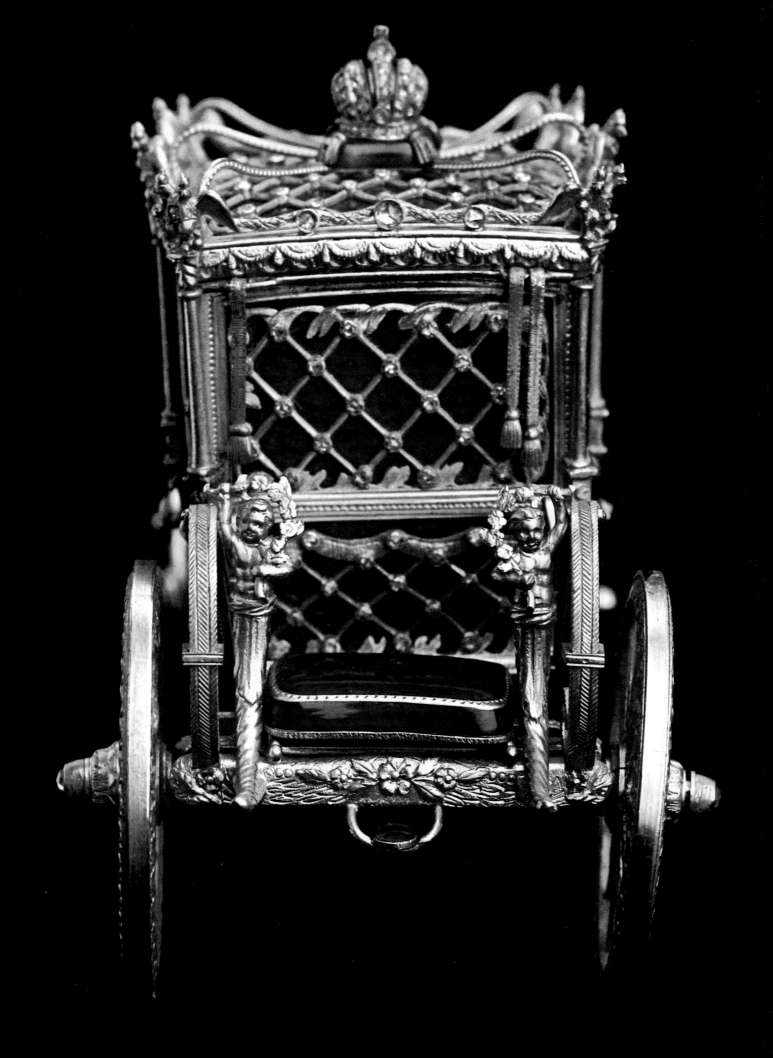

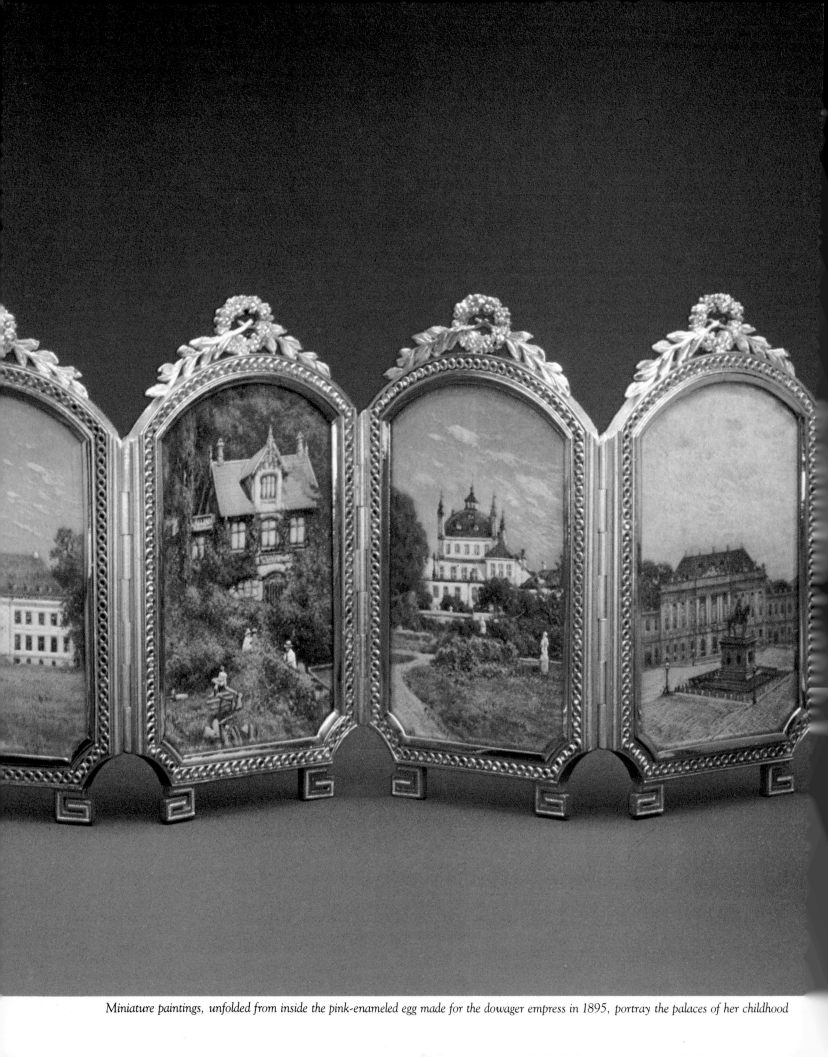

Miniature paintings, unfolded from inside the pink-enameled egg made for the dowager empress in 1895, portray the palaces of her childhood

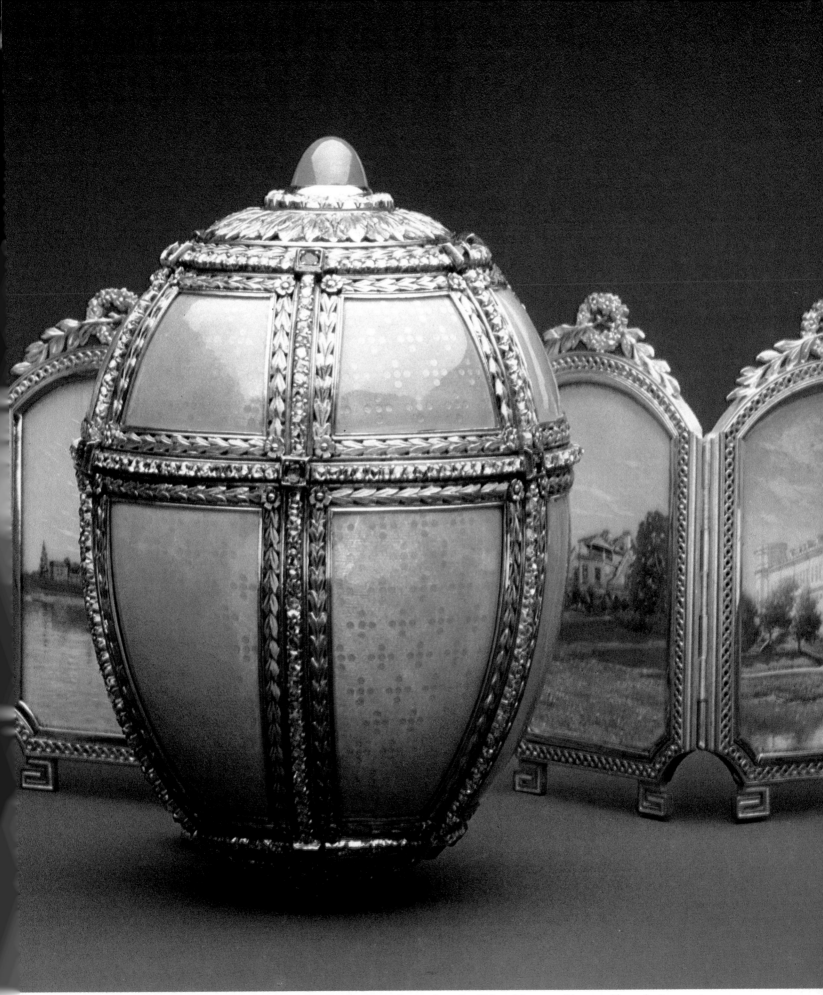

years in Denmark. Topped by a star sapphire, the egg has bands of rose diamonds and gold laurel leaves, with emeralds at the intersections.

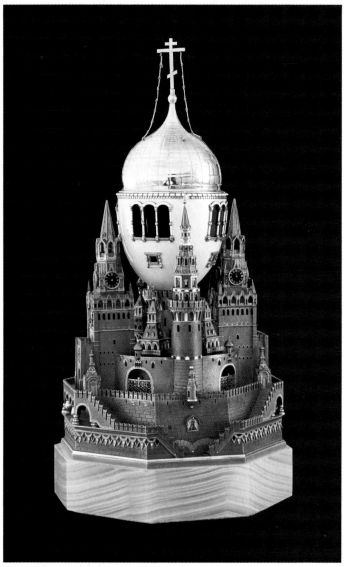

This 1904 replica of the Cathedral of the Assumption, the czars' traditional coronation site, has a mechanism that plays an Orthodox hymn. Two of the reddish-gold towers boast chiming clocks (one is in the detail at right), each with dials about one-half inch in diameter.

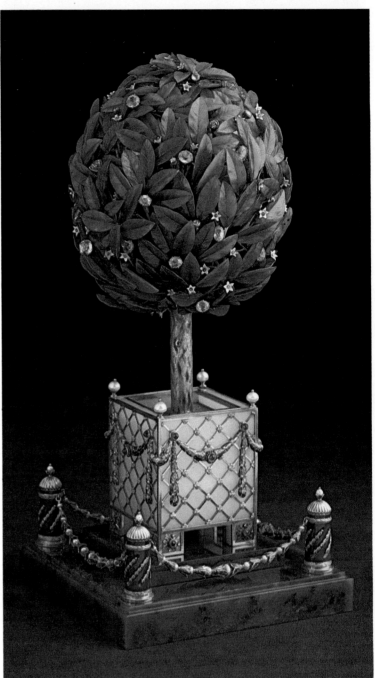

An orange tree with leaves carved from nephrite—a form of jade—has a gold trunk resting in a white quartz tub. At the touch of a button, the top leaves open (in detail at left), and a gold feathered songbird emerges. Nicholas gave this egg to his mother in 1911, during the last tranquil period of his reign.

OVERLEAF: *This detail of the Orange Tree Egg offers a splendid example of Fabergé's art. The nephrite leaves, wrought with intricate veins, frame white enamel blossoms with diamond centers and a variety of fruits made from gemstones. A gold twig connects each individual leaf to the main trunk.*

RUSSIA: A CHRONOLOGY

	PEOPLE AND EVENTS	ART AND ARCHITECTURE

HOUSE OF RURIK

	PEOPLE AND EVENTS		ART AND ARCHITECTURE
r. 1462–1505	Grand Prince Ivan III (the Great)		
		c. 1472	Ivory Throne made
		1478	Cathedral of the Assumption completed
		1482–1490	Cathedral of the Annunciation built
			Kremlin walls and towers undergo reconstruction because of raids
		1487–1491	Palace of Facets in Moscow completed
r. 1505–1533	Grand Prince Vasili	1505	Cathedral of the Archangel Michael commissioned
r. 1533–1584	Ivan IV (the Terrible) is first czar		
1547	Ivan marries Anastasia Romanovna	c. 1547	Government workshops created by Ivan for production of icons
1552	Ivan captures Kazan region		
1553	English traveler Richard Chancellor visits Moscow		
1556	Ivan captures Astrakhan		
		1558	Cathedral of St. Basil the Blessed built
1570	Ivan leads slaughter of Novgorod		
1580	In fit of anger Ivan kills his heir, Czarevitch Ivan		
r. 1584–1598	Fëdor I		

r. 1598–1605	Boris Godunov		
		1600–1603	Tower of Ivan the Great constructed
1605–1613	Time of Trouble		
r. 1605	False Dmitri		

HOUSE OF ROMANOV

r. 1613–1645	Mikhail Romanov		
		c. 1615	Kremlin workshops established to produce gold and silver treasures
r. 1645–1676	Alexei (the Gentlest Czar)		
1646	Alexei legalizes slavery		
1650	Alexei's army massacres the residents of Pskov		
1652–1660	Nikon is patriarch of Moscow		
c. 1653	Nikon's reforms and disagreements with Alexei cause schism in Church		
1662	Alexei orders massacre of Muscovites	1659	Diamond Throne presented to Alexei
		1666	Alexei begins construction of wooden palace at Kolomenskoye
r. 1676–1682	Fëdor II		
r. 1682–1689	Sofia is regent		
r. 1689–1725	Peter I (the Great)		
1696	Peter defeats Turks at Azov		
	Peter begins tour of Europe		
1698	Streltsy revolt brings Peter back to Russia		
	Peter begins Westernization process		
1700–1721	Great Northern War with Sweden		
		1703	Peter begins building of St. Petersburg
1712	St. Petersburg becomes official capital of Russia		

HOUSE OF ROMANOV
(CONTINUED)

	1719	Peter tortures his son Alexei to death for suspected treason
r. 1725–1727		Catherine I
r. 1727–1730		Peter II
r. 1730–1740		Anne
r. 1740–1741		Ivan VI
r. 1741–1762		Elizabeth

1715	Building of Peterhof begins

c. 1745	Tsarskoye Selo begun outside St. Petersburg

r. 1762		Peter III
r. 1762–1796		Catherine II (the Great)

1763	Catherine purchases first lot of paintings containing works by many masters
1769	Plans for the Hermitage completed

1771	Catherine takes the Crimea
1773	Cossacks devastate eastern Russia

1790	The Hermitage contains the largest painting collection in Europe
1792	Catherine commissions the Alexander Palace at Tsarskoye Selo

	1793	Catherine annexes Ukraine
	1795	Catherine gains most of Poland
r. 1801–1825		Alexander I
	1812	Napoleon invades Russia
	1825	Decembrist uprising
r. 1825–1855		Nicholas I
r. 1855–1881		Alexander II
	1861	Alexander abolishes serfdom

1876	Tchaikovsky writes *Swan Lake*
1884	Carl Fabergé begins the imperial Easter egg collection
1892	Tchaikovsky writes *The Nutcracker*

1894	Nicholas marries Alexandra

c. 1895	Russian ballet reaches its zenith
1897	Coronation Coach Egg made for Alexandra

1904	Russian fleet defeated in battle of Tsushima
1905	Bloody Sunday massacre in St. Petersburg
	Nicholas issues October Manifesto
	Rasputin begins influencing Alexandra and gains power at court
1906	Peter Stolypin becomes Nicholas's chief minister—begins suppression and reform
1911	Stolypin assassinated

1911	Nicholas gives Orange Tree Egg to his mother

1916	Rasputin assassinated
1917	Russian Revolution
	Collapse of imperial Russia
	Alexander Kerensky becomes premier, then Lenin and the Bolsheviks seize control
1918	Romanovs put to death

ACKNOWLEDGMENTS & CREDITS

Abbreviations:
BB/VAAP—B. Bogdanova/VAAP, Moscow
BK/VAAP—Boris Kuznetsov/VAAP, Moscow
DK/L—Dmitri Kessel/Life © 1965 Time Inc.
FMC—The Forbes Magazine Collection, N.Y.
NGA—National Gallery of Art, Washington, D.C., Andrew W. Mellon Collection
NYPL—New York Public Library
MMA—Metropolitan Museum of Art, N.Y., photograph by Sheldon Collins, 1979

The Editors are particularly grateful to Felix Rosenthal, Time Bureau, Moscow, for his extensive cooperation and efforts on our behalf.

The Editors would also like to thank the following for their assistance: Ira Bartfield and Barbara Bernard, Photographic Services, NGA; Jean Carroon, Photo Services, Walters Art Gallery, Baltimore, Maryland; Deanna Cross and Mary Dougherty, Photographic Services, MMA; Anatoli Dyuzhev, USSR Embassy, Washington, D.C.; Mr. and Mrs. Abraham Herenroth, N.Y.; Rosemary Jones, Virginia Museum, Richmond; Margaret Kelly and Barbara Pollack, FMC; Francis Norton, S.J. Phillips Ltd., London; Alison Pennie, Office of the Lord Chamberlain, London; Peter Schaffer, A La Vieille Russie, N.Y.; Vladimir Sichov, Paris; M. Urwick Smith, The Wernher Collection, Luton Hoo, Luton, England; Kenneth Snowman, Wartski, London; Alexander von Solodkoff, Russian and Icon Department, Christie's, London; Heinrich von Spretti, Department of Russian Works of Art, Sotheby's London; Harold Stream, Matilda Geddings Grey Foundation, New Orleans; Dr. Leonid Tarassuk, Department of Arms and Armor, MMA; Katrina Taylor, Hillwood Museum, Washington, D.C.; Ziolo, Paris; and the staff of VAAP, Moscow.

Maps by H. Shaw Borst
Endsheet design by Cockerell Bindery/TALAS

Cover: Steven Mays, FMC. 2: Novosti. 4–5: Editions Cercle d'Art/Ziolo, Paris. 6: © David Arky, 1982, A La Vieille Russie, N.Y. 11: National Museum, Copenhagen. 12: Slavonic Division, NYPL. 13: NYPL. 14–15: Slavonic Division, NYPL. 16: MMA. 17: Editions Cercle d'Art/Ziolo, Paris. 18–21: MMA. 22–23: Slavonic Division, NYPL. 25, 27: BK/VAAP. 28: David D. Duncan, Castellaras, France. 29–31: MMA. 32–33: BK/VAAP. 34–39: MMA. 40–43: BK/VAAP. 44, 46: Novosti. 47: Bibliothèque Slave, Paris. 48–49: Novosti/The Image Bank. 50–51: MMA. 52: Claus Hansmann, Stockdorf. 53: BK/VAAP. 54–55: MMA. 56–57: Novosti/The Image Bank 58: Novosti. 59–60, 62–65: BK/VAAP. 66–67: TASS, Moscow. 68–74: BK/VAAP. 75: David D. Duncan, Castellaras, France. 77: Rijksmuseum, Amsterdam. 78: State Historical Museum, Moscow. 79: Collection Count Alexis Bobrinskoy, London. 80(top): Bibliothèque Nationale, Paris. 80(bottom): Slavonic Division, NYPL. 82–83: NYPL. 84–85: Photo Bulloz. 86: Slavonic Division, NYPL. 87: Anne van der Vaeren/The Image Bank. 88–89: Jonathan Wright/Liaison Photo Agency. 90–91: George Holton/Photo Researchers. 92–93: Novosti/The Image Bank. 94–95: Jerry Cooke, N.Y. 96–97: Susan McCartney/Photo Researchers. 98–99: Malcolm Gilson/Alpha Photo Associates. 100: Wernher Collection, Photographic Archive, Mondadori, Milan. 102–103: Novosti. 104: Anne S.K. Brown Military Collection, Brown University Library, Providence, Rhode Island. 105: Frick Art Reference Library, N.Y. 106(top): Christie's, Geneva. 106 (bottom): S.J. Phillips Ltd., London. 107: Novosti/The Image Bank. 108–109: BK/VAAP. 110: Bibliothèque Nationale, Paris. 111: Mansell Collection. 112: Slavonic Division, NYPL. 113: Bruce Davidson/Magnum 114: NGA. 115(top, left): DK/L. 115(top, right): BB/VAAP. 115(bottom, left): NGA. 115(bottom, right)–119(top): BB/VAAP. 119(center): DK/L. 119(bottom)–121: BB/VAAP. 122(top row–second row, left): NGA. 122(second row, right): BB/VAAP. 122 (third row): DK/L. 122(fourth row, left): NGA. 122 (fourth row, right)–124: BB/VAAP. 125 (top row, first picture): DK/L. 125 (top row, second picture): BB/VAAP. 125 (top row, third picture): NGA. 125 (top row, fourth picture): Philadelphia Museum of Art, The George W. Elkins Collection. 125 (center, left): DK/L. 125(center, right–bottom, left): NGA. 125 (bottom, right)–127: BB/VAAP. 128: Brown Brothers. 130–131: Rare Book Division, NYPL. 132–133: Novosti. 134–137: Virginia Museum, Richmond. 138–139: Popperfoto. 140–141: Roger-Viollet. 142–143: Anne S.K. Brown Military Collection, Brown University Library, Providence, Rhode Island. 144: BBC Hulton Picture Library. 145: H. Peter Curran/FMC. 146: Larry Stein/FMC. 147: Steven Mays, FMC. 148–149: Steven Mays, Matilda Geddings Grey Foundation, New Orleans. 150–151: Steven Mays, FMC. 152: Virginia Museum, Richmond. 153: Walters Art Gallery, Baltimore, Maryland, photograph Robert Forbes Collection. 154–161: Steven Mays, FMC. 162–163: Steven Mays, Matilda Geddings Grey Foundation, New Orleans. 164–165: MMA. 166–169: Steven Mays, FMC.

SUGGESTED READINGS

Billington, James H., *The Icon and the Axe, An Interpretive History of Russian Culture*. Vintage Books, 1970.

Brodsky, Boris, *The Art Treasures from Moscow Museums*. Izobrazitelnoye Iskusstvo Publishers, 1980.

Hamilton, George Heard, *The Art and Architecture of Russia*. Penguin Books, 1954.

Lincoln, W. Bruce, *The Romanovs*. The Dial Press, 1981.

da Madariaga, Isabel, *Russia in the Age of Catherine the Great*. Yale University Press, 1981.

Massie, Robert K., *Peter the Great*. Ballantine Books, 1980.

Massie, Suzanne, *Land of the Firebird, The Beauty of Old Russia*. Simon and Schuster, 1980.

Riasanovsky, Nicholas, *A History of Russia*. Oxford University Press, 1977.

Snowman, A. Kenneth, *Carl Fabergé, Goldsmith to the Imperial Court of Russia*. The Viking Press, 1979.

von Solodkoff, Alexander, *Russian Gold and Silverwork, 17th–19th Century*. Rizzoli International Publications, Inc., 1981.

Vernadsky, George, *A History of Russia*. Yale University Press, 1961.

INDEX

Page numbers in **boldface type** refer to illustrations and captions.